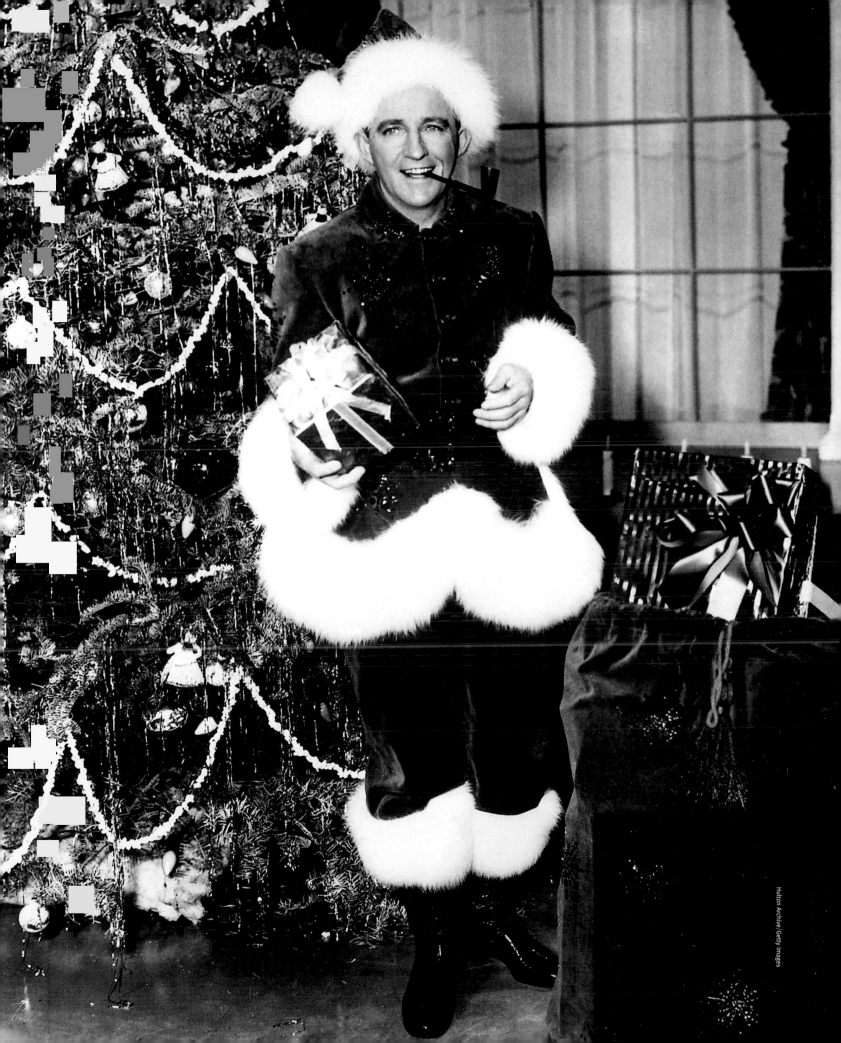

LIFE
Christmas
Around the World

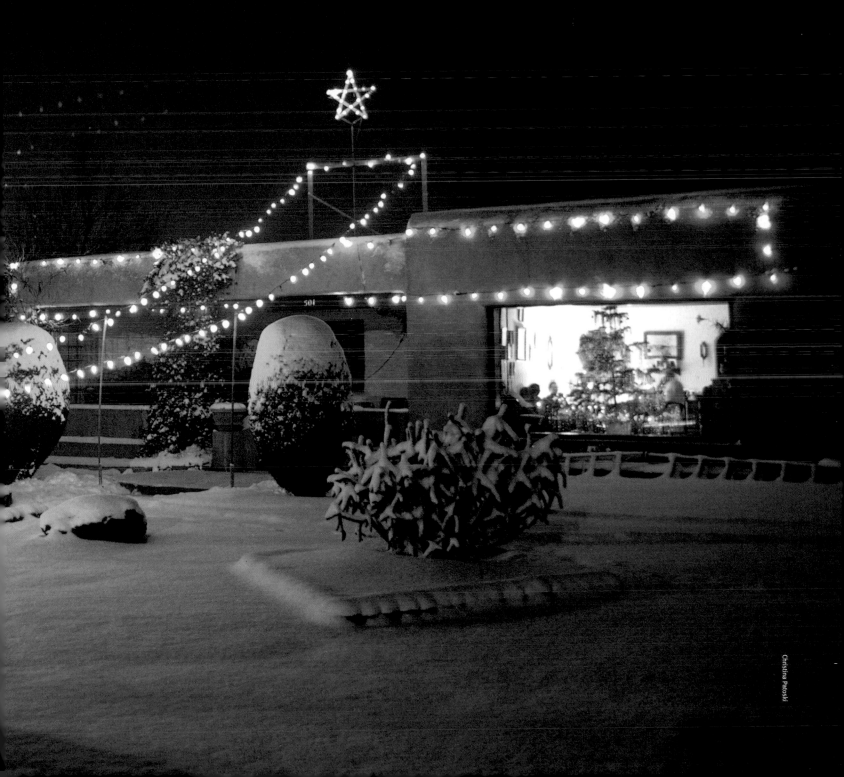

LIFE

Editor Robert Sullivan
Director of Photography Barbara Baker Burrows
Executive Editor Robert Andreas
Creative Director Lynda D'Amico
Deputy Picture Editor Christina Lieberman
Writer-Reporters Hildegard Anderson (Chief), Lindsey Lee Johnson
Copy Wendy Williams (Chief), Olga Han
Production Manager Michael Roseman
Picture Research Rachel Hendrick
Photo Assistant Joshua Colow
Contributing Editor JC Choi
Consulting Picture Editors Mimi Murphy (Rome), Tala Skari (Paris)

Publisher Andrew Blau
Finance Director Craig Ettinger
Assistant Finance Manager Karen Tortora

Editorial Operations Richard K. Prue (Director), Richard Shaffer (Manager), Brian Fellows, Raphael Joa, Stanley E. Moyse (Supervisors), Keith Aurelio, Gregg Baker, Charlotte Coco, Scott Dvorin, Kevin Hart, Rosalie Khan, Po Fung Ng, Barry Pribula, David Spatz, Vaune Trachtman, Sara Wasilausky, David Weiner

Time Inc. Home Entertainment

President Rob Gursha
Vice President, New Product Development Richard Fraiman
Executive Director, Marketing Services Carol Pittard
Director, Retail & Special Sales Tom Mifsud
Director of Finance Tricia Griffin
Marketing Director Ann Marie Doherty
Prepress Manager Emily Rabin
Book Production Manager Jonathan Polsky

Special thanks to Bozena Bannett, Alexandra Bliss, Bernadette Corbie, Robert Dente, Anne-Michelle Gallero, Peter Harper, Suzanne Janso, Robert Marasco, Natalie McCrea, Margarita Quiogue, Mary Jane Rigoroso, Steven Sandonato

Published by

LIFE Books

"LIFE" is a trademark of Time Inc.

Time Inc.
1271 Avenue of the Americas,
New York, NY 10020

ISBN: 1-932273-50-6
Library of Congress Control Number: 2004108514

We welcome your comments and suggestions about LIFE Books. Please write to us at: LIFE Books, Attention: Book Editors, PO Box 11016, Des Moines, IA 50336-1016

If you would like to order any of our hardcover Collector's Edition books, please call us at 1-800-327-6388 (Monday through Friday, 7:00 a.m.–8:00 p.m. or Saturday, 7:00 a.m.–6:00 p.m. Central Time).

Please visit us, and sample past editions of LIFE, at www.LIFE.com.

Classic images from the pages and covers of LIFE are now available. Posters can be ordered at www.LIFEposters.com. Fine art prints from the LIFE Picture Collection and the LIFE Gallery of Photography can be viewed at www.LIFEphotographs.com.

Previous pages: Bing Crosby in the 1954 film "White Christmas"; Christmas in Santa Fe. These pages: lights strung along the jawbone of a 67-foot whale, Alaska.

Al Grillo/Corbis Saba

The First Christmas

From Nazareth to Bethlehem, a young couple followed their fate.
Others came from far and near, drawn by a star.

Photographs by Denis Waugh

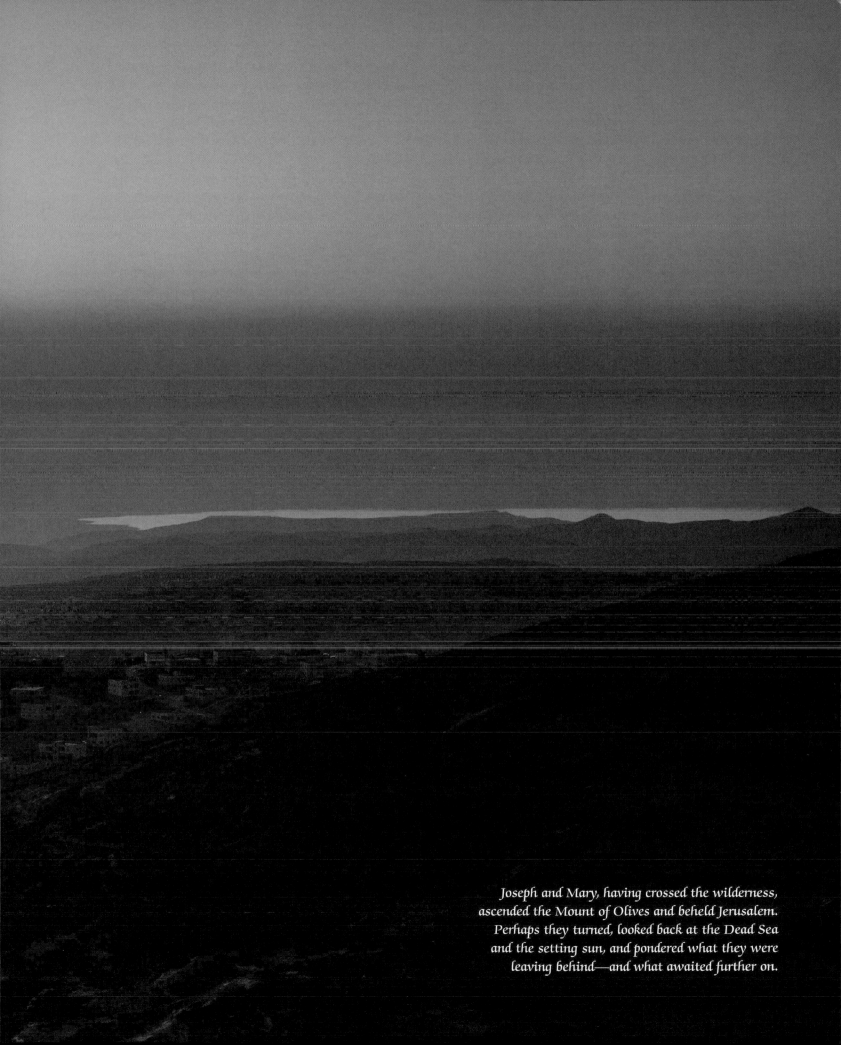

Joseph and Mary, having crossed the wilderness,
ascended the Mount of Olives and beheld Jerusalem.
Perhaps they turned, looked back at the Dead Sea
and the setting sun, and pondered what they were
leaving behind—and what awaited further on.

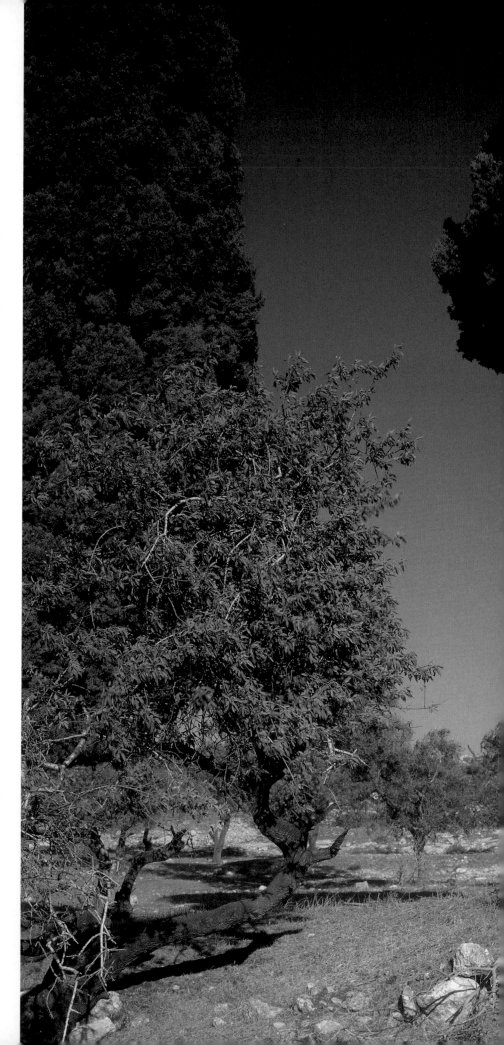

The Journey Begins

At Christmas we remember Jesus, but we should remember his parents, too, and their desperate 100-mile trek through the Holy Land. Two millennia ago, when Caesar Augustus decreed that all subjects of Roman rule must register in the city of their birth, simple folk like Joseph and Mary would never have dreamed of disobeying. And so, despite Mary's advanced pregnancy, they set out from the Galilean village of Nazareth and headed home to Bethlehem. They surely would have avoided Samaria to the south, an area hostile to mainstream Jews such as themselves, and instead would have traveled east toward the Sea of Galilee—thence south, tracing the Jordan River to Jericho, and then west into the wilderness of the Judean Desert. Here they encountered bedouin shepherds—and hopefully no mountain lions, scorpions or bandits—and everywhere they saw other travelers following Caesar's order. They doubtless witnessed, during their six-day journey made on foot and by donkey, villages that had been burned by the Romans and crosses that had been used to crucify Jewish rebels. Finally, they beheld glorious Jerusalem and, shortly on, Bethlehem. With the small town teeming with people needing to register, the local inn was full. And so Joseph and Mary made their camp in a shepherd's grotto, and awaited the birth of their son.

Perhaps 200 families lived in the village of Nazareth some 2,000 years ago. Joseph, a man of limited means, probably ran his carpentry business out of a small home he shared with his wife. The British photographer Denis Waugh returned to the Holy Land for LIFE to record scenes in the principal locales of the Nativity narrative—seeking the look and feel of the place back when.

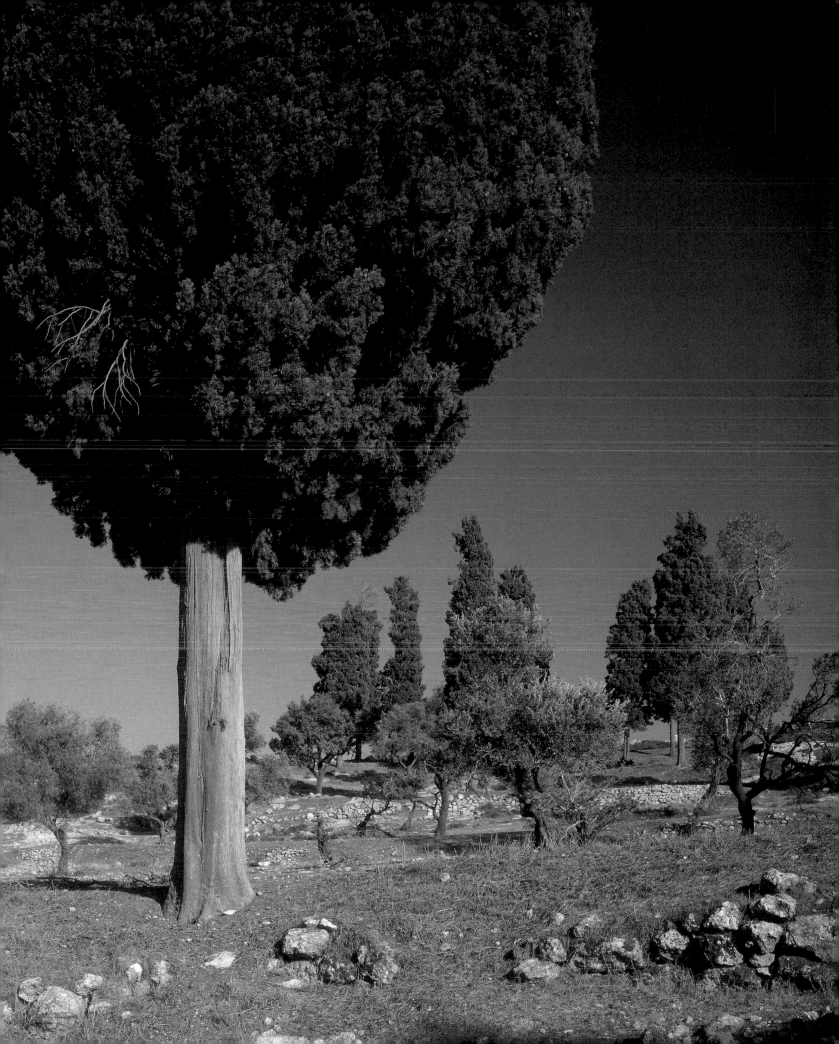

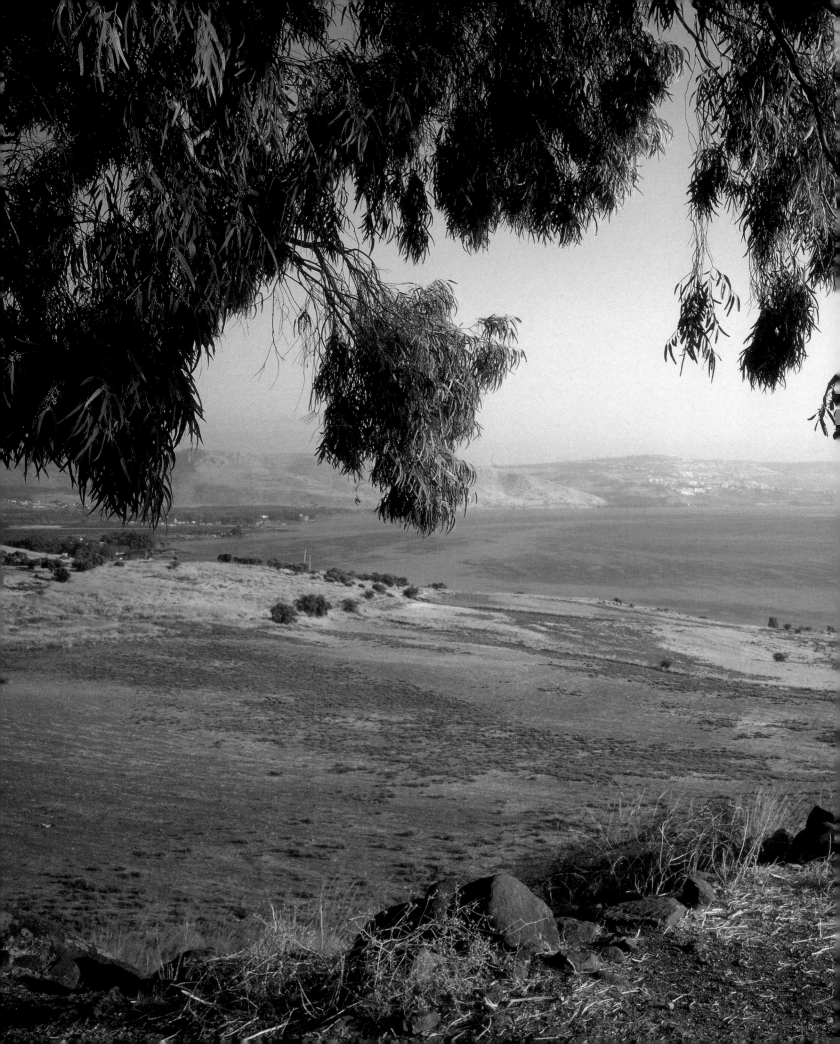

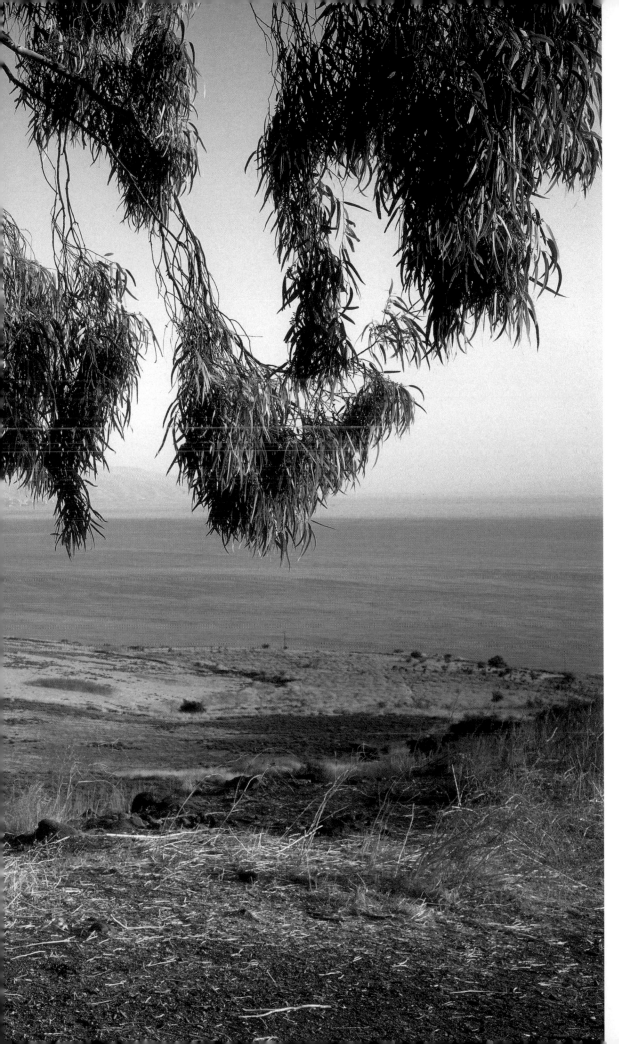

By the end of the first
day of their journey,
Joseph and Mary had
passed the Sea of
Galilee. Jesus saw
much this same view
when, 30 years later,
He came here to preach
the Sermon on
the Mount.

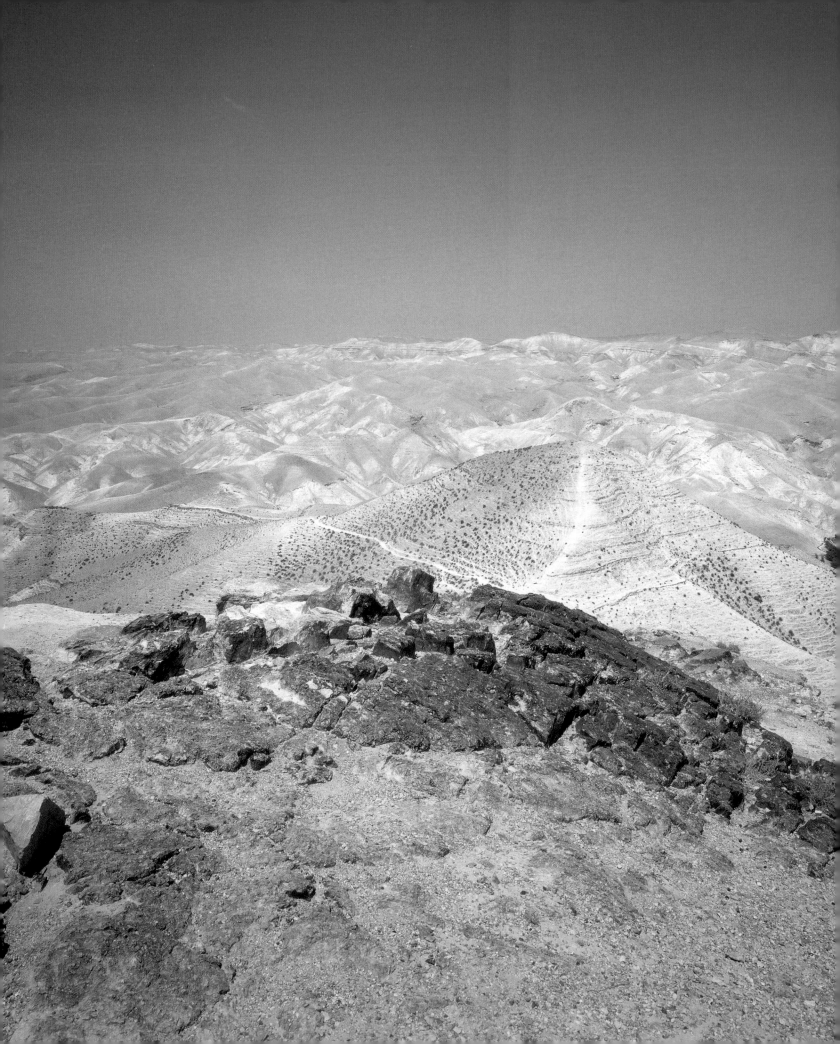

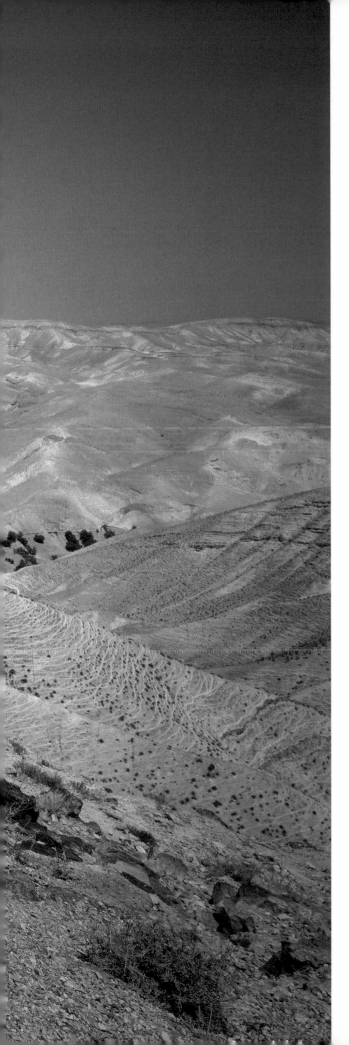

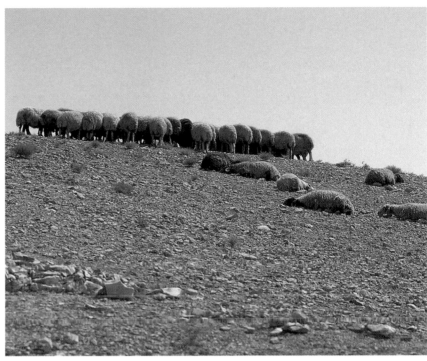

Mary and Joseph reached the treacherous Judean Desert by the fifth day of their journey. They would pass this way again several weeks later, heading back to Nazareth with their infant. Many of these places between Nazareth and Jerusalem—the seas, the mountains, the wilderness— would figure as settings for different chapters in Jesus' ministry and, finally, His Passion.

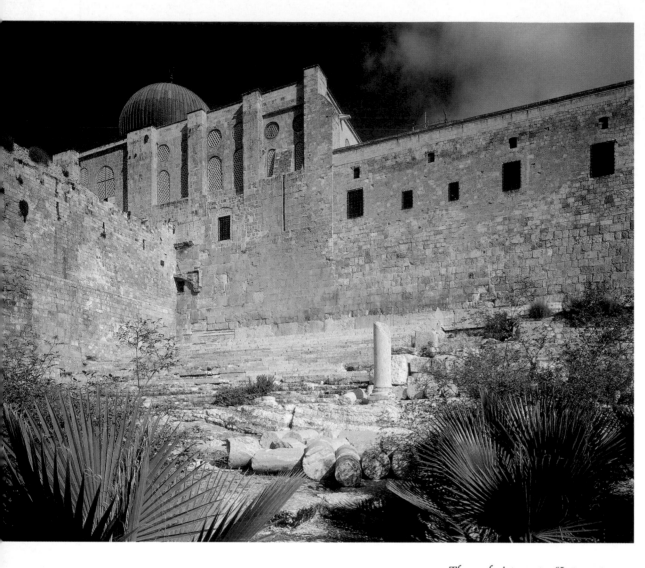

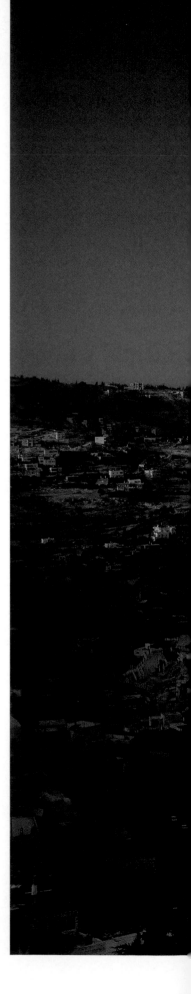

The psalmist wrote: "Let my tongue cleave to the roof of my mouth if I prefer not Jerusalem above my chief joy." Certainly Joseph and Mary understood the sentiment when they gazed upon the city and, especially, when, in accordance with tradition, they returned to the Holy Temple (above) to sacrifice two turtledoves, thanking the Lord for their son.

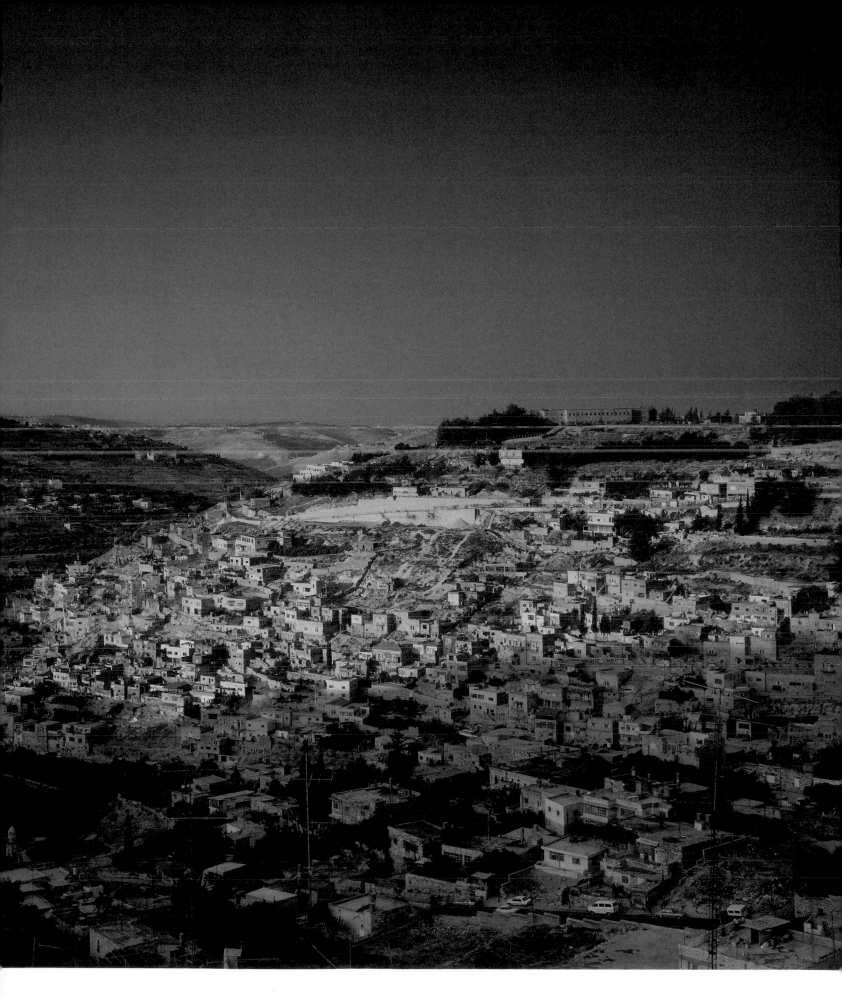

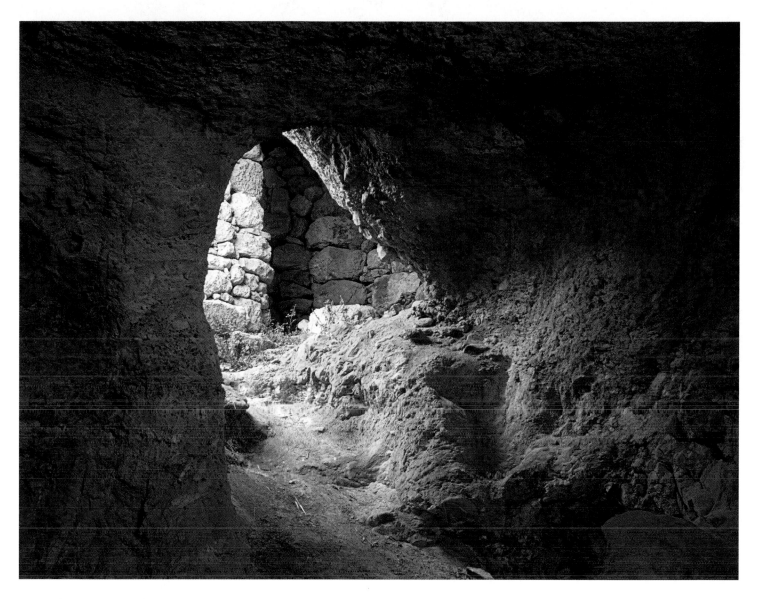

The Field of the Good Shepherd (opposite) looks much as it did when an angel appeared to shepherds and proclaimed Christ's birth. The shepherds were well familiar with natural grottoes like the one above (they had been using them as shelters for many centuries), which now served as a manger for the newborn babe. This grotto is approximately two miles from the Church of the Nativity in Bethlehem, believed to sit precisely atop the spot where Jesus was born—and Christianity began.

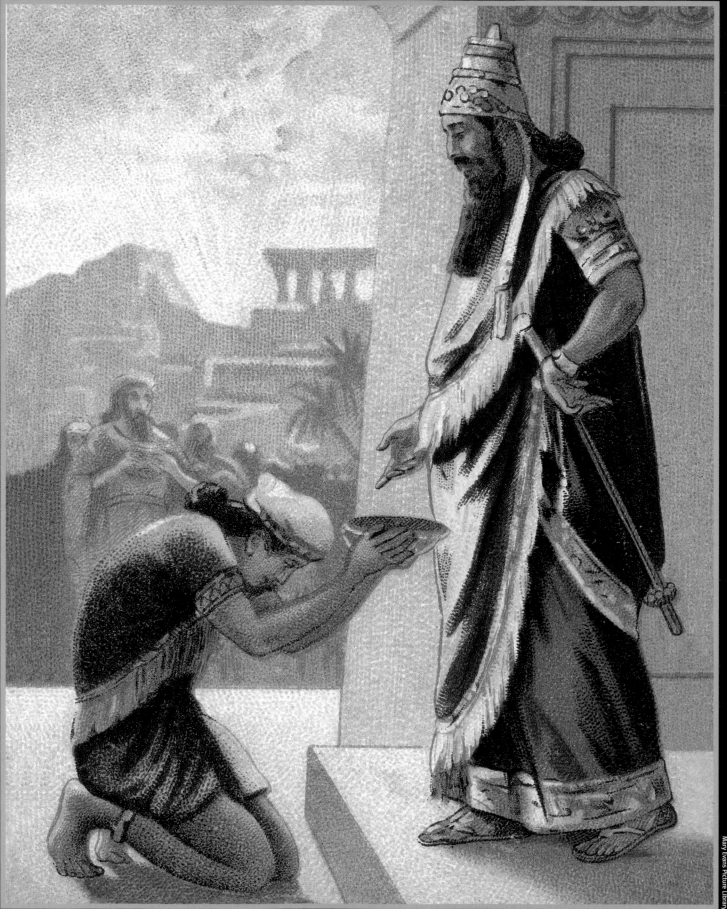

Making Merry

*T*he millions who celebrate the birth of Jesus justly view that event as the heart and soul of Christmas. Yet many of the trappings and traditions that now accrue to the holiday, adorning it prettily like ornaments on a tree, predate the Nativity by as much as 2,000 years. Bright fires, gift-giving, parades, roving carolers and 12-day festivals were hallmarks of other ancient, end-of-the-year observances and celebrations. Over time, they all became part of the grand and growing pageant that is Christmas.

The Persian New Year's festival, Nawruz, was one of several pre-Christian pageants in which offerings were made, gifts exchanged and the rebirth of life cheered.

The Mesopotamian, Persian and Babylonian cultures held multi-day rituals that acknowledged the winter solstice, the approaching new year, or both. The ancient Greeks staged a festival honoring their god Kronos, while the Romans enjoyed an annual blowout that nodded to their god Saturn and bequeathed a word for unrestrained excess, *saturnalia.* The Roman Saturnalia was definitive from the get-go, with music and dancing, masquerades and unbridled ingesting and imbibing. Kids were off from school, family visits were paid to friends crosstown, good-luck gifts were exchanged, trees were decorated with candles. Brotherhood and gaiety infused all. The Saturnalia, extending from December 17 to 23, was redolent of both the partying aspect of our modern Christmas holiday and, interestingly, the long-ago Yule celebrations of pagans in the far north.

Yes, it is very true that heathens lent much to what is, today, for most, a Christian observance.

As Roman culture became more decadent, the revelry that attended Saturnalia became ever wilder. The Lord of Misrule presided over something closer to mayhem, as Seneca the Younger reported in the first century A.D.: "It is now the month of December, when the greatest part of the city is in a bustle. Loose reins are given to public dissipation."

The pagans of the Norse lands, some having survived months of everlasting night, celebrated the first hints of sunlight at year's end with a no-holds-barred festival called Yule. During Yule, when light remained scarce and legions of ghosts were presumed to be everywhere in the blackness, nothing was more comforting than the burning of a bright Yule log—a tradition that would later make the short hop from Norway to England. Yule was also a time for brewing and drinking ale, itself a useful antidote to haunting. During the pagan fest the rule was little work and much play. Though much about Yule remains unclear, most agree that ale was at the heart of the festivities. The term *drikke jól* meant both "drink Yule" and "celebrate Yule." Of course, the Vikings had good reason to imbibe—they believed that ale would bring them nearer to the gods. We can only imagine the revelry that ensued.

The Romans, too, celebrated what they called the Birthday of the Unconquerable Sun with one solemn day after Saturnalia. The date set aside was December 25.

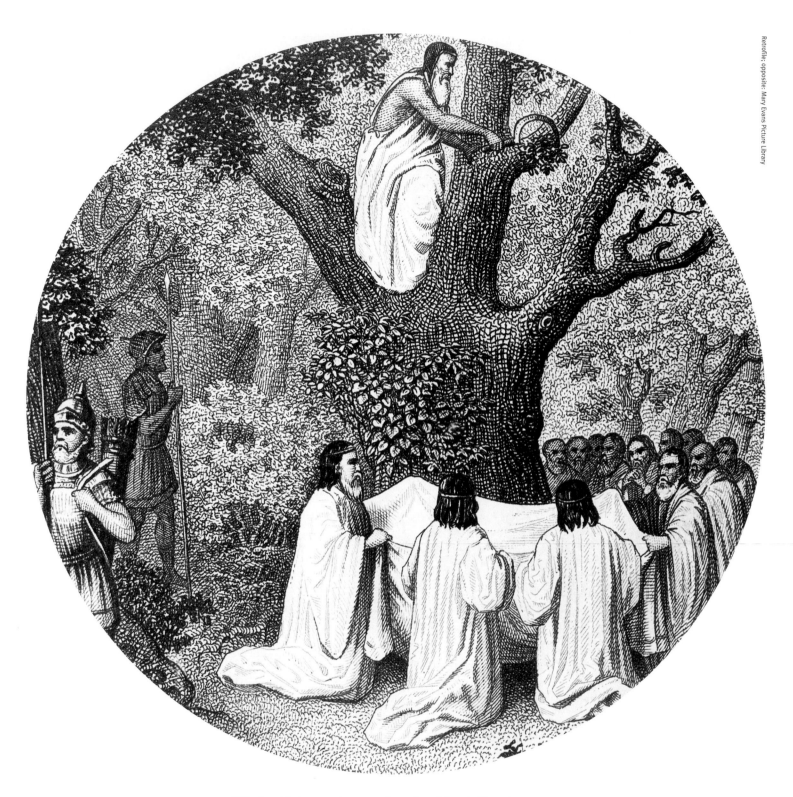

"The Druids," wrote Rome's Pliny the Elder, "hold nothing more sacred than the mistletoe and the tree on which it grows provided it is an oak. They choose the oak to form groves, and they do not perform any religious rites without its foliage." Here, Druidic priests gather mistletoe at a giant oak. The leaves and berries would endure as a bright Christmas tradition.

No one knows when Christ was born. A safe bet is within seven years of the first year A.D. But it is a fool's wager to put money on a specific day. July 4 would be as likely as December 25. In earliest Christianity, Christ's birthday had no fixed date.

The very earliest followers of Christ—the apostles, the Gospel writers, Saint Paul—were persuasive in their message and quickly gained adherents and devotees. As Christianity attained something approaching a toehold in the Roman Empire, it represented itself clearly as a minority religion, an opposition religion. It celebrated the birth of Christ solemnly and viewed with opprobrium the end-of-the-year hedonism that attended Saturnalia. As it would be through the ages, particularly when Puritans weighed in (but even today in our postmod-

ern world), the tension between the sacred face of Christmas and its festive side was evident. Converts to Christianity heard what their preachers were saying about circumspection and reverence, but they were reluctant to forgo all manner of celebration and, well, fun. Pagan rites and Saturnalia were part of their life, even as they sought to be Christlike. Eventually, their leaders decided it was best to go with the flow, co-opting and toning down the merriment while ascribing to some rituals a Christian significance. Christmas, yet without a name, began taking shape.

As to the term and the date: With Christianity suddenly a true force, the Bishop of Rome ordered, in 137 A.D., that Christ's birth be honored with a festival. In 325, the first Christian emperor, Constantine the Great, said Christmas was an "immovable

By 1892, when the illustrator Harriet M. Bennett made this painting, the British had long since adopted the Yule log. They would get theirs in the forest on Christmas Eve, lug it home, decorate it and keep it burning through the 12 days of Christmas. Charred remains were stored to kindle next year's log.

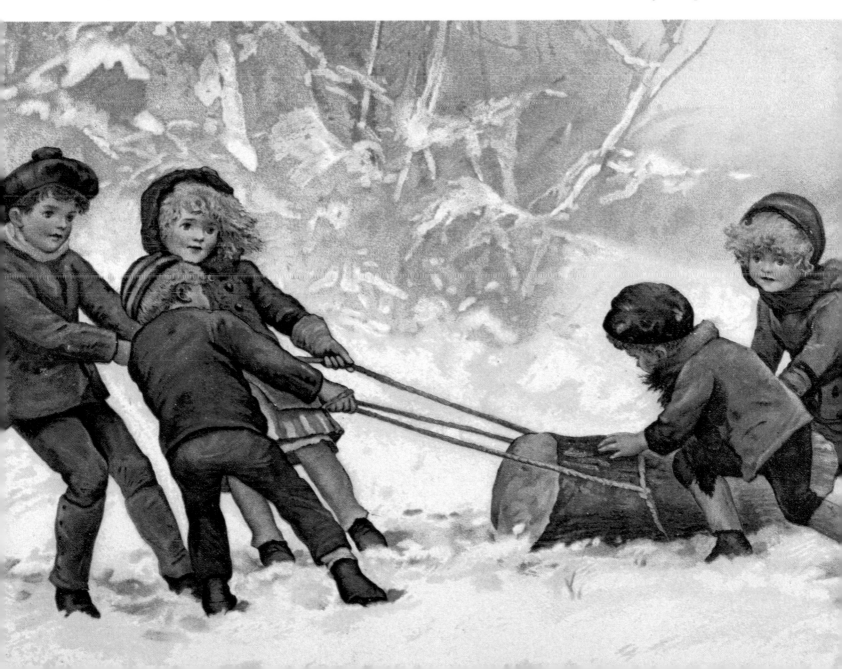

Constantine the Great ruled a burgeoning Roman Empire in the 4th century—and saw to the burgeoning of a new religion. Though his personal conversion to Christianity is disputed, and though he never made Christianity the state-sponsored faith, and though he never outlawed paganism, he did remove all legal onus to being a Christian, returned confiscated church property and established not only a fixed Christmas holiday but also Sunday as a day of worship. He unshackled Christianity, which grew into the world's largest religion.

feast" to be observed on December 25—a day with built-in resonance in the area. By then the holy day was known as Mass of Christ, Christ's Mass, Christmass. Since Christ's name in Greek is Xristos, many centuries later—circa 1500—Christmas would be called, by some societies, Xmas. In 20th century America this would come to be seen by many as a denigration, but in fact it was just as respectful as the original Roman term.

The journey of Christmas—the *making* of Christmas—from the moment that ancient tradition started to flow into Christian ritual is fascinating. Hardly anything—the garland, the lights, the presents, the bonhomie—was discarded, while much else was appropriated. Christmas became ever more about celebration, happiness, joy, reverence, fun, merriment, contemplation, charity, sharing, thanksgiving and . . . a time for pause and reflection.

As the day took on its eternal accoutrements, it embellished them. In this short history of Christmas, we could traipse through the centuries chronologically, adding this and that to the Christmas résumé. But perhaps the point is better made by hitting some highlights. How did the tree get from there to here? What is Santa's relation to Saturn?

Here, then, some Christmas traditions, briefly explained:

The Tree

In the dead of winter, the pagans of northern Europe looked to the evergreen tree as a sign of rebirth. Not only the Romans but also the Druids of central Europe decorated their trees with candles and ornaments. In Christian history, the story goes, two men, both working in Germany, are linked to the Christmas tree—and underlie the notion that

der Tannenbaum is a Teutonic gift to the holiday.

Saint Boniface was an English monk evangelizing among Druids in the 8th century. One story holds that Boniface used the triangular fir tree to describe the Holy Trinity to the heathens, who came to revere this tree as they had theretofore honored the mighty oak. Another, more dramatic version has Boniface smiting an oak with but a single blow, and then watching as a small fir sprouts in its place.

Pumping up the volume still further, the Victorian author Henry Van Dyke, in his volume *The First Christmas Tree*, writes of Boniface learning that a son of Chieftain Gundhar is to be sacrificed by the Druids on Christmas Eve. The offering is to be made close by the giant, sacred oak. Boniface swings his ax yet one time, and the oak tree falls. At this point the monk points to a small evergreen that is growing nearby and declares to the astonished pagans,

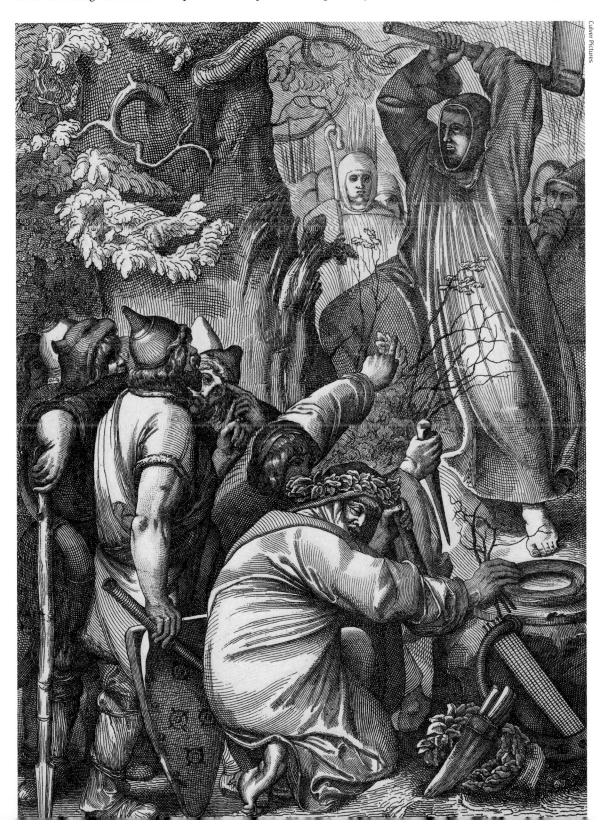

Pope Gregory II's charge to Boniface in 719 was clear: "[T]hou shalt hasten to whatsoever tribes are lingering in the error of unbelief, and shalt institute the rites of the kingdom of God." Boniface vigorously executed the order throughout Germany, never more so than when he took his ax to the oak and, stunningly, brought it down. Willibald, in his "Life of Boniface," described the moment: "When the pagans who had cursed did see this, they left off cursing and, believing, blessed God." Mission accomplished.

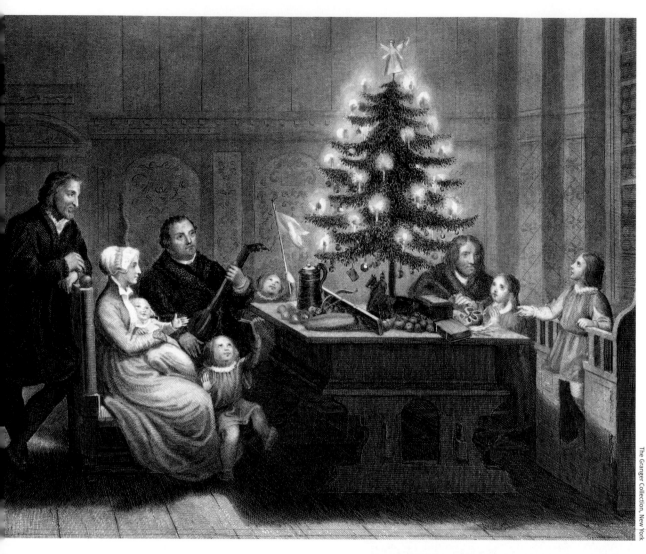

The 19th century German engraving at left depicts Martin Luther, his wife, Katharina von Bora, and their children with a decorated tree in Wittenberg on Christmas Eve, 1536. Luther's inspiration traveled: Below is an 1891 painting entitled "Silent Night" by the Danish artist Viggo Johansen, and opposite is the famous 1848 picture of Victoria and Albert from "The Illustrated London News" that spurred a tree craze in Great Britain.

"This is the word, and this is the counsel. Not a drop of blood shall fall tonight, for this is the birth-night of the Saint Christ, Son of the All-Father and Saviour of the world. This little tree, a young child of the forest, shall be a home tree tonight. It is the wood of peace, for your houses are built of fir. It is the sign of endless life, for its branches are ever green. See how it points toward Heaven! Let this be called the tree of the Christ-Child; gather about it, not in the wild woods but in your homes; there it will shelter no deeds of blood, but loving gifts and lights of kindness."

It comes as no surprise to learn that the Druids were duly inspired, and converted in an instant. According to Van Dyke, the wood from the oak tree was chopped up and used to build a monastery. As for the fir, it, too, was felled—and taken to the great hall of the chieftain to serve as the first Christmas tree.

The second legend: In the mid-1500s, Martin

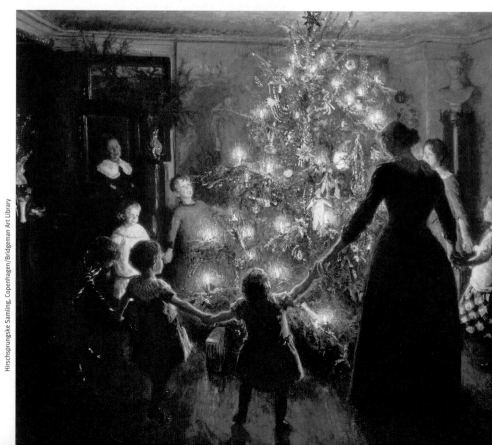

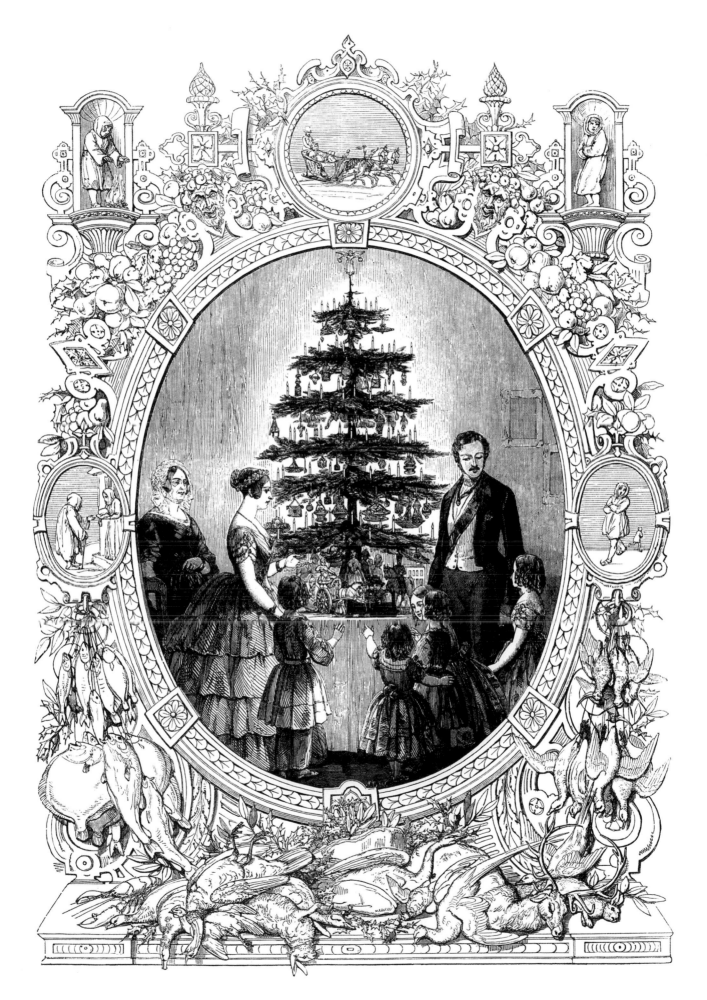

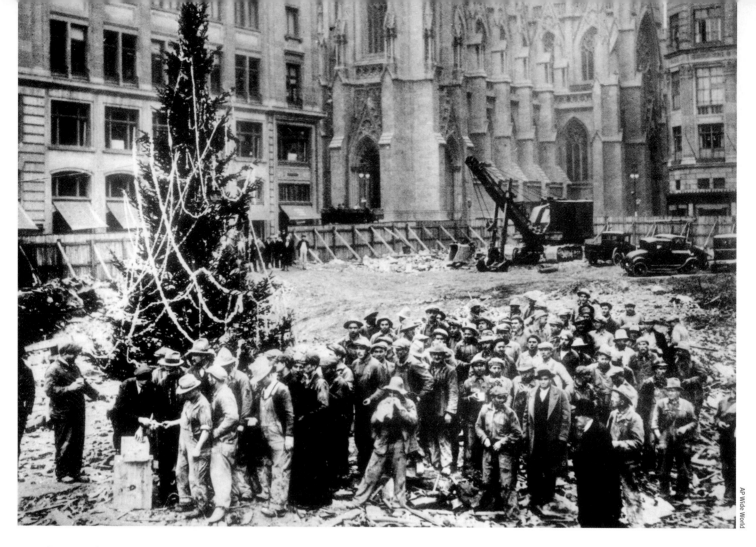

AP Wide World

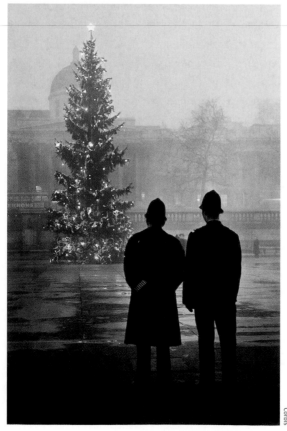

Above: Light amidst the darkness. In the gloomy year of 1931, construction workers in New York City line up to receive their pay in the smallish shadow of the very first Rockefeller Center tree. Saint Patrick's Cathedral can be seen in the background. Right: Two bobbies look on as the tree in London's Trafalgar Square, a spruced-up gift from Norway, is aglow in 1953.

Corbis

Luther, who would split with Rome to found the Protestant Church, went walking in the woods one Christmas Eve and was taken by the starry, starry night. He brought home a small evergreen, which he decorated with candles to show his children how impressive the twinkling stars had been. The tree, he said, was the metaphorical Christ, the Light of the World.

As the stories of Boniface and Luther spread and were enlarged, so grew the practice of bringing home a tree. By the end of the 16th century, indoor Christmas trees had become a staple in most German homes. Many of these trees were hung with ornaments that could be bought at Christmas markets in the town square. Around 1610, thin strips of silver began to be used as decoration: the advent of tinsel.

The arboreal custom would spread throughout the Continent, via the Georgian kings, then to England, where in the 1840s the famous royals Victoria and Albert started a national sensation by elaborately decorating a tree at Windsor Castle with such as fruits, gingerbread, candies, candles, beads

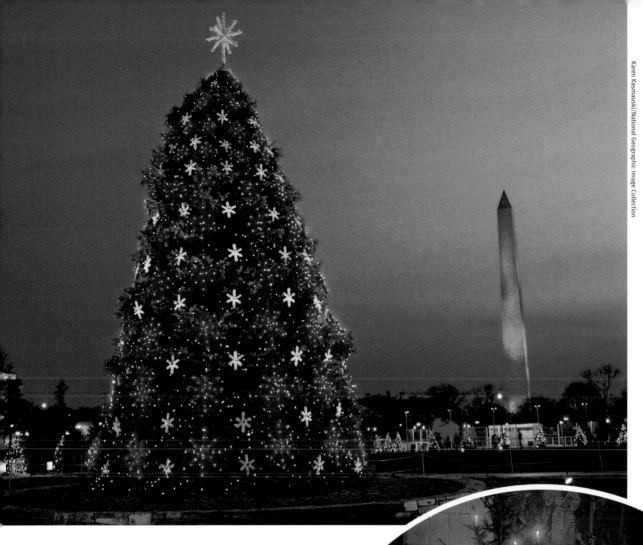

What it has come to, and where it came from: The National Tree of the United States of America grabs the spotlight from the Washington Monument each December in the New World, while in the Old—specifically in Saint Kunibert's Church in Cologne— a more traditional set of illuminations graces the latest in a long, long line of German trees.

and other adornments.

By this time, the tree tradition had been exported to Pennsylvania by German emigrants, and it underwent a thoroughly American transformation: commercialization. In 1830 a notice in the York, Pa., *Republican* announced that a splendid display downtown could be viewed by the public "for 6-$\frac{1}{4}$ cts., which will admit the bearers to the 'Christmas tree' during the time it remains for exhibition."

From that day to this, from aluminum monstrosities to Charlie Brown's persevering little fir, the tree has been the center of our gatherings. Famous, gigantic Norway spruces rise each December in London's Trafalgar Square and New York City's Rockefeller Center, where a more meager tree first appeared in 1931 to brighten spirits during the Great Depression. There are dazzling trees at the White House and at the Vatican. Each of them sends the same messages—light against the darkness, warmth and life in the midst of a bleak midwinter— that they sent to Luther, Boniface and the ancients.

The Christmas Card

This is one holiday staple that cannot be traced to the Romans or the Persians or the barbarian hordes. The mass-produced holiday card was devised in answer to a 19th century lament: how to find the time to write all of the many greetings that one hopes to send at Christmastime.

Certainly there were earlier, isolated examples of printed year-end missives—15th century German *Andachtsbilder,* which were cards with devotional pictures, and 16th century Dutch *sanctjes,* or "Nicholas cards," left during social calls at Yuletide. But it was not until Sir Henry Cole, founding director of what is now London's Victoria & Albert Museum, despaired at the size of his greetings list that the card as we know it was devised. In 1843, the same year Charles Dickens's *A Christmas Carol* was published, Cole approached the academician and painter John Callcott Horsley and asked him to come up with an edition of cards with a single message. A MERRY CHRISTMAS AND A HAPPY NEW YEAR TO YOU adorned a hand-colored lithograph of a happy family toasting an absent friend (presumably the card's recipient). Side illustrations depicted charitable acts of kindness to the destitute, and so all the elements of a good English Christmas—hearth, home and helping the poor—were invoked (even if puritanical sorts objected to the central image of frivolity, pointing out that having the young ones share in a wine toast clearly fostered "the moral corruption of children"). Cole took what he needed from the first printing, and the surplus cards—perhaps as many as 1,000—were sold to the public for a shilling each, and proved immensely popular.

Sir Henry, the story goes, sent no cards in 1844. Why he tired of his innovation is lost in the mists of Christmas lore. But he had created an industry. By the 1860s, cards were a fashion in England, with many companies competing, and in the 1870s, when postal rates were lowered, they became a craze. At the time, Americans were reliant on British exports, but in 1880, Louis Prang, a German immigrant who ran a lithography business in Boston, offered four thousand-dollar prizes for the best Christmas card designs,

HEARTY CHRISTMAS GREETING.

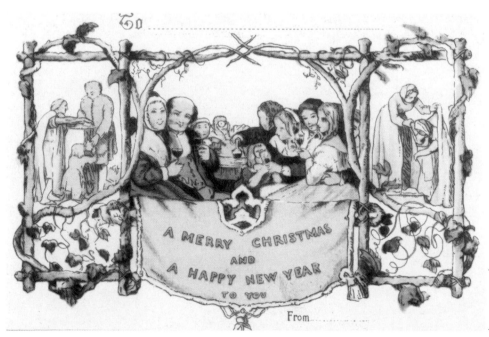

TO

A MERRY CHRISTMAS AND A HAPPY NEW YEAR TO YOU

From

MERRY CHRISTMAS.

Come under the mistletoe.

Wishing you a happy Christmas

Horsley's 1843 design (opposite, bottom) started it all off. In the late 19th century, multicolored, sometimes garish, often treacly cards were the rage in Great Britain. By 1909 some English moderns were using photography on their cards (above, right).

A CARD FOR XMAS AND THE SAME · FOR · FORTUNA · WISHING YOU GOOD LUCK

Christmas Greetings

While many British children in the Victorian Age lived in abject poverty or were coerced into dangerous labor as chimney sweeps and mill workers, rich kids were idealized as little angels. Speaking of which, angels and fairies were other fascinations of the Victorians.

which he would then reproduce in bulk. Prang had already made cards to be sold in England, but this was something new and entrepreneurial, and it proved a smash. Among the winners printed by Prang were scenes with flowers and angels. *Harper's Weekly* wrote in 1881, "The American Christmas cards excel the imported cards this season, and many of them are framed and presented as separate gifts, instead of merely accompanying a Christmas present." Into the 1890s, Prang produced some of the most beautiful items ever to grace the mail, issues with as many as 32 colors in a single image, that are today prized by collectors. Eventually he was undercut by cheaper cards and quit the business altogether. Despite his absence, the Christmas card phenomenon snowballed to 1.5 billion items in the first half of the 20th century, and doubled to nearly three billion in the second half.

Prang, who is now known as the Father of the American Christmas Card, has been immortalized by the Greeting Card Association's annual awards, which have been dubbed the Louies.

A Holy Happy Christmastide.

The Victorians were piecing it together. They acknowledged the sacred side of Christmas. They venerated youth and renewal. They honored Christ in all His names, the Roman and—in Xmas—the Greek. They boosted their variations on ancient traditions, such as minstrelsy and feasting.

A Christmas Greeting

God Bless ye Master of this house Likewise ye Mistress too, & all ye little children that round ye table go.

The Christmas Present

Gifts and children have always been part of the festival; in the Christian tradition, the infant Jesus represents nothing less than God's gift of His redeeming son to a wayward world. Even earlier than the birth of Christ, year's end was seen as a propitious time for making amends and resolutions, for setting records straight and building bridges—hence, gifts. Some benefactors were legend, none more so than Nicholas, bishop of Myra in Lycia on the coast of what was, in the 4th century, Asia Minor. The patron saint of sailors, travelers, bakers, brides, merchants, all of Russia and, perhaps most significantly, of children, Nicholas is a complex figure barnacled with all sorts of tales, tall and small. One is representative: He came to know a poor man who had three daughters, each of them personable, intelligent and altogether companionable. But no man would marry any of the daughters because the father could not provide a dowry. The father grew sad, the daughters despondent. Then, for three nights, Nicholas passed by the family's house and threw a bag of money through an open window. Now with a dowry, each of the girls married, thanks to Saint Nicholas, the secret midnight gift-giver.

His feast day was (and in many places still is) celebrated on December 6, providing an annual occasion for the exchange of tokens. But as we will see in a following chapter, he and many subsequent present-bearers—such kindly folk as Father Christmas and Santa Claus—came to be more closely associated, in many Christian countries, with December 25, Christmas.

Americans were delivered a vision of Saint Nick in the early 1800s by Washington Irving, our first truly international writer, who traveled in Europe and brought to the Hudson River Valley many Dutch traditions. "And lo, the good Saint Nicholas came riding over the tops of the trees, in that selfsame wagon wherein he brings his yearly presents to children," wrote Irving (as Diedrich Knickerbocker) in his 1809 *History of New York,* "and he descended hard by where the heroes of Communipaw had made their late repast. And he lit his pipe by the fire, and sat himself down and smoked; and as he smoked the smoke from his pipe ascended into the air and spread like a cloud overhead." It was a short trip from that image to the Santa we know today.

Galleria dell'Accademia, Florence/Bridgeman Art Library

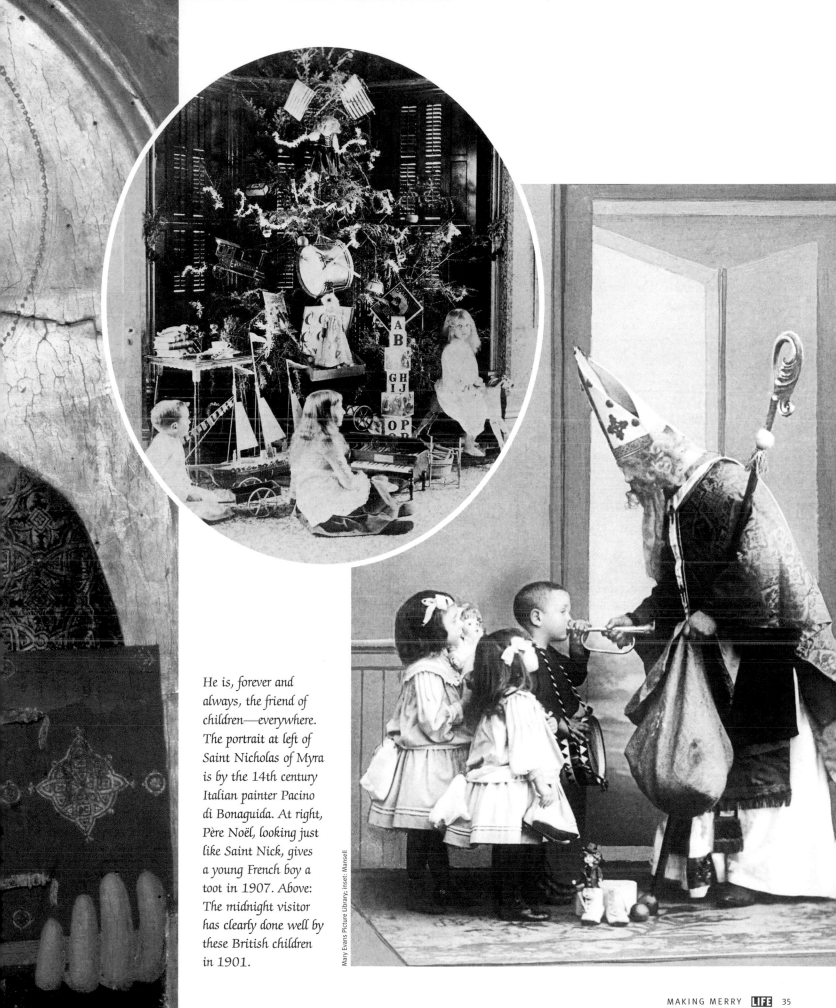

He is, forever and always, the friend of children—everywhere. The portrait at left of Saint Nicholas of Myra is by the 14th century Italian painter Pacino di Bonaguida. At right, Père Noël, looking just like Saint Nick, gives a young French boy a toot in 1907. Above: The midnight visitor has clearly done well by these British children in 1901.

The master of the house salutes the arrival of the boar's head as it is brought to the table, heralded with a hunting horn. A brief sampling of lyrics from "The Boar's Head Carol," published in 1521: "The boar's head, as I understand, Is the rarest dish in all the land . . . Our steward hath provided this, In honour of the King of bliss."

The Feast

The end-of-the-year holiday has long provided opportunity and dispensation for a repast that can outstrip even the modern American Thanksgiving. We could deconstruct another Christmas tradition immediately after this one—the Nap—but let's leave it at the Feast, with the Nap implicit.

The ancients reveled in the feast, and once England—the almighty holiday-shaper—got into the game, gastronomical gorging was further glorified. Bearing the massive boar's head, medieval serfs would enter the great hall amidst blazing torches, attended by lutists and flutists. In the boar's mouth was a lemon. Never mind that the boar belonged to Freyja, Norse goddess of fertility, or that the lemon was the Norse symbol of plenty. England was in charge here and could paint the picture as it wished, and then call the finished product English. Such are the privileges of empire. England's unruly offspring, the United States, would one day behave in a similar fashion.

Oliver Cromwell and other British Puritans, seeking to purge the Church of England of linger-

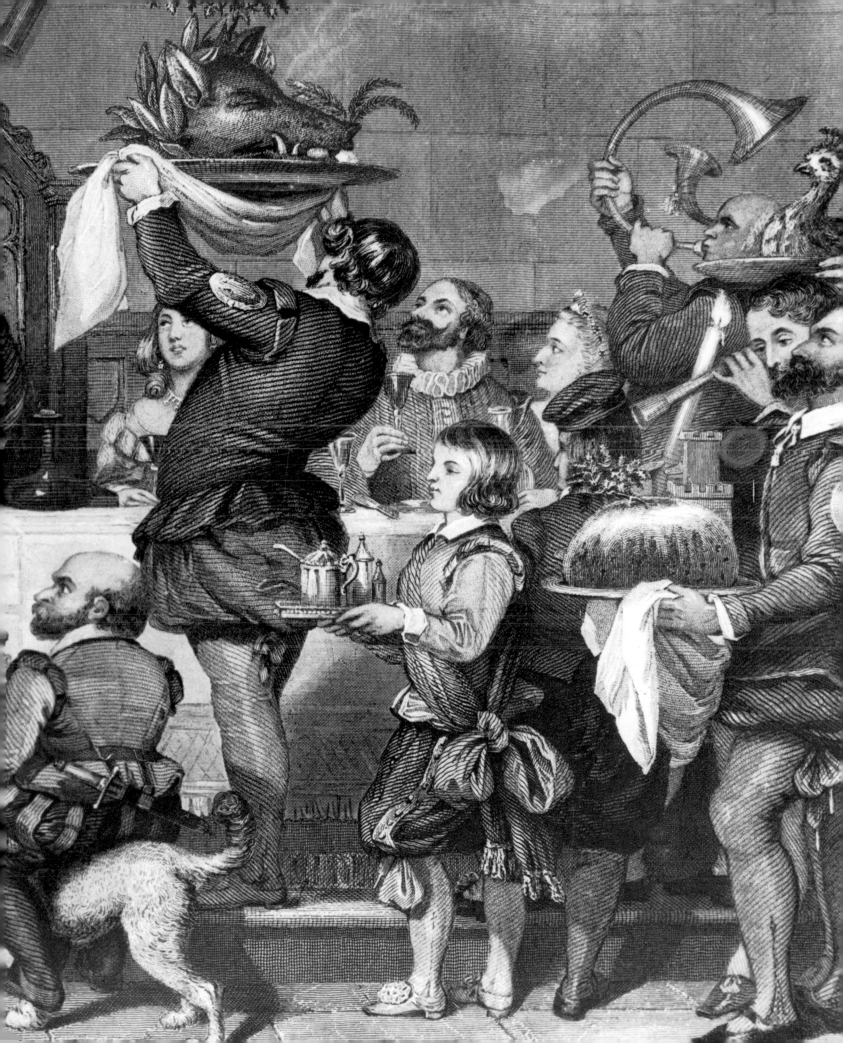

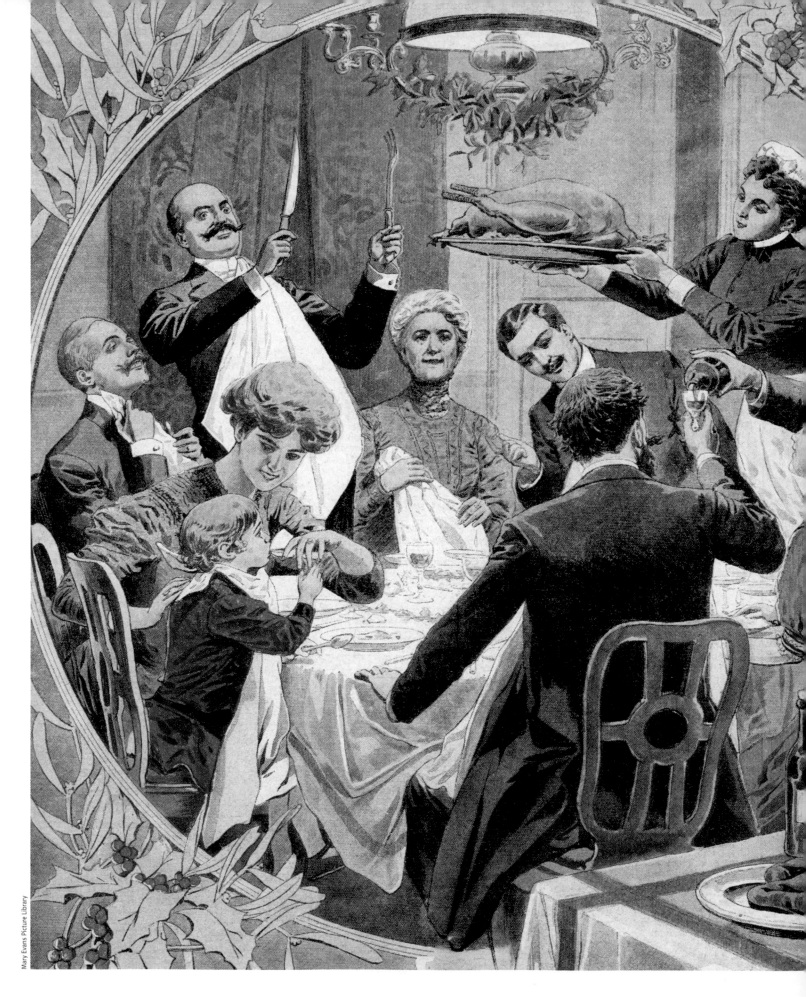

ing vestiges of its Roman Catholic heritage, made regular efforts in the 17th century not only to replace the feast with a fast but also to outlaw any and all trappings of a festive holiday— in fact, to abolish Christmas. The reaction was literally violent, with riots in London and elsewhere. By century's end, with Cromwell having been usurped, Christmas had regained a solid footing. Witness the lyrics of "Christmas Song," written in 1695, which read in part: "Now thrice welcome, Christmas, Which brings us good cheer, Minc'd pies and plumb-porridge, Good ale and strong beer, With pig, goose, and capon, The best that may be, So well doth the weather, And our stomachs agree." Take that, Cromwell.

The feast was a scene-setter and useful metaphor. Consider Dickens's turkey the size of a

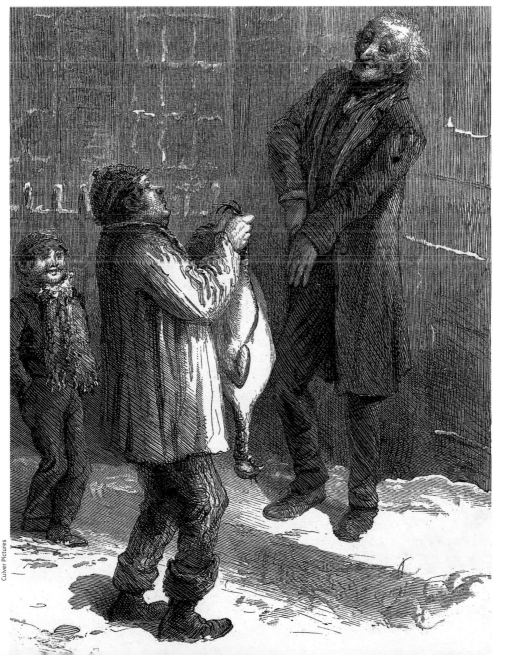

The meal has always had a double edge, in every land, from Rome to present-day America. It could be seen as a just reward or an unseemly, hedonistic expression in a land that elsewhere knew hunger and want. In 19th century England, it took a genius like Dickens to wrestle with the questions, and to use the feast as symbol. When the redeemed Scrooge purchases a prize turkey as an anonymous gift for the impoverished Cratchit family, the extent of his journey is clearly expressed. Dickens's commentary on his country was missed by no one.

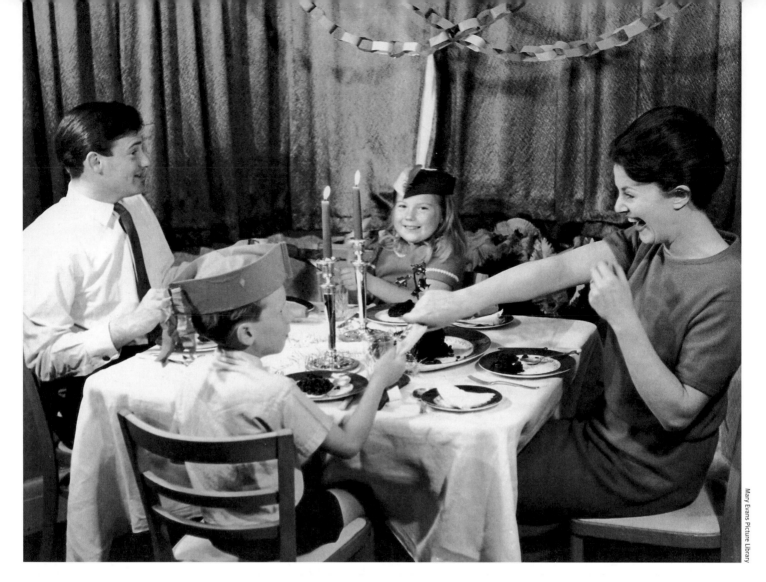

With Sinatra's "A Jolly Christmas" on the box and crackers in hand, Christmas is, by the postwar years, a smooth blend. Crackers were invented in the mid-1800s by Brit Thomas Smith, who wrapped small charms, trinkets and a popper inside a paper tube, which, when pulled apart, created a big bang and much good cheer.

small boy. Another 19th century literary figure, Washington Irving, again, was also influential. After journeying abroad in the first decades of the century, he brought home to America reports of lavish merriment and an obscenely opulent groaning board that had been witnessed, he said, at an English manor house. His descriptions were in the "Old Christmas" section of his best-selling 1820 collection *The Sketch Book of Geoffrey Crayon, Gent.*, which also included the stories "The Legend of Sleepy Hollow" and "Rip Van Winkle." Some critics alleged that Irving's picaresque of a baronial English Christmas was nearly as fanciful as his headless horseman, but Irving returned to England and insisted that his first impressions were neither exaggerated nor, as alleged, out of date: "The author had afterwards an opportunity of witnessing almost all the customs above described, existing in unexpected vigour in the skirts of Derbyshire and Yorkshire, where he passed the Christmas holidays." No matter how Irving might or might not have embel-

lished, life proceeded to imitate art as the New World adopted the romantic vision of the Old. In the melting pot, many more traditions and flavors—particularly, in recent years, Latin spices—have found their way to the Christmas table. Still, the essence of what Irving taught America, that Christmas is a time for gathering over food with family and friends, remains the centerpiece.

The Music

Parties mean tunes, and among parties, Saturnalia is the eternal king. Regarding the later, religious Christmas, hosannas were sung in Christ's praise shortly after His death, and much of the chanting that filled ancient monasteries, and that has enjoyed a popular renaissance in our time, was in contemplation of Christ's birth, sacrifice or resurrection. In the 13th century, Saint Francis of Assisi's staged Nativity scenes were graced by hymns and songs, and Jacopone da Todi produced some of the earli-

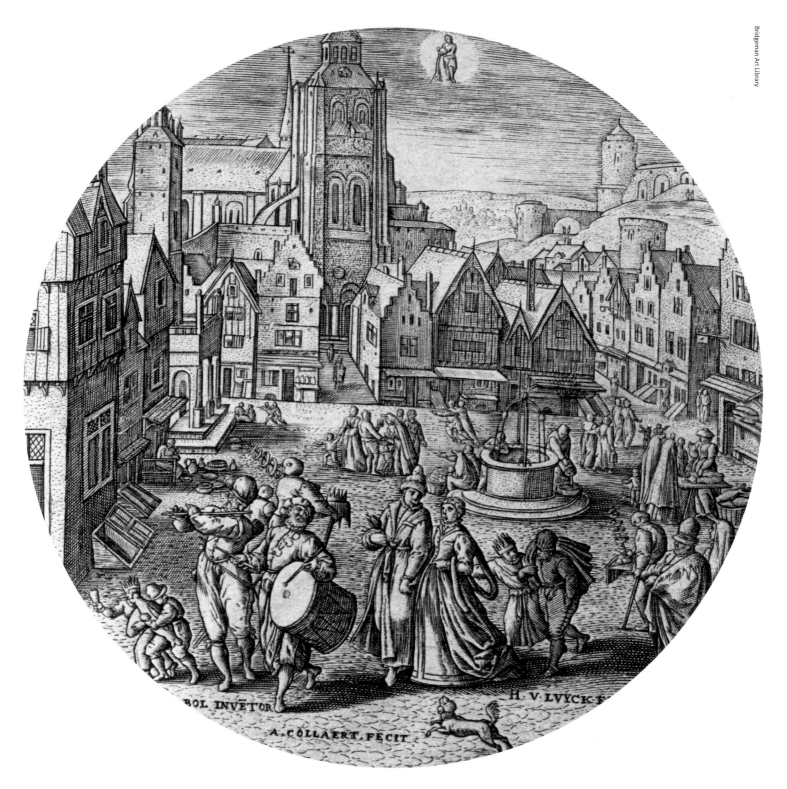

BOL INVĒTOR

A. COLLAERT. FECIT

H. V. LVYCK F

The 16th century Flemish illustrator Hans Bol depicted burghers
celebrating Twelfth Night in the market square of Bergen.
The square has already enjoyed a vigorous Yuletide workout,
as purveyors of foods and decorations for all of those suddenly
ubiquitous indoor trees have been doing brisk business in
the run-up to the holiday. Let the games begin!

est carols, which celebrated the blessed birth in a sweet and gentle way that would inform a thousand subsequent lyrics: "Come and look upon her child nestling in the hay! See His fair arms open'd wide, on her lap to play . . . Little angels danced around, Danced and carols flung; Making verselets sweet and true, Still of love they sung."

The word *carol* is from the Middle English *carole,* which means a joyous dance set to song. By the early 1400s, English composers were contributing. "In cradle keep a knave child, That softly slept; she sat and sung, Lullay, lulla, balow, My bairn, sleep softly now" may be from the first English carol. Four centuries later, they gave us the Great British Carol Book, with such classics as "Hark! The Herald Angels Sing" (with a melody by Mendelssohn), "Good King Wenceslas" (on a 16th century canticle) and the words to "Joy to the World!" (music attributed to Handel). The English translated an anonymous Latin hymn and found "O Come, All Ye Faithful," and turned the Frenchman Adolphe Charles Adam's "Cantique de Noël," which debuted in Paris at midnight Mass in 1847, into "O Holy Night." In the United States, Phillips Brooks, an Episcopal minister, provided the words to "O Little Town of Bethlehem," which was performed for the first time by the children of the Holy Trinity Sun-

day School in Philadelphia in 1868. Edmund H. Sears, a Unitarian minister in Massachusetts, wrote the lyrics to "It Came Upon a Midnight Clear." And in 1857 a third minister, the Episcopalian John Henry Hopkins Jr., of New York, wrote the music and words to "We Three Kings of Orient Are." All along the way, the master composers, such as Michael Praetorius (c.1570–1621), Heinrich Schütz (1585–1672) and Johann Sebastian Bach (1685–1750), were writing Christmas scores that would prove eternal. George Frideric Handel's *Messiah,* now a Christmas staple, was in fact first presented at Easter time in Dublin in 1742. The Russian Pyotr Ilich Tchaikovsky's ballet score loosely inspired by the German E.T.A. Hoffmann's 1816 *The Nutcracker and the Mouse King,* debuted in December 1892, in St. Petersburg, and today splits the December bill with *Messiah* on famous stages, and in school auditoriums, the world over.

While the bigger productions were intended for

UNIFORM WITH THIS VOLUME.

WASHINGTON IRVING'S
CHRISTMAS STORIES.

FROM THE "SKETCH BOOK."
HANDSOMELY ILLUSTRATED.
PRINTED ON FINE TONED PAPER, and bound in EXTRA CLOTH, FULL GILT

Washington Irving knew all about the traditional wassailing of the fruit trees on Twelfth Day Eve (top), and translated such rituals in his writings for a U.S. audience. The Christmas chapters of his "Sketch Book" proved a primer and road map for the classic All-American Christmas.

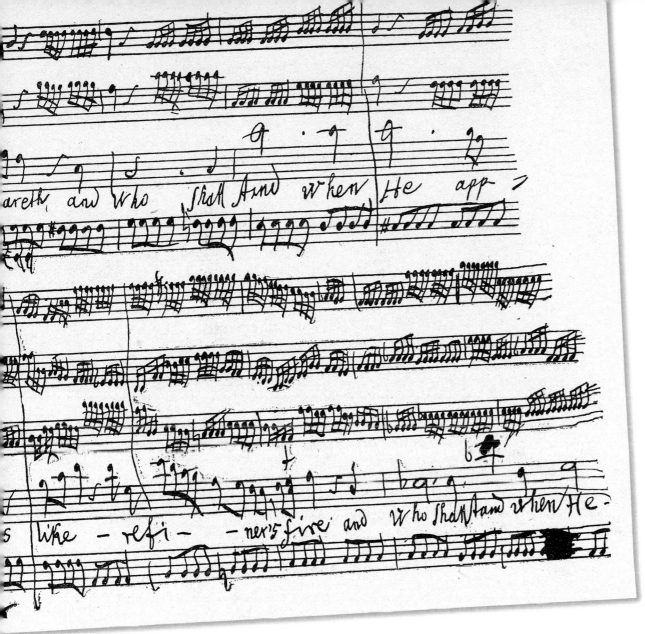

areth and Who shall And when He app

s like refi ner's fire and Who shall stand when He

George Frideric Handel's
oratorio "Messiah" was
first offered at Easter.
It was composed in just
three weeks in 1741;
in 1742 it premiered
in Dublin, proved an
immediate success and
raised considerable
money for charity.
Later, Handel presented
annual Easter
performances in London
to support the Foundling
Hospital, of which he
was a patron. But
Christmas has a
powerful pull, and
eventually "Messiah"
switched seasons from
spring to Yuletide.

Mansell

the concert hall or cathedral, and while pre-Reformation carols were mostly sung by a cleric with no accompaniment, beginning with the Lutheran chorale in the 16th century, Christmas music became a shared experience—even nonsingers were encouraged to join in. Interestingly, the carol's voyage from the pews out into the streets was in emulation of the Saturnalian tradition of getting out into the community, reestablishing bonds and sharing joy. Yet again it was Irving who introduced the tradition to the U.S. in his *Sketch Book*: "Even the sound of the waits, rude as may be their minstrelsy, breaks upon the mid-watches of a winter night with the effect of perfect harmony. As I have been awakened by them in that still and solemn hour, 'when deep sleep falleth upon man,' I have

listened with a hushed delight, and, connecting them with the sacred and joyous occasion, have almost fancied them into another celestial choir, announcing peace and good-will to mankind." The same author, later: "I had scarcely got into bed when a strain of music seemed to break forth in the air just below the window. I listened, and found it proceeded from a band, which I concluded to be the waits from some neighbouring village. They went round the house, playing under the windows.

"I drew aside the curtains, to hear them more distinctly. The moonbeams fell through the upper part of the casement, partially lighting up the antiquated apartment. The sounds, as they receded, became more soft and aerial, and seemed to accord with quiet and moonlight. I listened and listened—

they became more and more tender and remote, and, as they gradually died away, my head sank upon the pillow and I fell asleep." Such sublime and soothing imagery was irresistible, and soon carolers were heard across America.

The explosion of Christmas music in our time has seen singing cowboys and Tin Pan Alley and Elvis making for a delightful—if occasionally bemusing—discography. Except for the most egregious novelties ("Grandma Got Run Over by a Reindeer" comes to mind), all of it is part of a long and noble tradition in which Christmas composers have sought to conjure heavenly or joyous words and music, to invoke the mystery of a blessed night.

The Nativity and the Crèche

If the Christmas tree is largely the product of Germanic traditions, and the Christmas card demonstrably belongs to the British, then our vision of Christ's birth in Bethlehem, in enactment and statuary, owes everything to the Italians.

The scene at the manger, with animals and wise men attendant, was described in the Bible most memorably by Saint Luke, the literary lion among the three Synoptic Gospel writers. His report of Christ's life came sometime in the 1st century: "And there were in the same country shepherds abiding in the field, keeping watch over their flock by night. And, lo, the angel of the Lord came upon them, and the glory of the Lord shone round about them: and they were sore afraid. And the angel said unto them, Fear not: for, behold, I bring you good tidings of great joy, which shall be to all people. For unto you is born this day in the city of David a Saviour, which is Christ the Lord. And this shall be a sign unto you; Ye shall find the babe wrapped in swaddling clothes, lying in a manger. And suddenly there was with the angel a multitude of the heavenly host praising God, and saying, Glory to God in the highest, and on earth peace, good will toward men." That is from the King James version of the New Testament—still the most poetic English-language edition of the holy book.

The drama of that night was reinterpreted artistically many, many times in the first millennium, as countless painters, sculptors and musicians were inspired by the beauty—and majesty—of the Nativity. The tableau as we see it in our mind's eye can be precisely dated (December 24, 1223) and attrib-

Poetic license has been taken by Giotto di Bondone in this 13th century fresco, which is in the Upper Church of San Francesco in Assisi, Italy. When Francis prepared his Christmas crib at Greccio, he did so in a rude cave or grotto, not in a cathedral. In fact, this masterly artwork sends a message contrary to that of the humble Francis.

uted to Saint Francis of Assisi. Until then, the tradition called for ornate statuary of the manger, encrusted in gold and jewels, implying and honoring the prince of peace, the kingly child. But Francis, in reading his Bible, pictured instead a baby born in the most meager circumstance, whose humble parents could not know what awaited their son. Giovanni Velita, a farmer, gave his friend Francis a crib and some straw; animals were recruited from Velita and other neighboring farmers in the Umbrian hills. Saint Francis hoped "to celebrate the memory of the Child who was born in Bethlehem and see with my bodily eyes, as best I can, how He suffered the lack of all those things needed by an infant; how He was 'laid in a manger' and how He rested on the straw, with the ox and ass standing by." Velita sent out invitations to clerics and locals, and on Christmas Eve in 1223 an audience made a pilgrimage to a cave in the town of Greccio where, bathed in firelight, they were inspired by a simple, human reenactment of Christ's birth. Hymns were sung on that serene night, and the people left feeling they had witnessed something important. Many heeded Francis's urging to work their animals less vigorously and feed them better during the holiday. In the aftermath of Francis's tribute, reports of miracle healings were heard across the region.

The Franciscan interpretation of the Nativity became greatly influential in Italy, as December reenactments became common and scale models of the *fare il presepe*—the representation of the Holy Family—proliferated. (*Crèche* is a French word of Germanic extraction; *manger* is English; *crib* a derivation of *crèche*. In Italy, the Nativity scene is still called the presepe.) Artisans in coastal Sicily used coral, ivory and bone in their creations; pine and olive twigs were employed in Rome. If Saint Francis had wanted to simplify the scene so that humanity might apprehend what God was up to, this aspiration faded, especially among the presepe builders of Naples. By the 18th century their elaborations included a heavenly multitude of angels and pilgrims, and enough animals to fill a dozen barns. Some of the best Neapolitan sculptors landed commissions not from cathedrals but from the wealthy who wanted a presepe for their homes. Still, today, Naples is the crèche capital, if you will, of the world: On Via San Gregorio Armeno, Nativity scenes fill the shop windows even in midsummer.

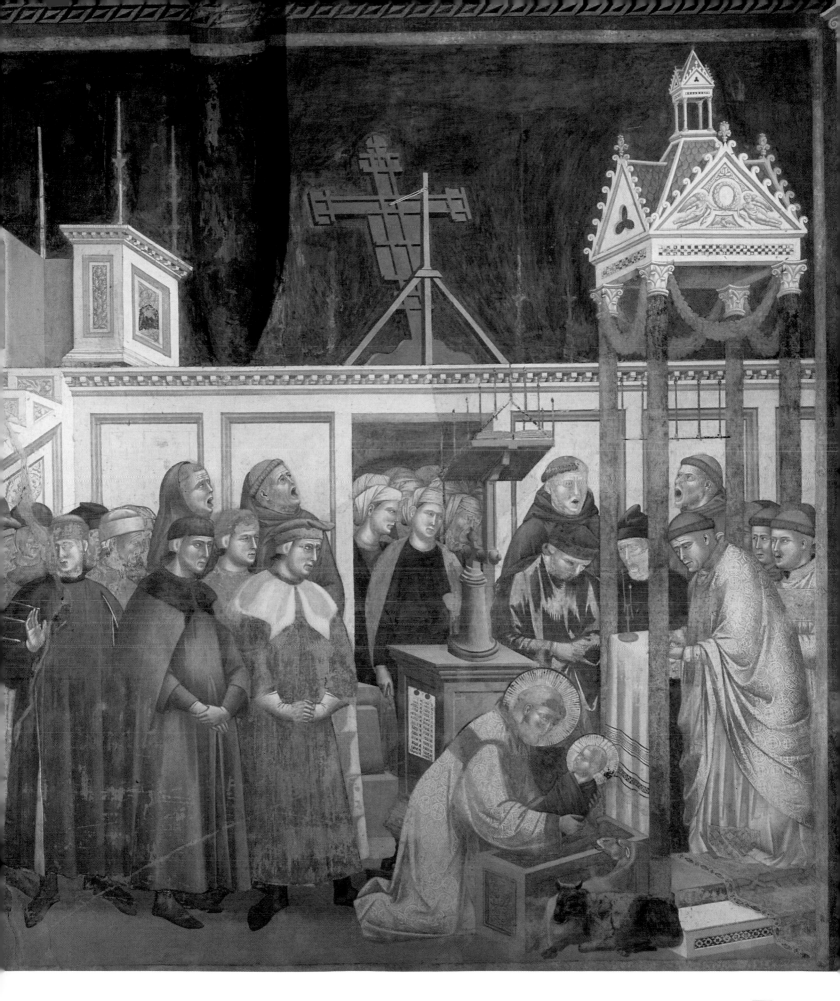

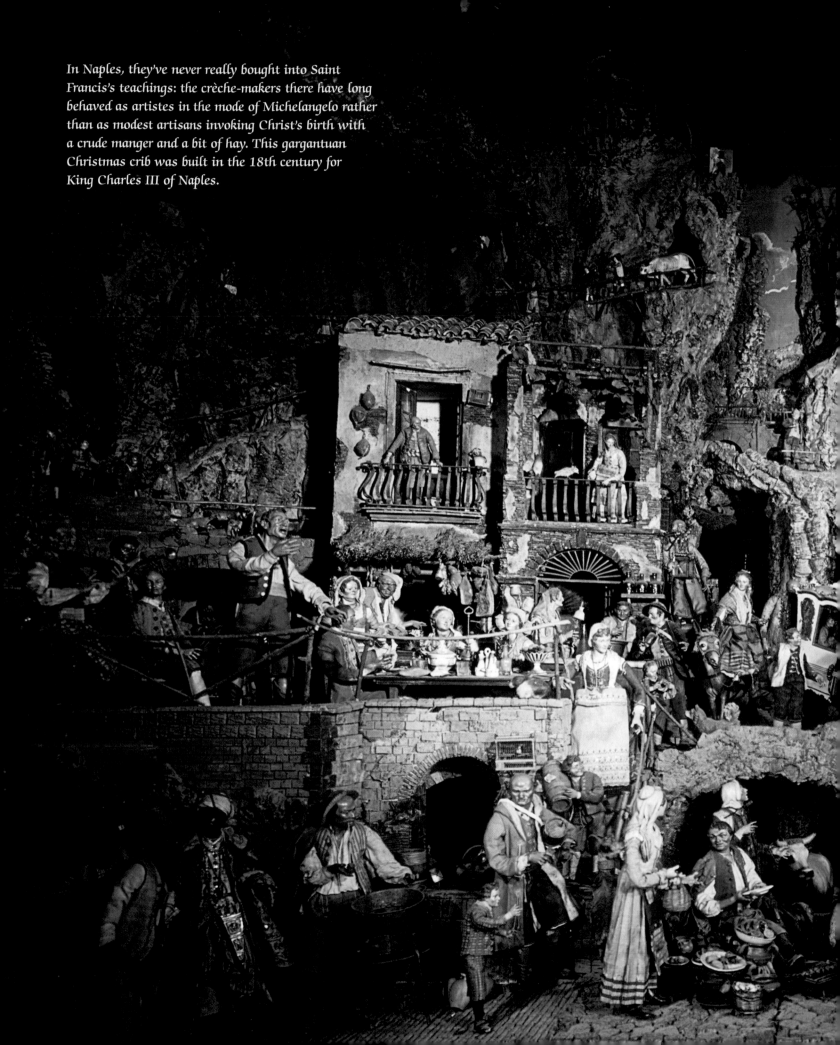

In Naples, they've never really bought into Saint Francis's teachings: the crèche-makers there have long behaved as artistes in the mode of Michelangelo rather than as modest artisans invoking Christ's birth with a crude manger and a bit of hay. This gargantuan Christmas crib was built in the 18th century for King Charles III of Naples.

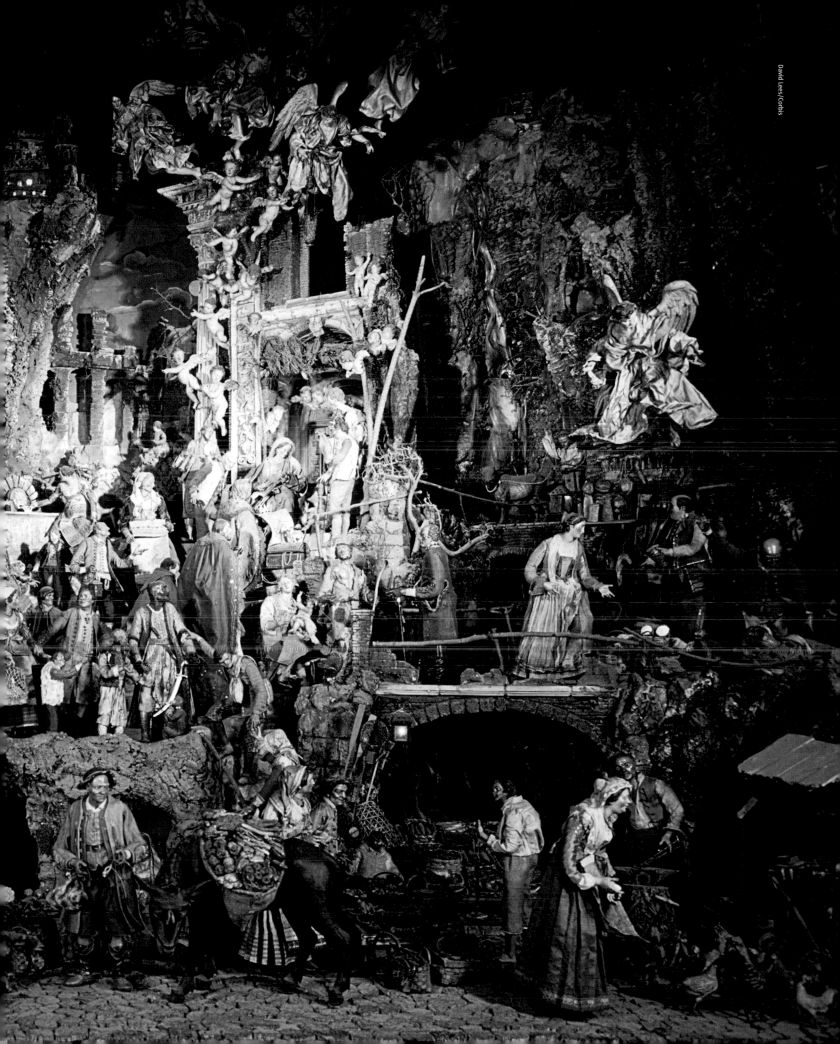

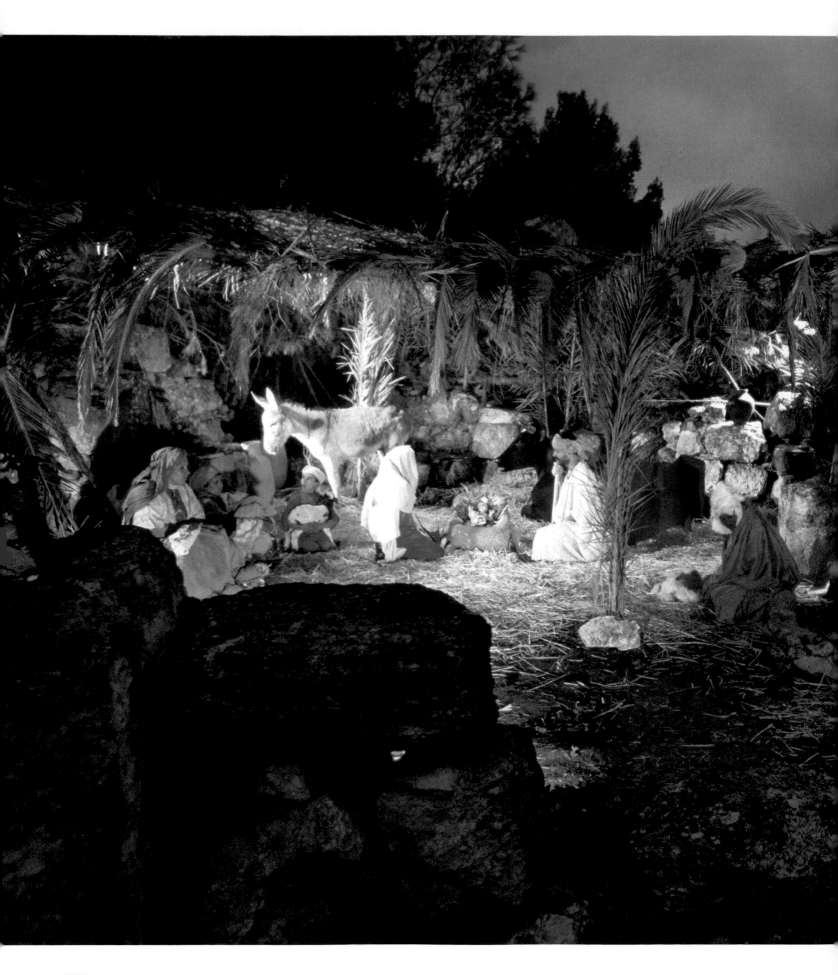

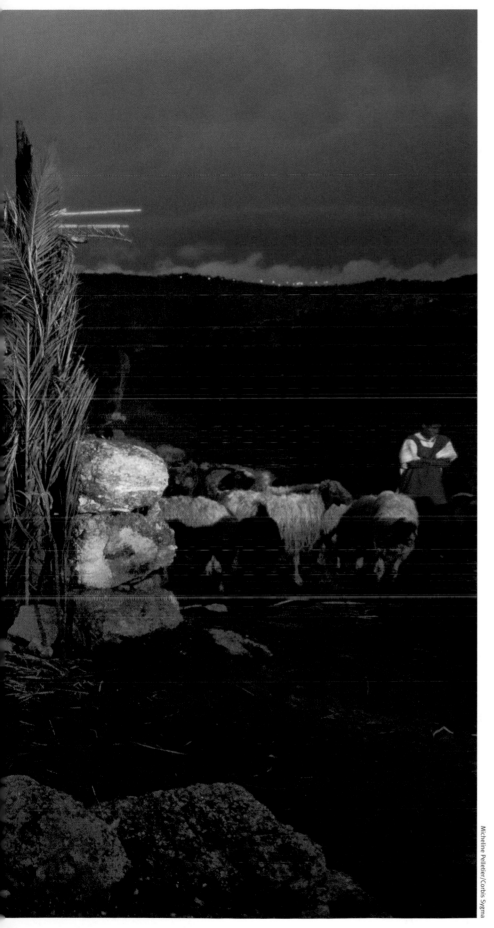

Micheline Pelletier/Corbis Sygma

In the town of Bethlehem, which today is caught up in the strife that has riven the Holy Land, the birth of Christ is reenacted. It is as close as these devout actors can come to the source, in their earnest effort to commune with heaven.

As the building of crèches large and small spread through Europe, so did the presentation of Christmas-season dramas. By the 15th century, mystery and miracle plays became secular dramas and moved from the churches into town squares. The Paradise play, featuring an evergreen tree bedecked with apples that tempted the central characters of Adam and Eve, was as popular a December offering in many places as the Nativity. The ornamented trees of Germany, the Italian-colored scene by the manger, the singers in the streets, the warmth and conviviality of the Victorian Christmas, the log in the fireplace that first scared off Norway's ghosts: All these things found a happy home, as did the people of these scattered lands, in America.

Sometimes in the land of the free—a society built to be secular and to welcome the neighbor while not intruding upon his individual rights—problems have arisen. In the present day, some attempts to display a crèche in a public space wind up in court. But in the sanctity of the American home, one can celebrate Christmas however one wishes. And so, in many, many places, as the children struggle with sleep, embers in another room cast an orange glow when Dad pulls the cord and the lights on the tree are extinguished. Mom sets aright a donkey by the stable that has toppled over, then checks the turkey in the oven—a bird as big as a small child. The family beds down, ready, waiting, longing for morning, and with it the thrilling arrival of Christmas Day.

Santa

*I*n our Christmas Eve dreams, Santa Claus is a jolly old elf with a broad belly and a billowy beard who brings us whatever we ask for—as long as we have been good. We know where he lives: at the top of the world, the North Pole, where his elves work throughout the year making toys. We know his fabulous reindeer by name, all nine of them (if you include Gene Autry's red-nosed Rudolph), yearning ever so for the big night when they will pull his jingling sleigh over the rooftops of the world. We know his nicknames: Saint Nick and Kris Kringle.

That, at least, is the Santa Claus who resides in the hearts and minds of millions of Americans. But that's not the whole story.

The original Saint Nicholas, a 4th century bishop of Myra in Asia Minor, was known for his charity. After his death, he became the patron saint of just about everything—particularly kids. The Dutch quite took to him; as the protector of sailors, he was the figurehead on the first of their ships to arrive in America. He was Sint Nikolaas, then Sinterklaas, and then, among speakers of English, Santa Claus.

What does Kris Kringle have to do with it? That name comes from the Germans, who believe that *Christkind*, or the Christ Child, visits children's homes bearing gifts each Christmas Eve.

In 1823, the American Clement Clarke Moore, undoubtedly drawing from tales by Washington Irving, gifted us with "A Visit From Saint Nicholas," which he is said to have written for his children. It was Moore who gave us Santa as an elf with cheeks "like roses," nose "like a cherry," and that "bowlful of jelly" shape. The next stage in the jolly fellow's development was left to an illustrator. From 1863 to 1886, *Harper's Weekly* ran a series of cartoons by Thomas Nast that showed Santa as a big, bearded grandfatherly sort.

As with much else in the melting pot that is America, the German and Dutch traditions blended, always with Irving's and Moore's (and Myra's) Saint Nicholas in attendance. Today, Kris Kringle, Saint Nick and Santa Claus are one and the same.

In other lands, this elusive December guest assumes other forms, and behaves in other ways. Sinterklaas arrives in Amsterdam by ship, having begun his trip in Madrid. He mounts a white steed and, with the faithful Zwarte Piet (Black Pete) by his side, makes his rounds. Pete, like the German Knecht Ruprecht and the French Père Fouettard, gives treats to good children—while the bad may expect to be hit with a rod or stuffed into his sack.

Italy's idea of Santa may look scary, but she's actually quite nice, an old witch named La Befana who travels by broomstick in search of baby Jesus. While she never seems to find Him, she does leave gifts for children along the way. Norwegians and Danes are also visited by spirits at Christmas, not all of them as unthreatening as Befana; in Yuletide, the Julenisse, a mischievous Christmas elf, comes

looking for trouble—he lives in Danish attics and lurks around the barn on Norwegian farms. To appease him, it's always imperative to leave a good Christmas Eve dinner of porridge. One country over, in Finland, the jovial Christmas Goat arrives on a bicycle to dole out the presents.

Iceland's Yuletide Lads, the 13 sons of an ogre who fed on unruly children, were once as feared as their mother, but lately have become more friendly. For 12 nights and on Christmas Eve, one of them descends from the mountains with gifts. As surely as we know Dasher and Dancer, Icelandic children know the Lads' names—Sheepfold Stick, Gully Oaf, Shorty, Spoon Licker, Pot Scraper, Bowl Licker, Door Slammer, Curd Glutton, Sausage Swiper, Window Peeper, Sniffer, Meat Hook and Candle Beggar.

In a warmer clime, Argentine children line up at Harrods department store in Buenos Aires to meet Los Tres Reyes—The Three Kings—who will bring presents on the Epiphany. The Magi enjoy great popularity throughout the Latin world. Meanwhile, across the world, Japan has its own take: Santa Kurohsu, or Grandfather Santa Claus.

Why all the variation in this image of the great Christmas gift-giver? Because whoever or whatever this blithe spirit is—man, witch, elf, lad, bike-riding goat—he is ultrasecretive, determined to do his good works surreptitiously. He is faster than fleet, and almost beyond knowing.

Almost . . . A photographic examination of supersonic objects was conducted by the Institute of Arctic Studies at Dartmouth College on December 24, 1991, the findings published in the 1996 book *Flight of the Reindeer: The True Story of Santa Claus and His Christmas Mission*. They showed a cruising speed of approximately 650 miles per second for the sleigh and reindeer—if, of course, that is what the tantalizing imagery on the last page of this book really represents. "The math works," said Oran Young, director of the Institute at that time. "He'd need a speed such as that to cover the globe in a day. We figured he had just over 31 hours of darkness to work with, thanks to the rotation of the planet, and he needed to travel 75 million miles, if he is returning to his base for regular resupply. In '91 he probably made more than 1,700 round-trips, if you extrapolate from the speed we clocked him at.

"That's *some* effort. I'll tell you, he really is quite a guy . . . well, elf."

These early images resemble the real Saint Nicholas, a bishop who wore flowing robes and carried a staff. On the left, Father Christmas wears a crown of holly and a serious expression. On the right, an illustration from 1900 shows a hooded Santa bringing a tree and gifts to a German family.

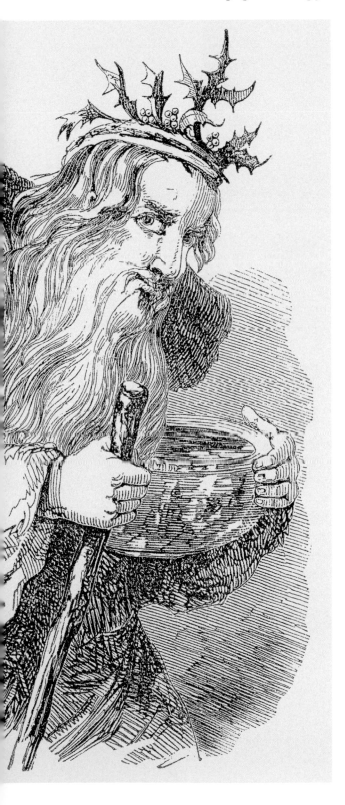

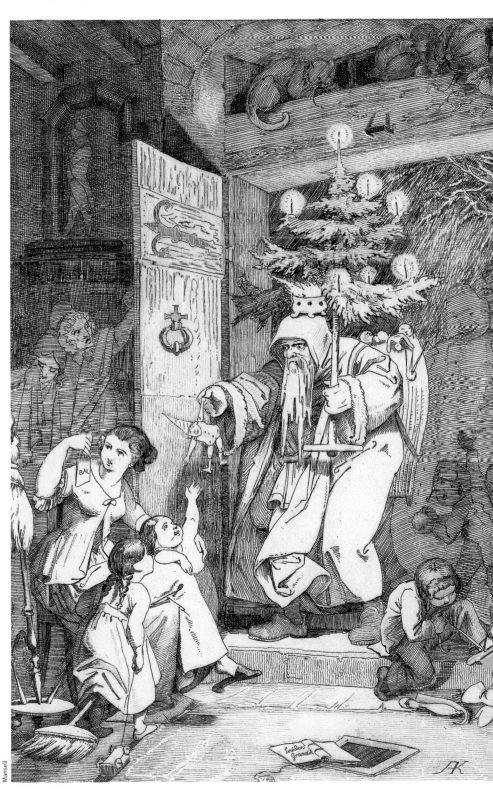

Mansell

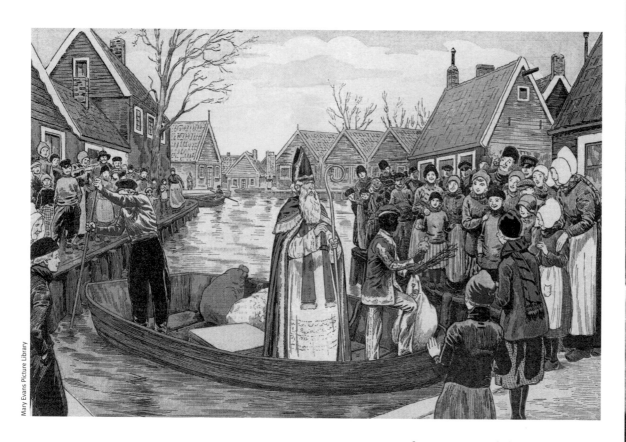

Mary Evans Picture Library

A seafaring Saint Nicholas, or Sinterklaas, has long been a welcome visitor to Dutch harbors. His sidekick, Zwarte Piet (Black Pete), has a less friendly reputation—particularly among misbehaving children, who have been known to suffer a few raps from his stick, or worse. Softened by time, Pete now gives out candy. Above, Saint Nicholas arrives by canal in a Dutch village. At right, Sinterklaas (with a few Petes) is the guest of honor at the Sinterklaas Procession in Amsterdam in 1991.

Owen Franken/Corbis

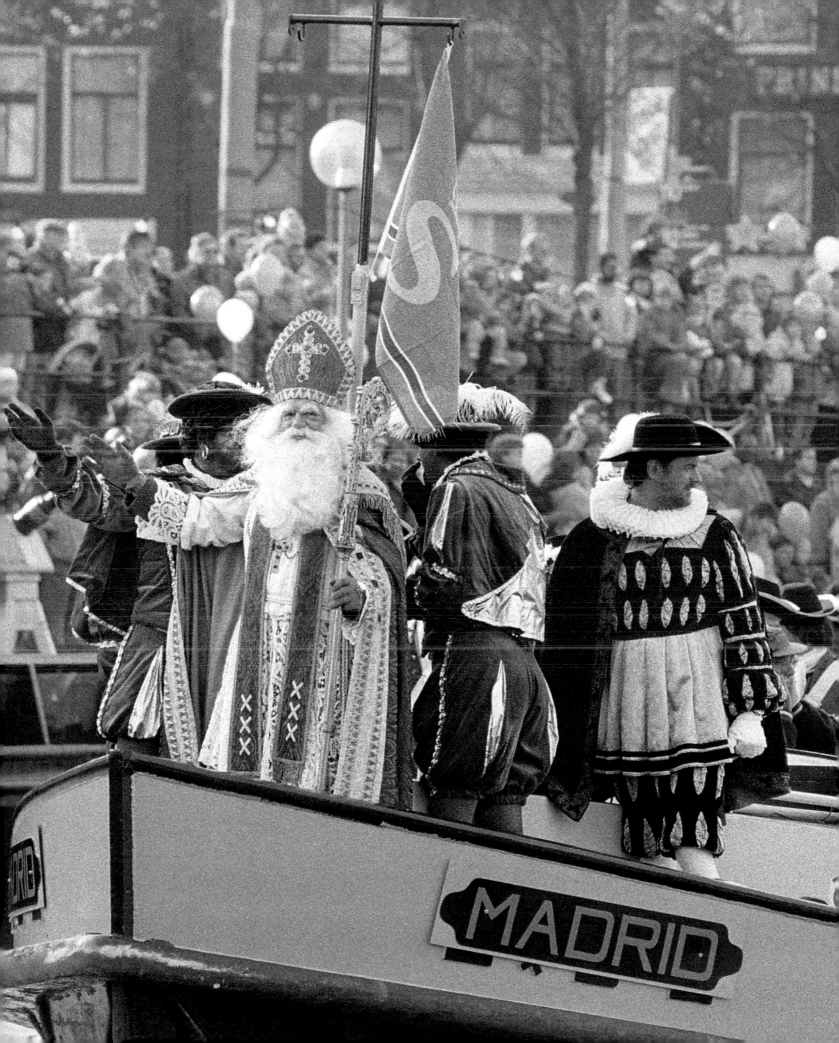

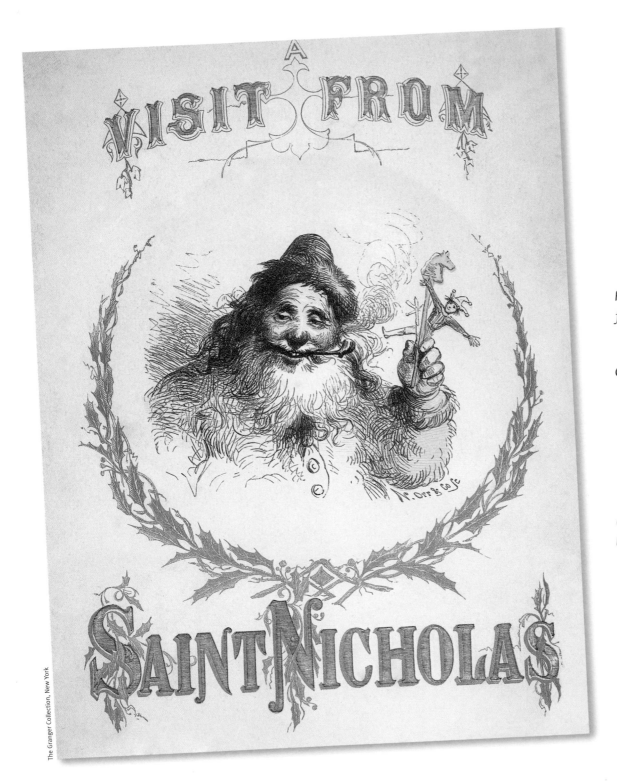

A VISIT FROM SAINT NICHOLAS

When the editors of the "Troy Sentinel" first published the anonymous poem "Account of a Visit from Saint Nicholas" on December 23, 1823, they knew they had something special. "We know not to whom we are indebted for the following description of that unwearied patron of children . . . Sante Claus," they wrote, "but, from whomsoever it may have come, we give thanks for it." Later known by its immortal opening line, "The Night Before Christmas" was a defining moment in the history of Santa. At left, an 1862 edition. Opposite, the story brings delight to a child, as it has done for generations. A footnote: In recent years Clement Clarke Moore's authorship has been disputed by some scholars, if not yet discredited.

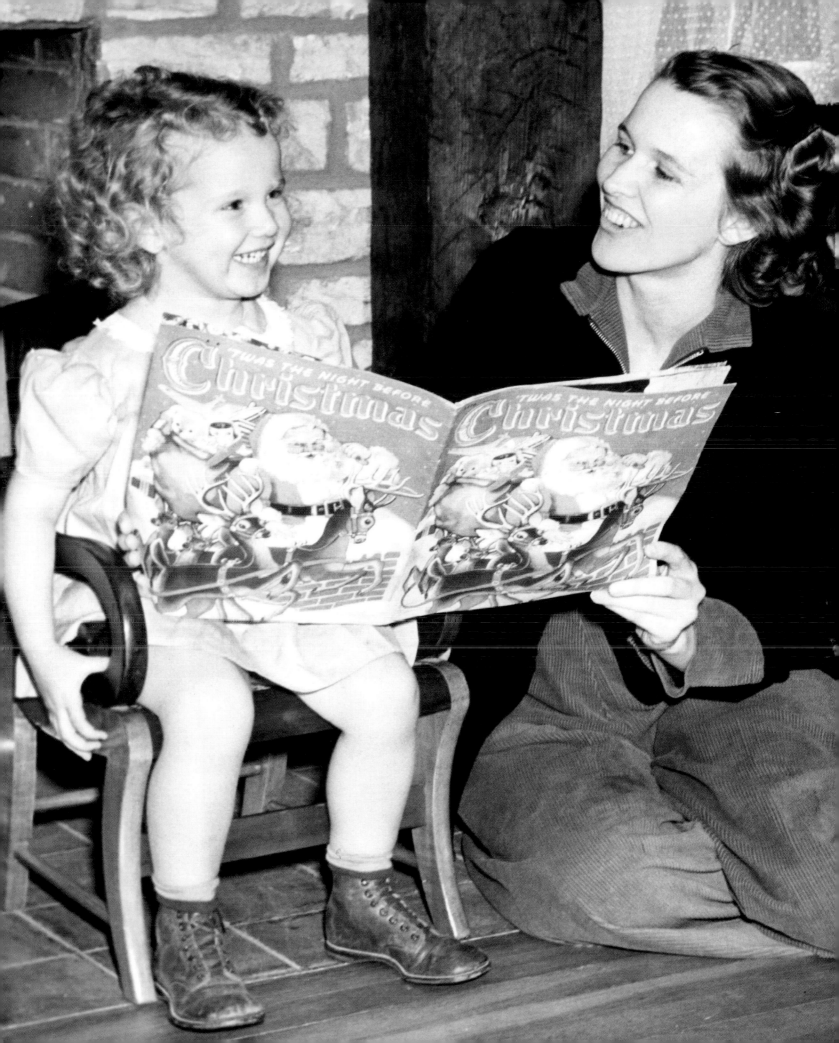

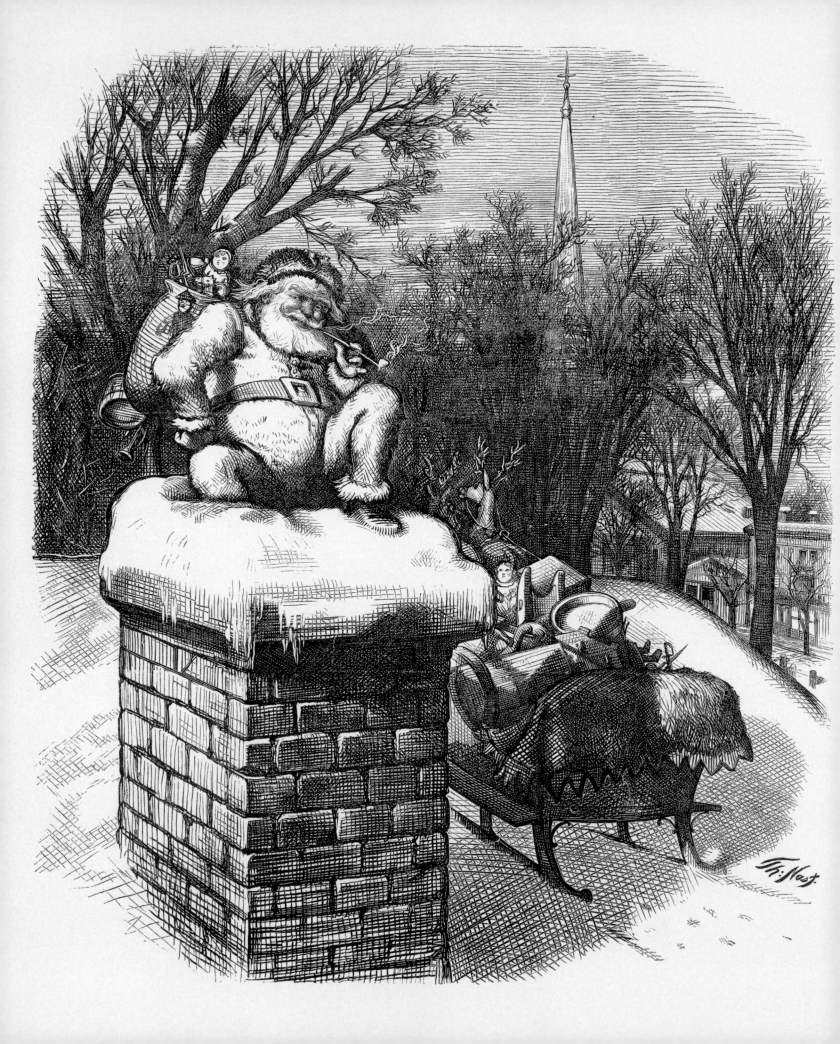

Thomas Nast's whimsical 19th century illustrations for "Harper's Weekly" shaped the image of Santa Claus in the American imagination. Opposite: Santa waits for the kids to go to bed in an 1874 rendering. Below: "Caught!" was published in 1881.

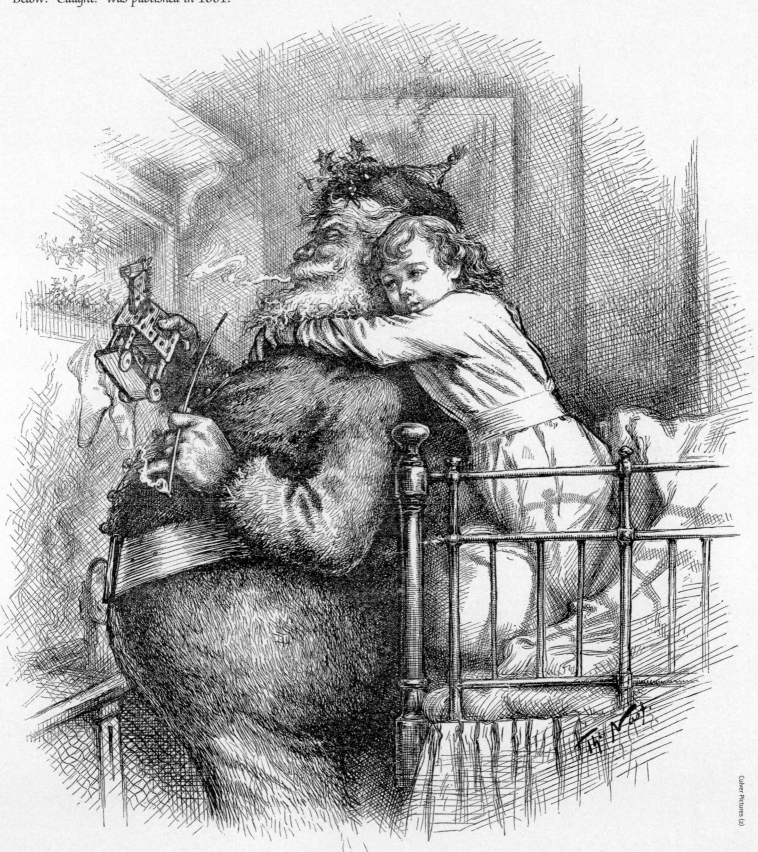

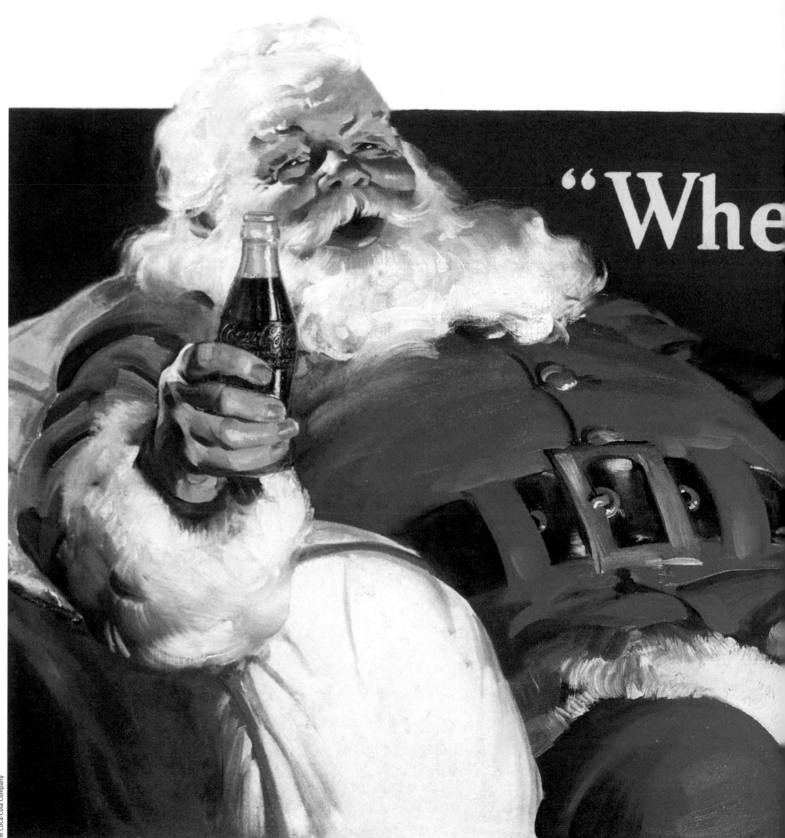

"Whe

It has been speculated for years that Santa as we know him originally appeared in Coca-Cola advertisements in the 1930s. He was a distillation of Nast and Moore, attired in black boots and a red suit. And Coke's depiction may well have been the first, although there is evidence suggesting that this notion of Santa had already taken root in the '20s. In any case, it is beyond doubt that Haddon Sundblom's delightful illustrations, like the one from 1939 seen here, at the very least went a long way toward establishing Santa as, well . . . Santa.

Visions of sugarplums, or of dolls or baseball mitts or shiny new 10-speeds. In 1947 these kids got to share all their Christmas desires with the big man himself. It was a thrilling chance, for who else can deliver like Santa? Then again . . .

Martha Holmes (5)

Santa-Graf. (s)

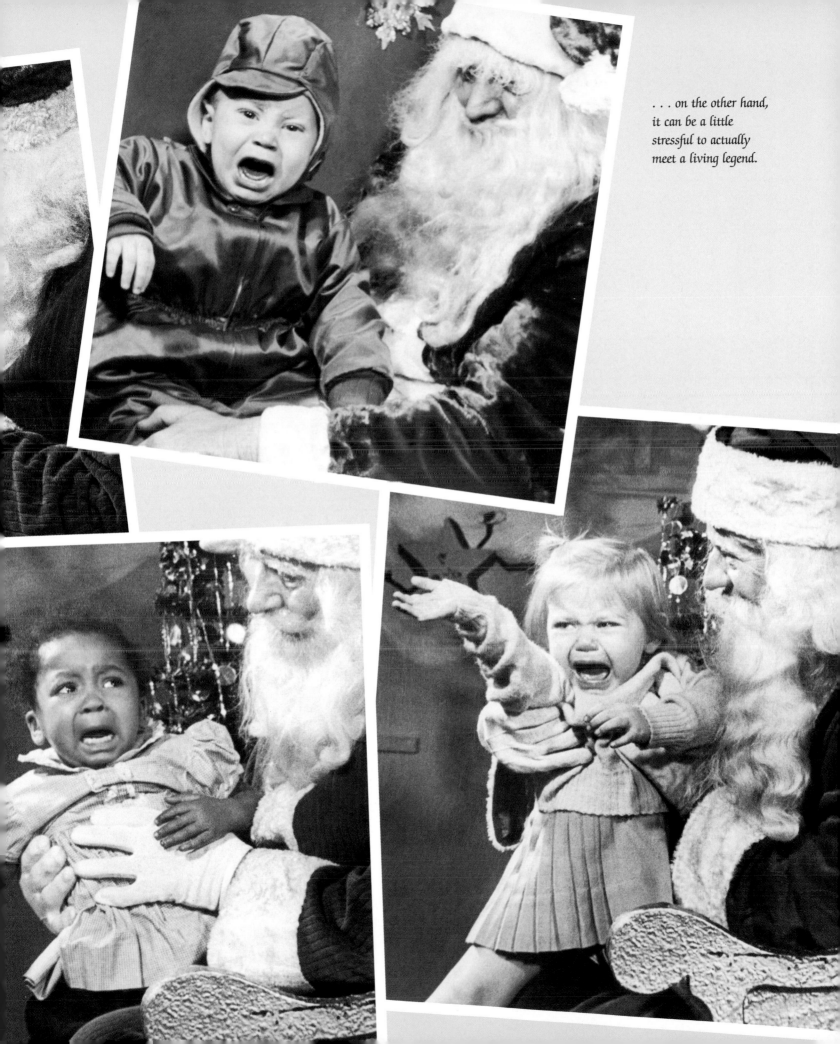

. . . on the other hand,
it can be a little
stressful to actually
meet a living legend.

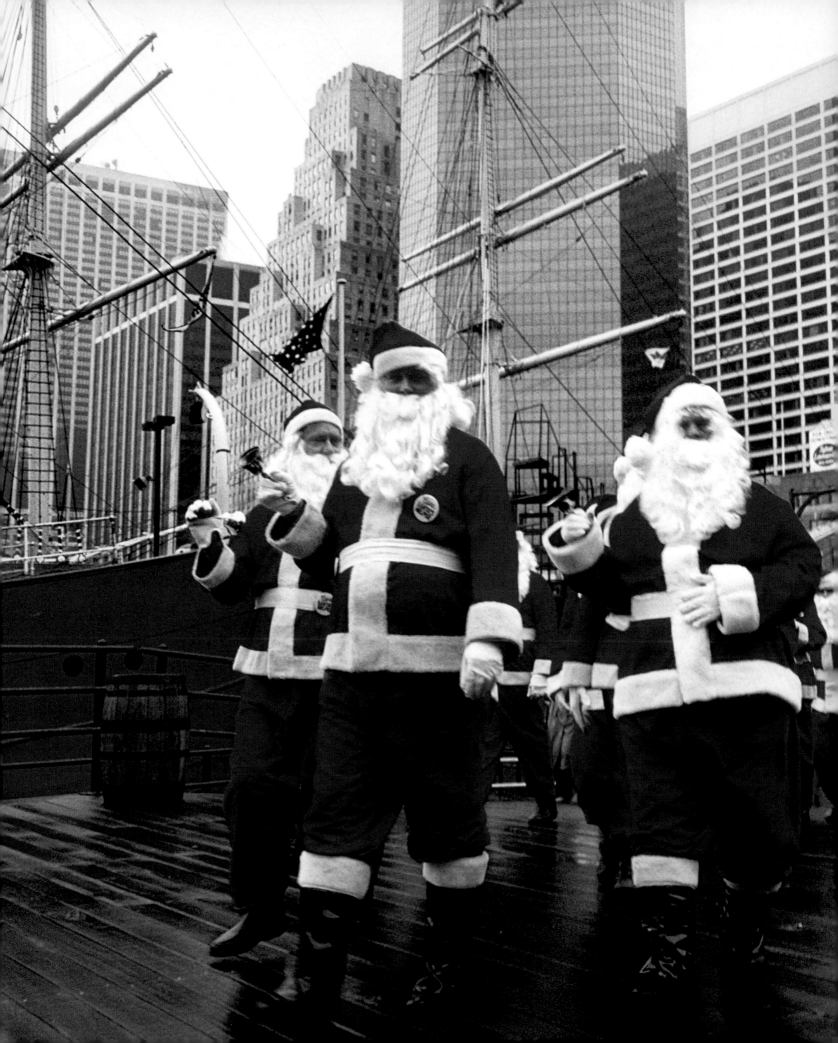

Bell a-ringing, Santa emerges from the South Street Seaport in New York City to raise money to assist the needy. Volunteers of America has been summoning Santa for more than a century.

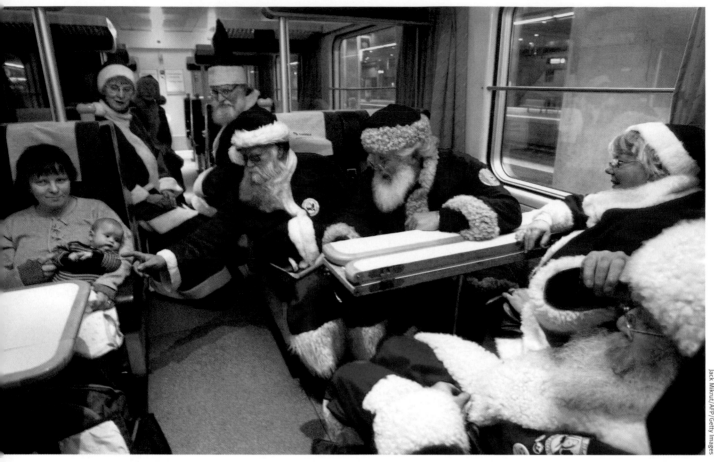

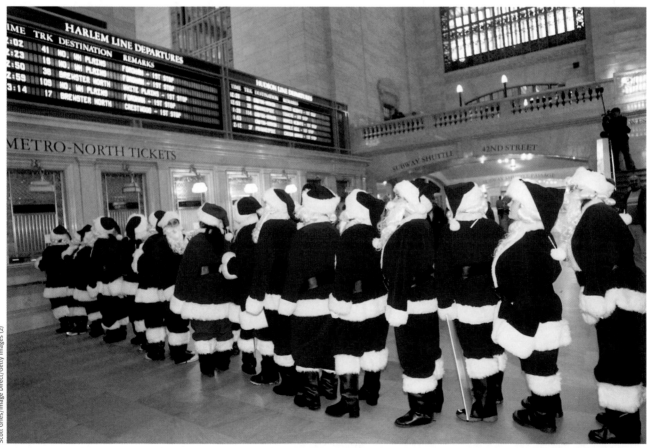

With so many children in the world to attend to, Santa always
scouts out the shortest routes possible. This, of course, entails
a variety of conveyances. Below, a double-decker bus helps in
canvassing New York City for toy distribution sites. Opposite,
bottom: Also in the Big Apple, a trip to Grand Central Terminal
keeps the jolly one rolling. Top: In Stockholm, a wee train
passenger gets some loving attention from Old Saint Nick
on his way to the Santa Winter Games in Swedish Lapland.

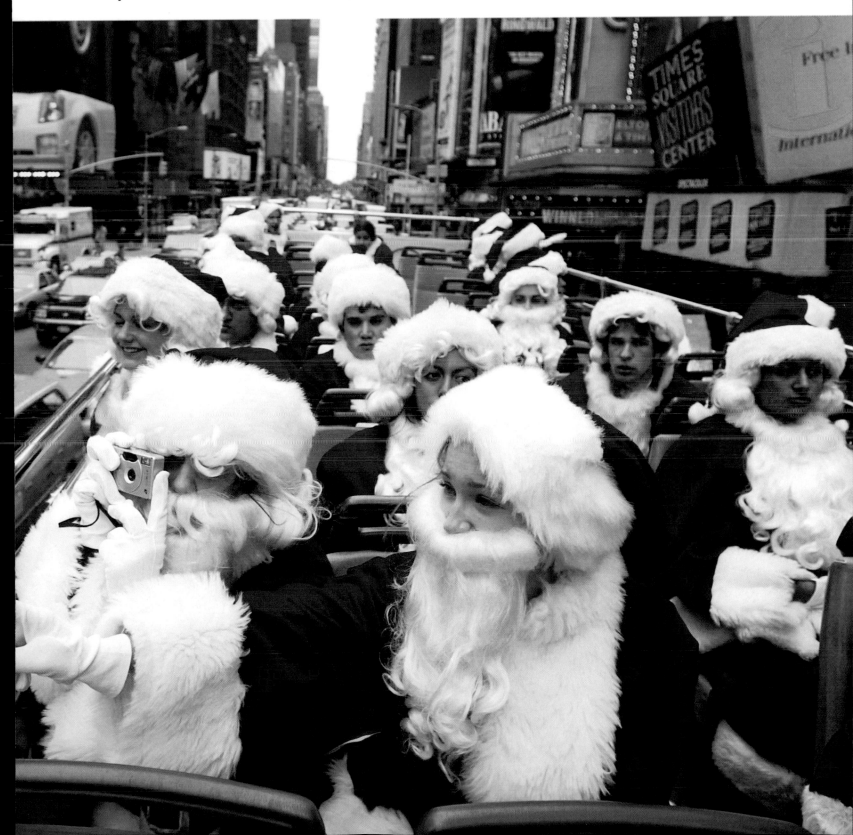

Although Santa is, understandably, best known for his wondrous flights across the skies with his gallant skein of reindeer, he also sometimes finds it necessary to rely on subterranean transport.

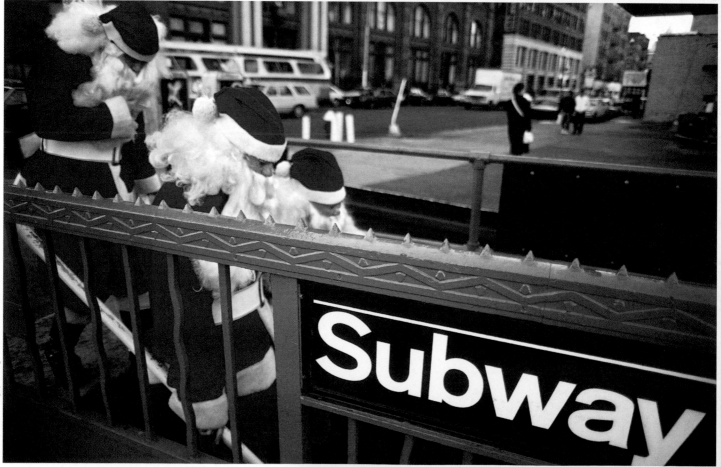

December 24 is, to put it mildly, a busy day for him, and yet, in 2003, he still found time to feed some of his finny friends in this aquarium in Shanghai. Given the continuing societal changes in China, Santa has been noticeably more visible in that land.

Wow! Apparently the rip-roaring Yuletide jaunt in his globe-orbiting sleigh doesn't entirely satisfy Santa's need for speed. In the summer of 2002 he seized on an idle moment to try out this roller coaster in Copenhagen during the 39th World Santa Claus Congress. Let's hope that belly full of jelly didn't present any problems. Above, on the Big Night, the Man in Red treads happily and quietly across the rooftops of Paris.

As much as Santa loves his (and her) fabulous vocation, by the end of the day, it's time for some needed z's. Tomorrow the whole grand scenario will begin to play out again.

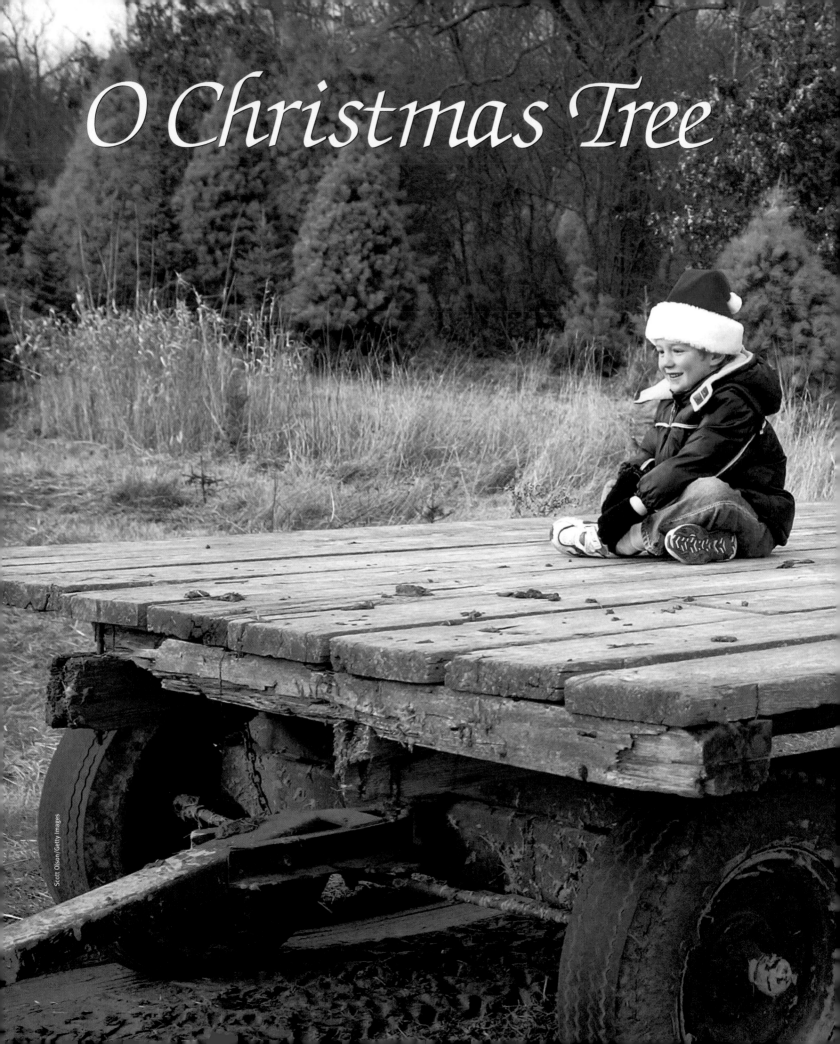

O Christmas Tree

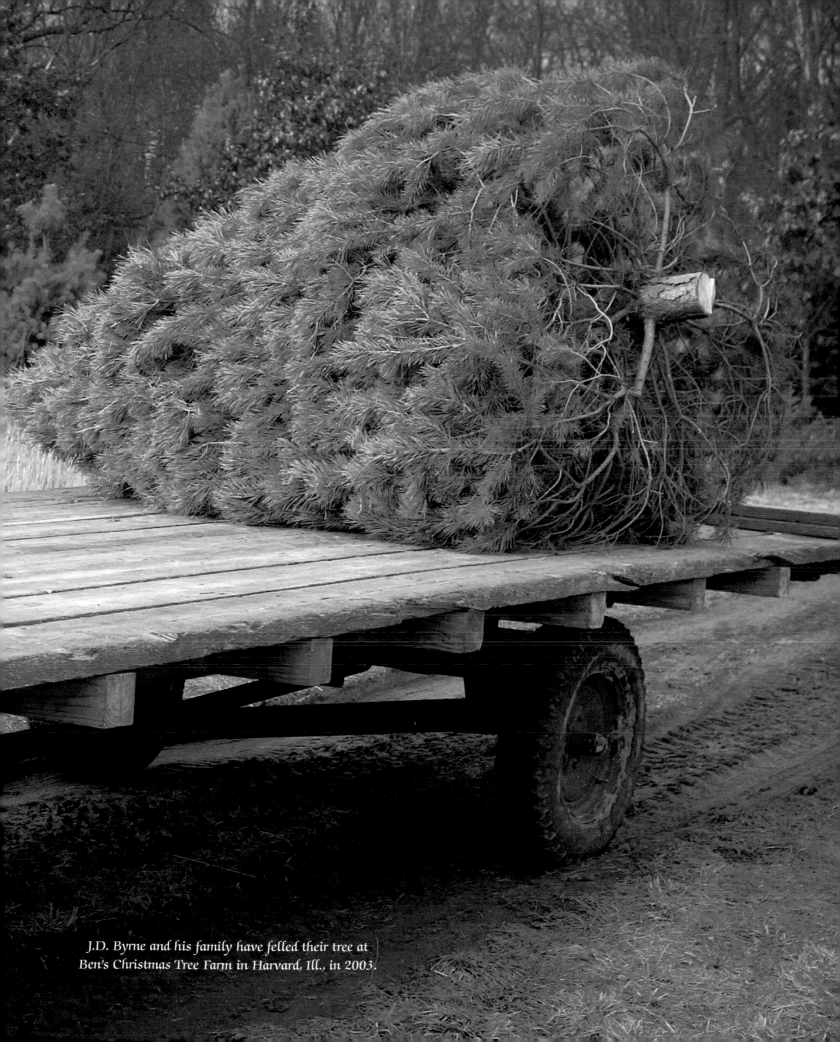

J.D. Byrne and his family have felled their tree at
Ben's Christmas Tree Farm in Harvard, Ill., in 2003.

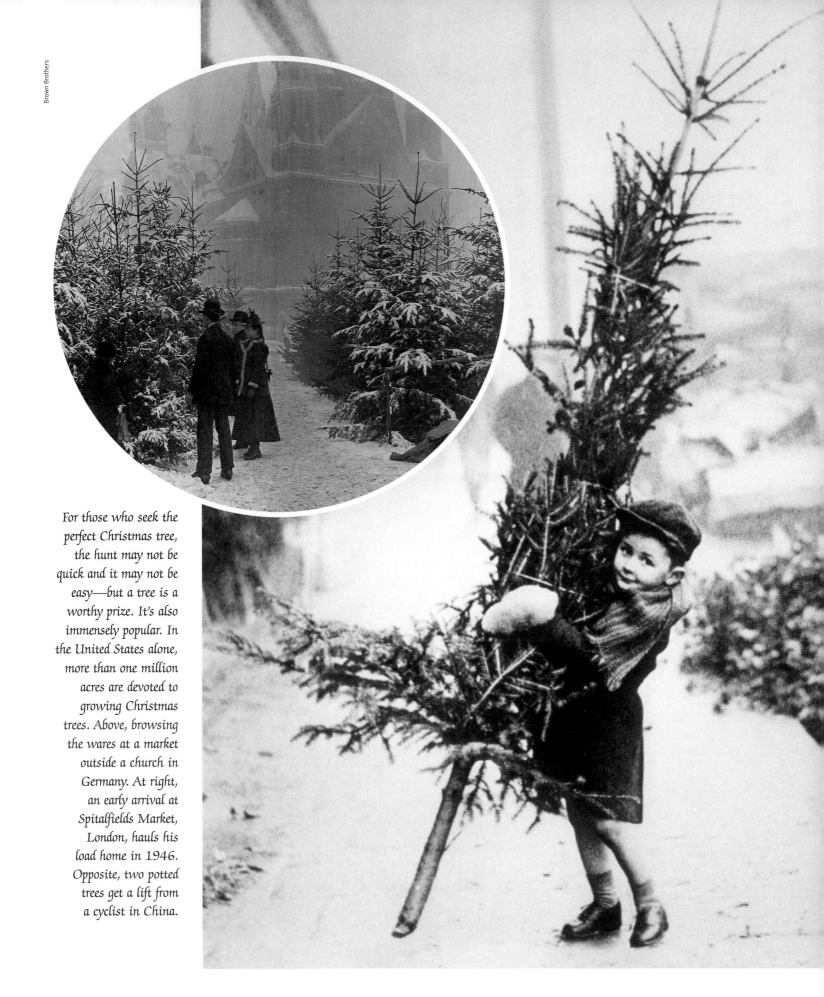

For those who seek the perfect Christmas tree, the hunt may not be quick and it may not be easy—but a tree is a worthy prize. It's also immensely popular. In the United States alone, more than one million acres are devoted to growing Christmas trees. Above, browsing the wares at a market outside a church in Germany. At right, an early arrival at Spitalfields Market, London, hauls his load home in 1946. Opposite, two potted trees get a lift from a cyclist in China.

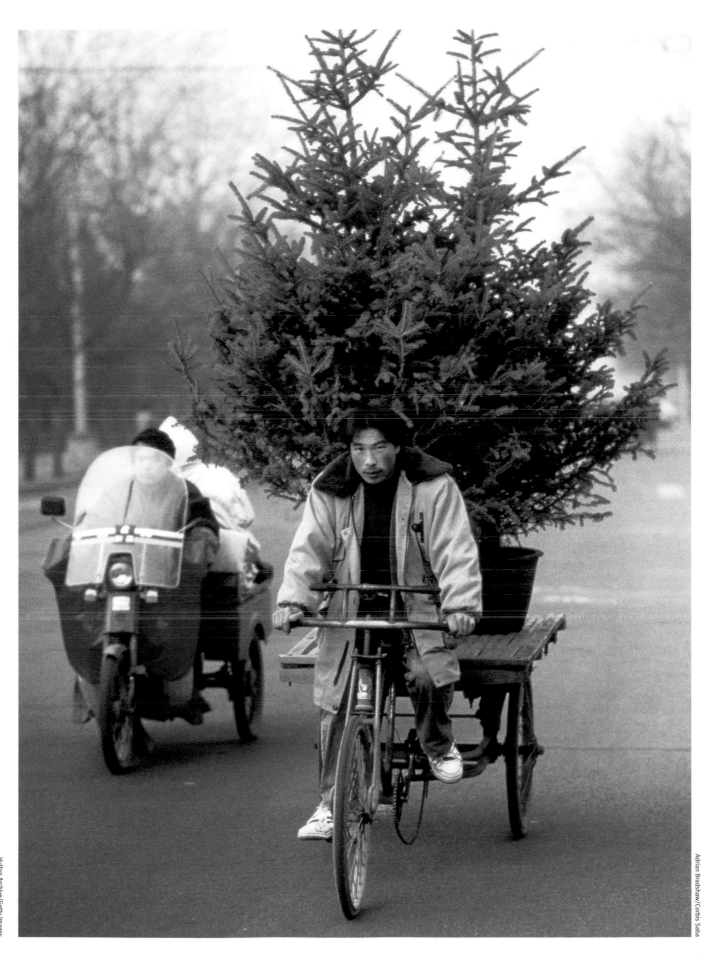

A tree is a tree is a tree is a tree . . . unless it's a Christmas tree, grand in its array of ornaments. Once, a few blazing candles were enough. But we love our sparkling angels, prancing reindeer and jolly snowmen. And if we so desire to see elephants and sombreros hanging from the boughs, we will, for with today's tree, more is usually more.

Beautify your tree with a

NATIONAL SPUN GLASS

TREE TOP

FIRE-PROOF NOTICE
PROPER PROTECTION FOR HANDS SHOULD
BE TAKEN WHEN USING SPUN-GLASS TREE TOP

George Johnson Collection; bottom: Robert Brenner Collection; inset: Steven Mays Collection

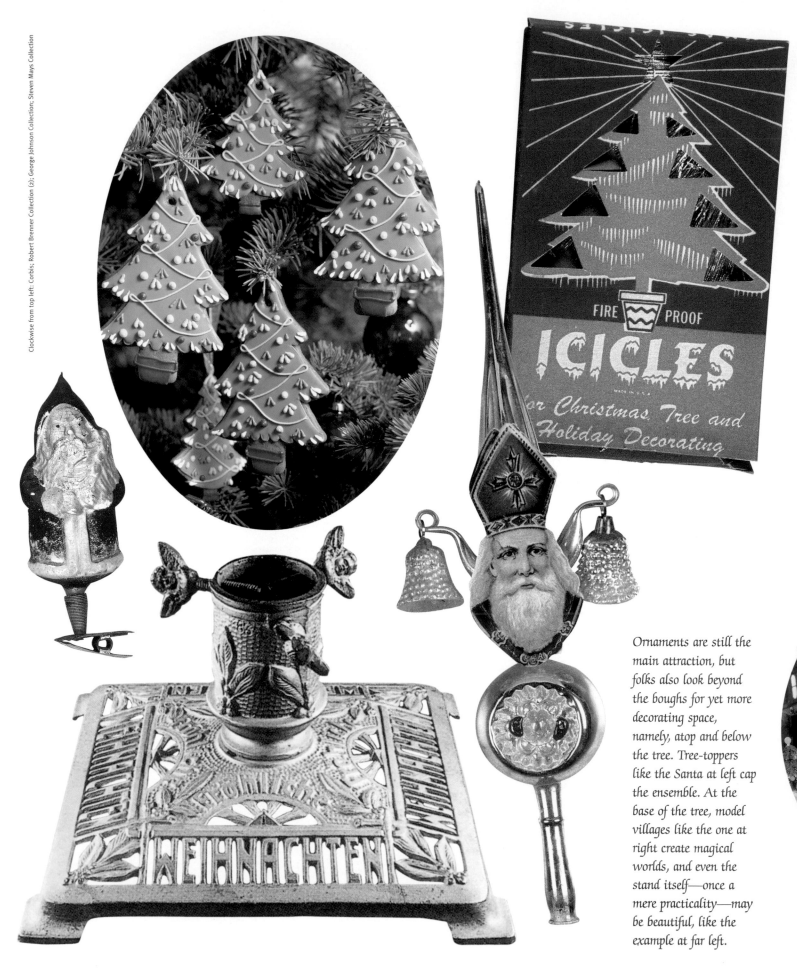

FIRE PROOF

ICICLES

for Christmas Tree and Holiday Decorating

WEIHNACHTEN

Ornaments are still the main attraction, but folks also look beyond the boughs for yet more decorating space, namely, atop and below the tree. Tree-toppers like the Santa at left cap the ensemble. At the base of the tree, model villages like the one at right create magical worlds, and even the stand itself—once a mere practicality—may be beautiful, like the example at far left.

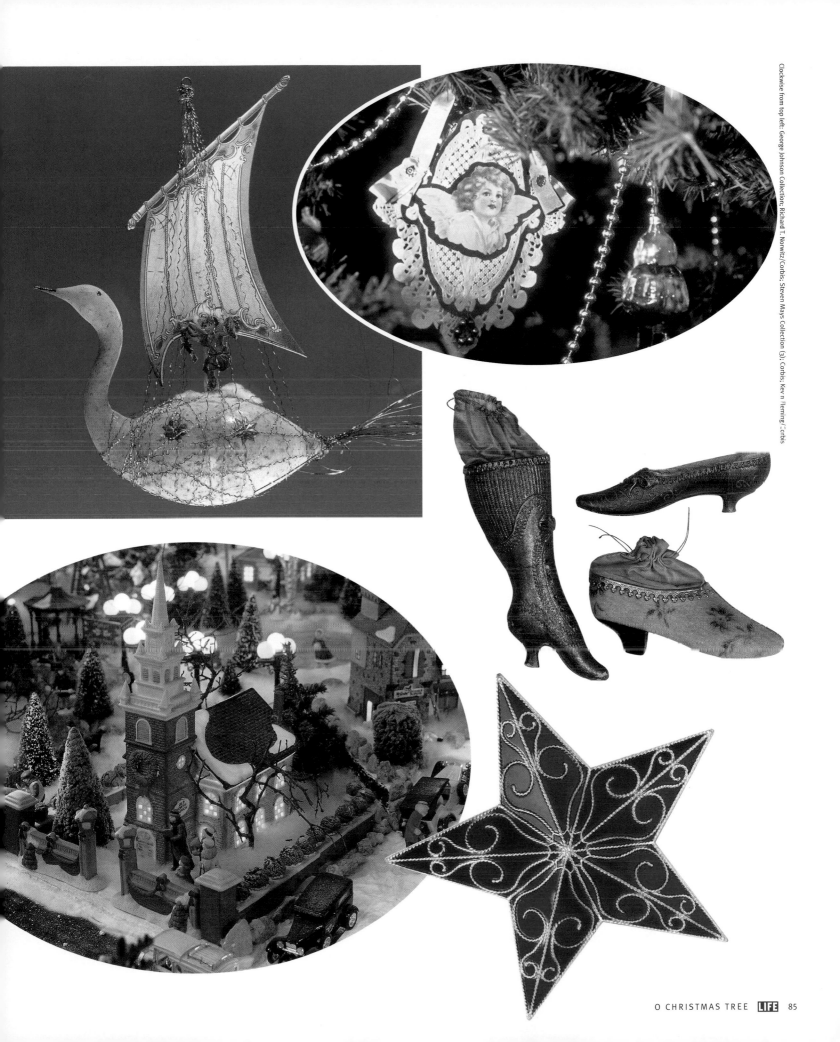

Clockwise from top left: George Johnson Collection; Richard T. Norwitz/Corbis; Steven Mays Collection (3); Corbis; Kevin Fleming/Corbis

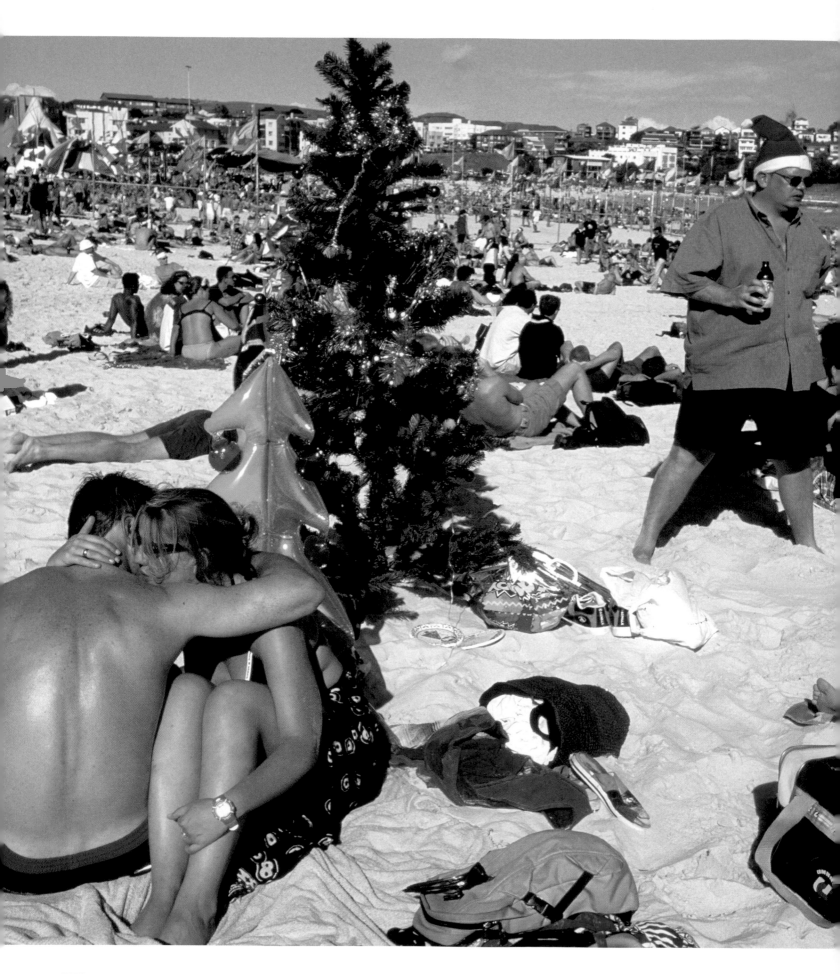

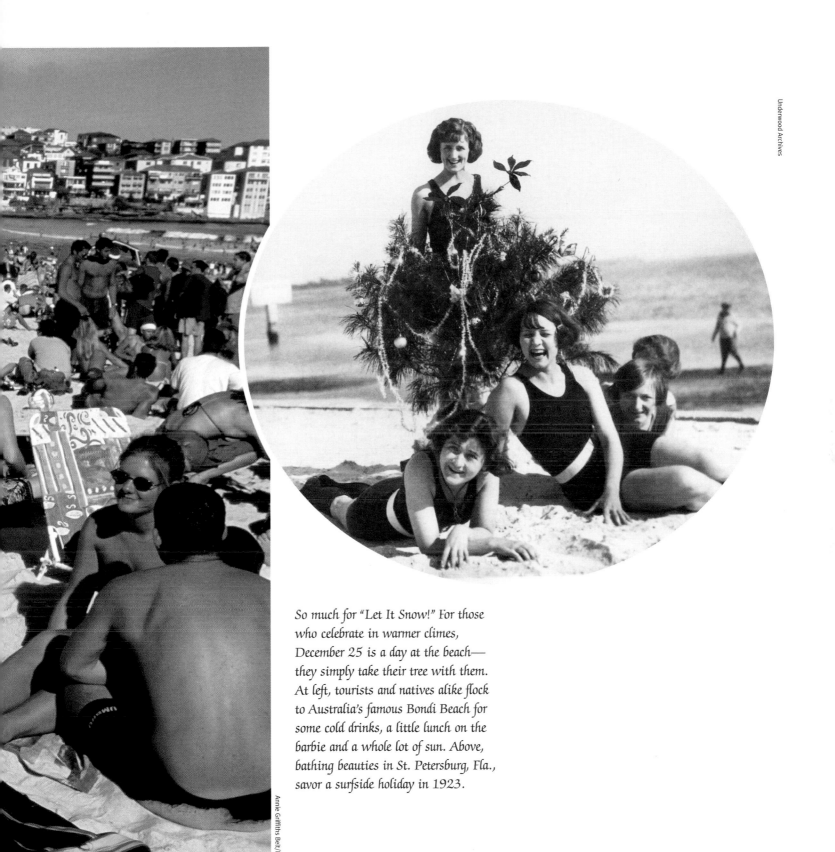

So much for "Let It Snow!" For those who celebrate in warmer climes, December 25 is a day at the beach—they simply take their tree with them. At left, tourists and natives alike flock to Australia's famous Bondi Beach for some cold drinks, a little lunch on the barbie and a whole lot of sun. Above, bathing beauties in St. Petersburg, Fla., savor a surfside holiday in 1923.

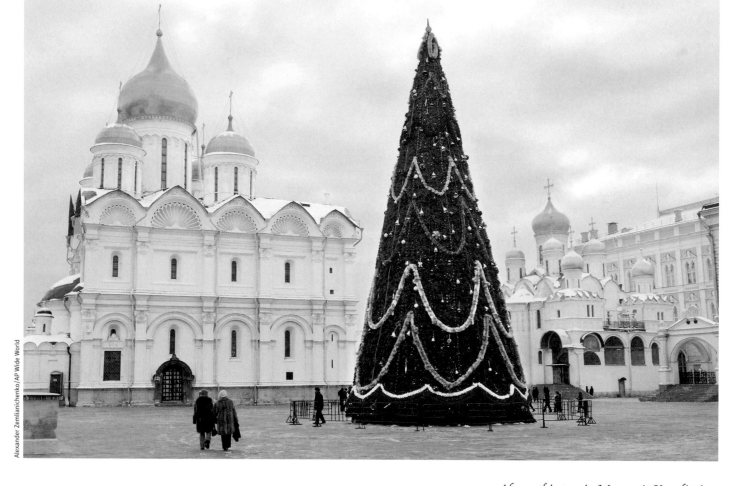

Above, this tree in Moscow's Kremlin is a lovely sight amid the golden spires of the Archangel and Annunciation cathedrals in 2002. It is often called a New Year's tree in Russia, Christmas trees having been banned by the Communists for much of the 20th century. At right, carolers in a Van Nuys, Calif., church bring new meaning to the term "living Christmas tree."

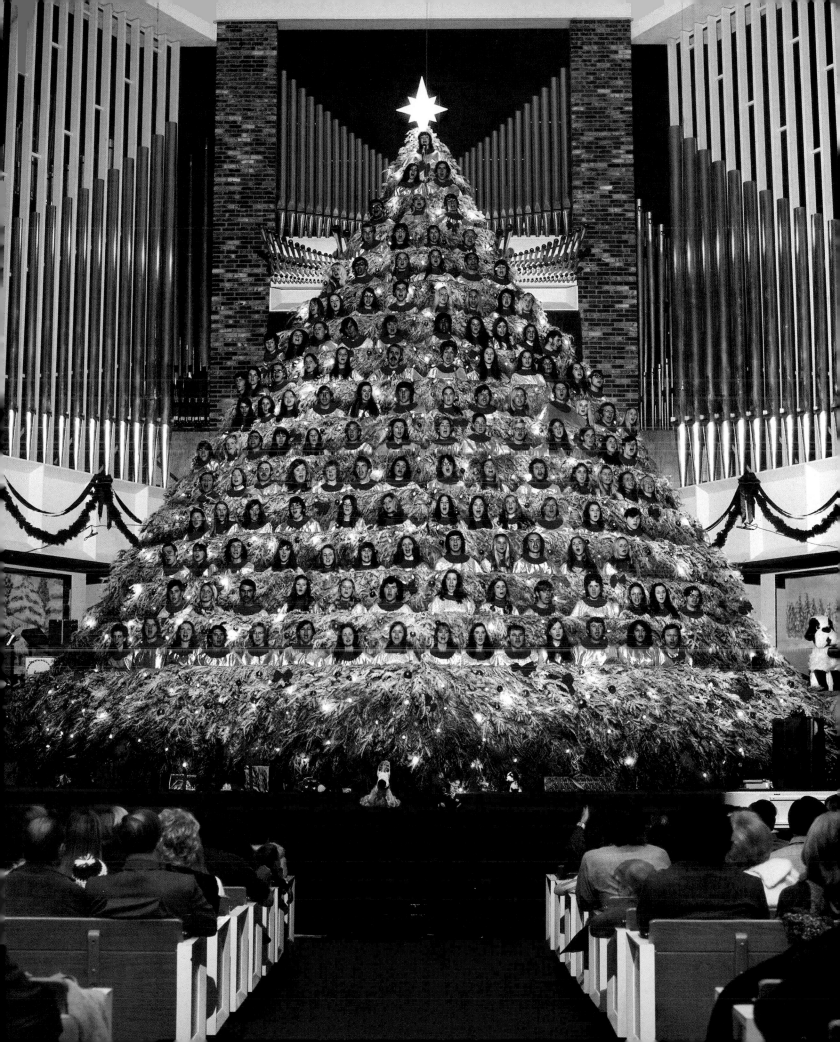

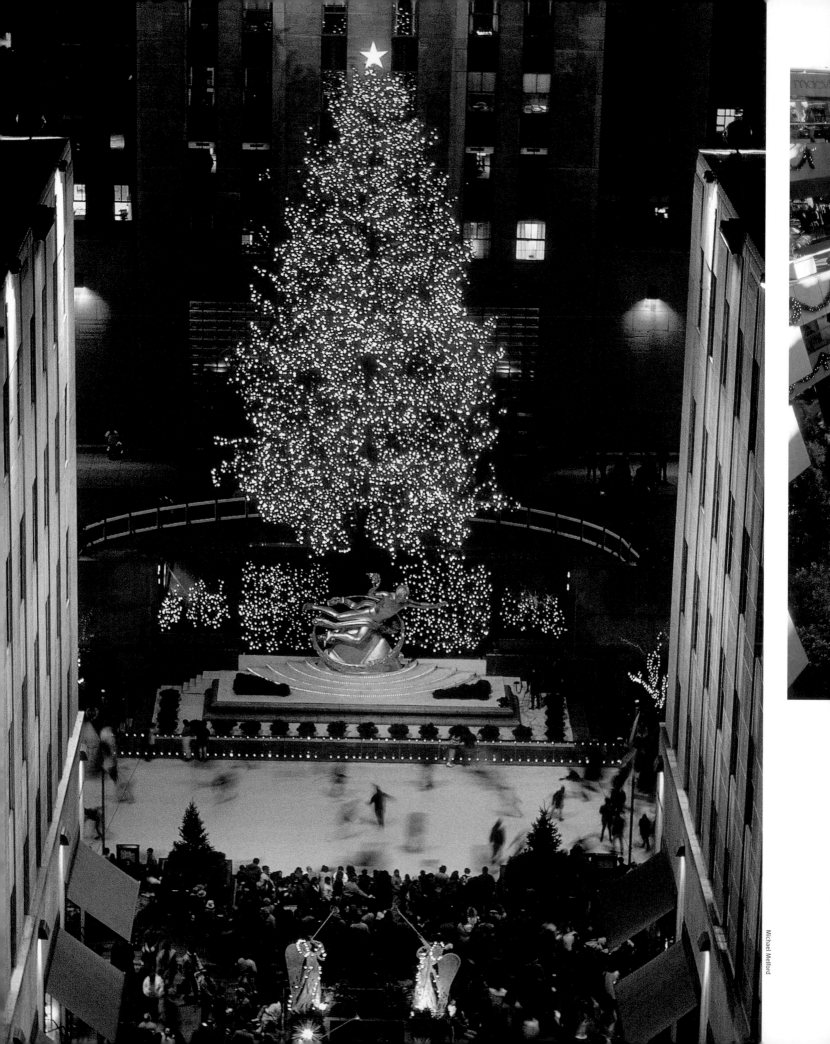

Opposite: The annual search for America's most famous Christmas tree begins by car and moves to the air—a helicopter is called on to locate the one-in-a-million tree that will stand in New York City's Rockefeller Center. Typically a Norway spruce, the ideal specimen is 75 to 90 feet tall. Thirty thousand colorful lights transform the natural wonder into a glittering, glorious national icon. Above, the Galleria Mall in Houston erects a 55-foot artificial tree in its skating rink each November.

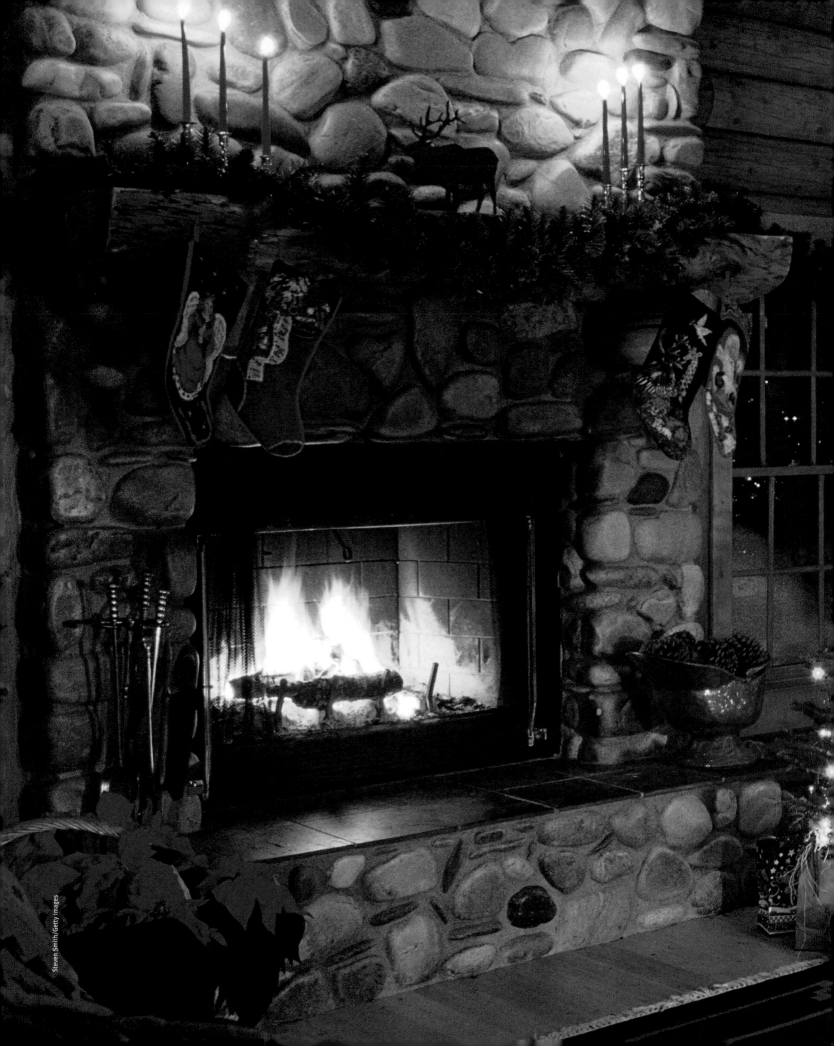

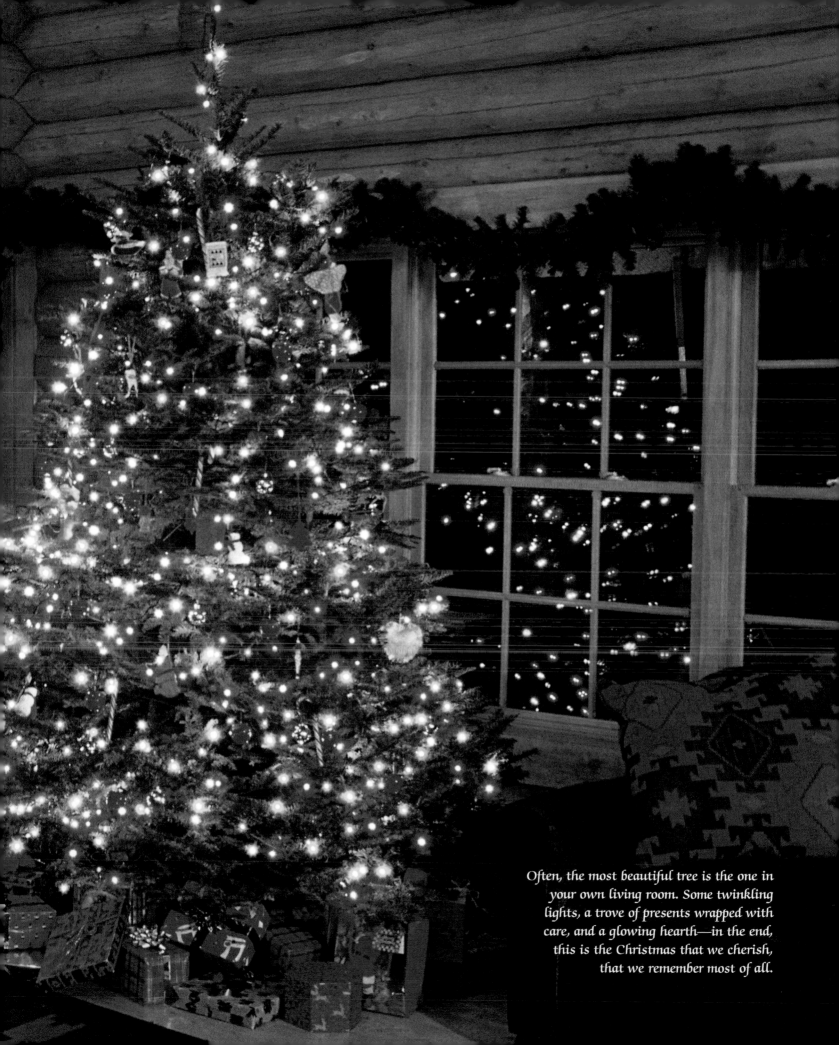

Often, the most beautiful tree is the one in your own living room. Some twinkling lights, a trove of presents wrapped with care, and a glowing hearth—in the end, this is the Christmas that we cherish, that we remember most of all.

Let There Be *Lights!*

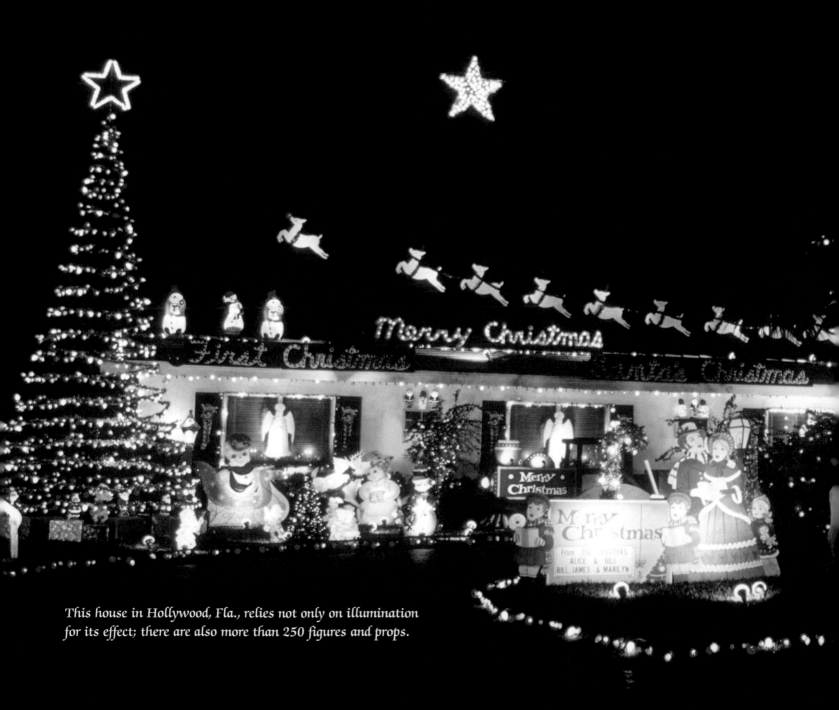

This house in Hollywood, Fla., relies not only on illumination for its effect; there are also more than 250 figures and props.

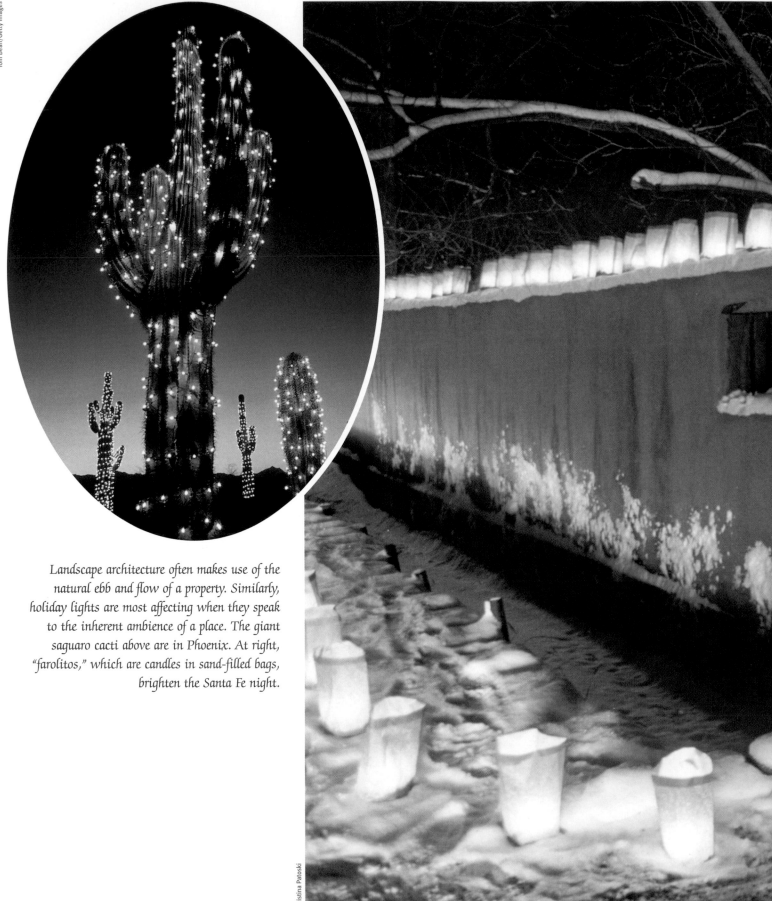

Landscape architecture often makes use of the natural ebb and flow of a property. Similarly, holiday lights are most affecting when they speak to the inherent ambience of a place. The giant saguaro cacti above are in Phoenix. At right, "farolitos," which are candles in sand-filled bags, brighten the Santa Fe night.

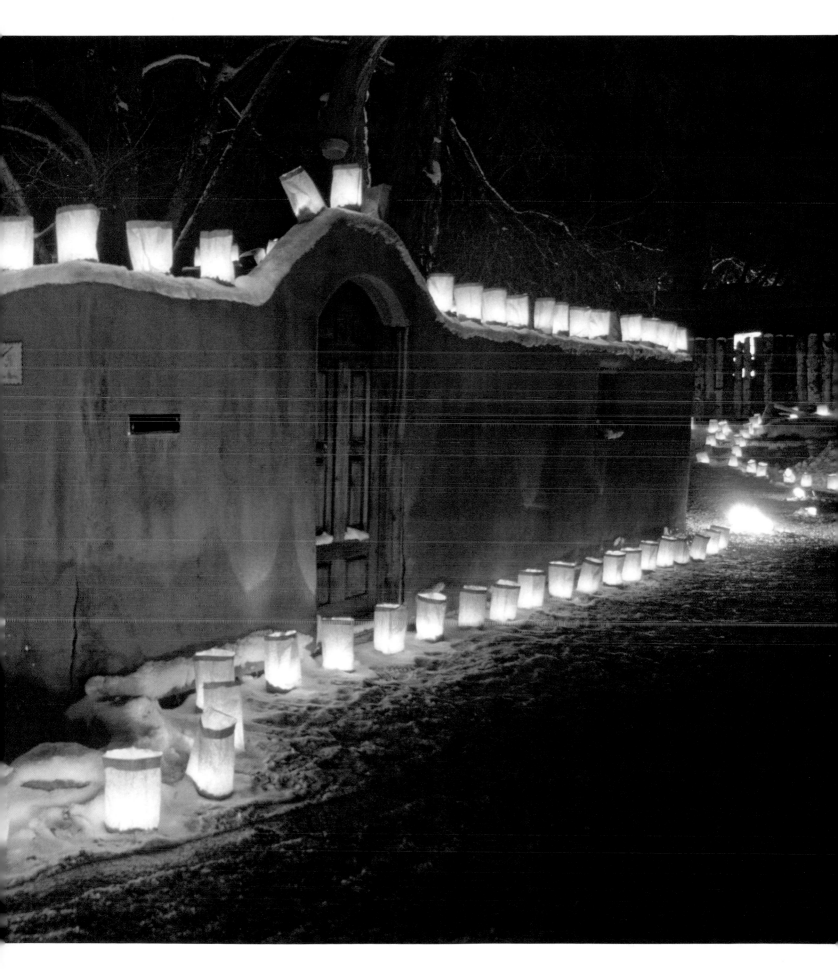

John Dominis

Above, part of what is surely the most spectacular
Christmas display in Mexico City, these lights
celebrate children and the traditional piñata in a
candlelight procession. Opposite, 7,000 champagne
glasses create a pair of enchanting Christmas trees
in Tachikawa, a suburb of Tokyo.

Itsuo Inouye

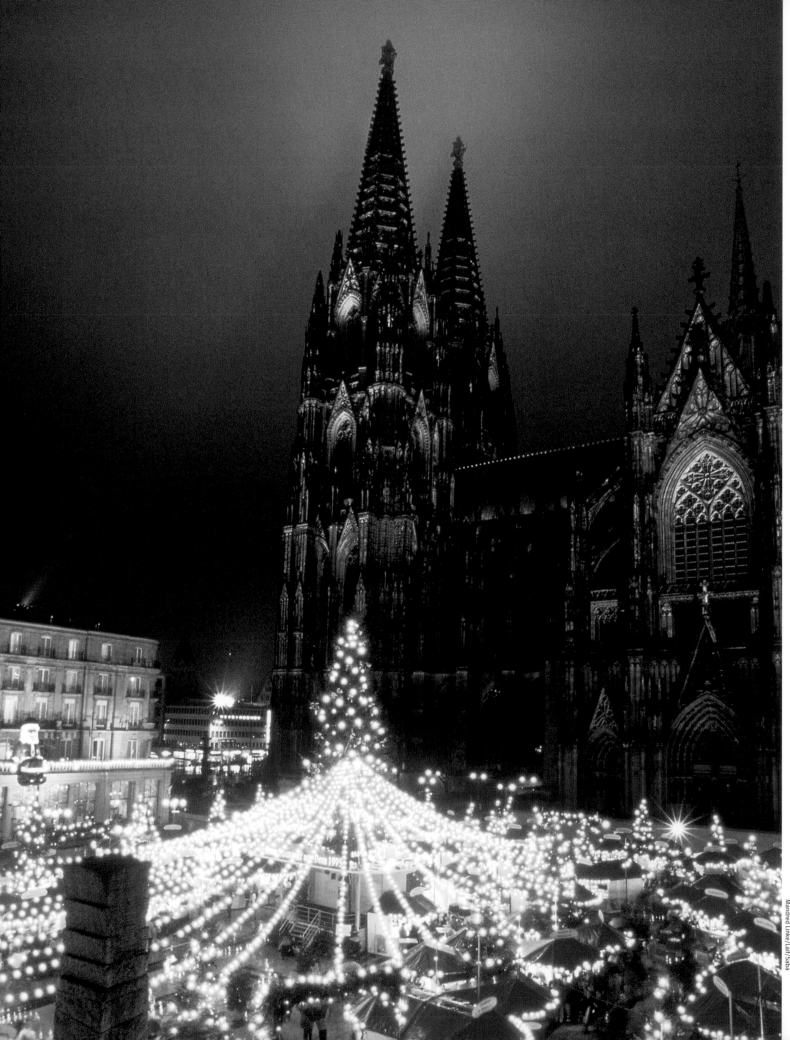

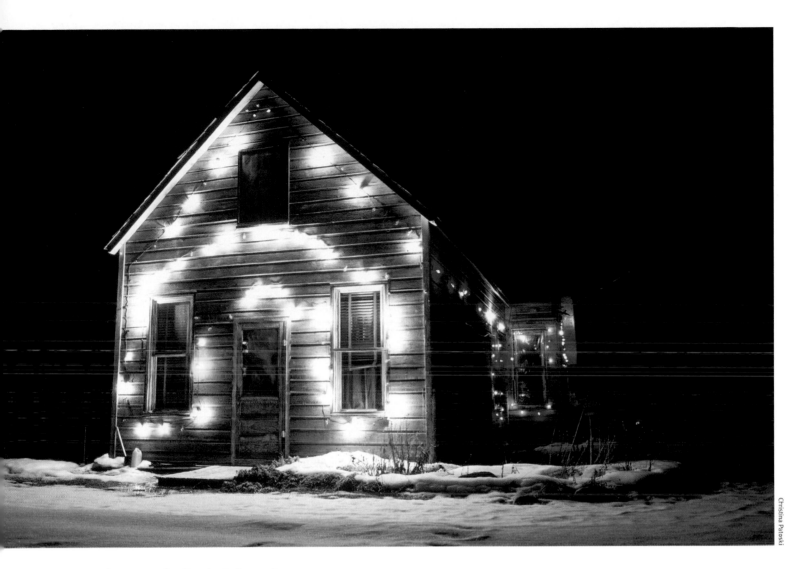

Christina Patoski

An incandescent marketplace in Cologne, Germany, provides a thrilling juxtaposition to the majestic church in the background. One of the world's foremost cathedrals, it was begun in 1248 and finally completed in 1880. The heartfelt simplicity of an isolated miner's cabin in Blaine County, Idaho, serves as a delightful contrast.

The folks taking in this spectacle have opened up their umbrellas on a drizzly evening in New Castle, Del., but the elements also lend a warm glow to this picture. Then again, 600,000 lights certainly got things off to a good start.

Fred Comegys

Nobody said the lights have to be stationary, as this cruiser certainly demonstrates at the 94th Annual Christmas Boat Parade, held in 2002 in Newport Beach, Calif.

Glen Koenig/Los Angeles Times

It may not be a Bronco, or even a Mustang, but this
long-horned beauty is ready to kick up its heels in Dallas.

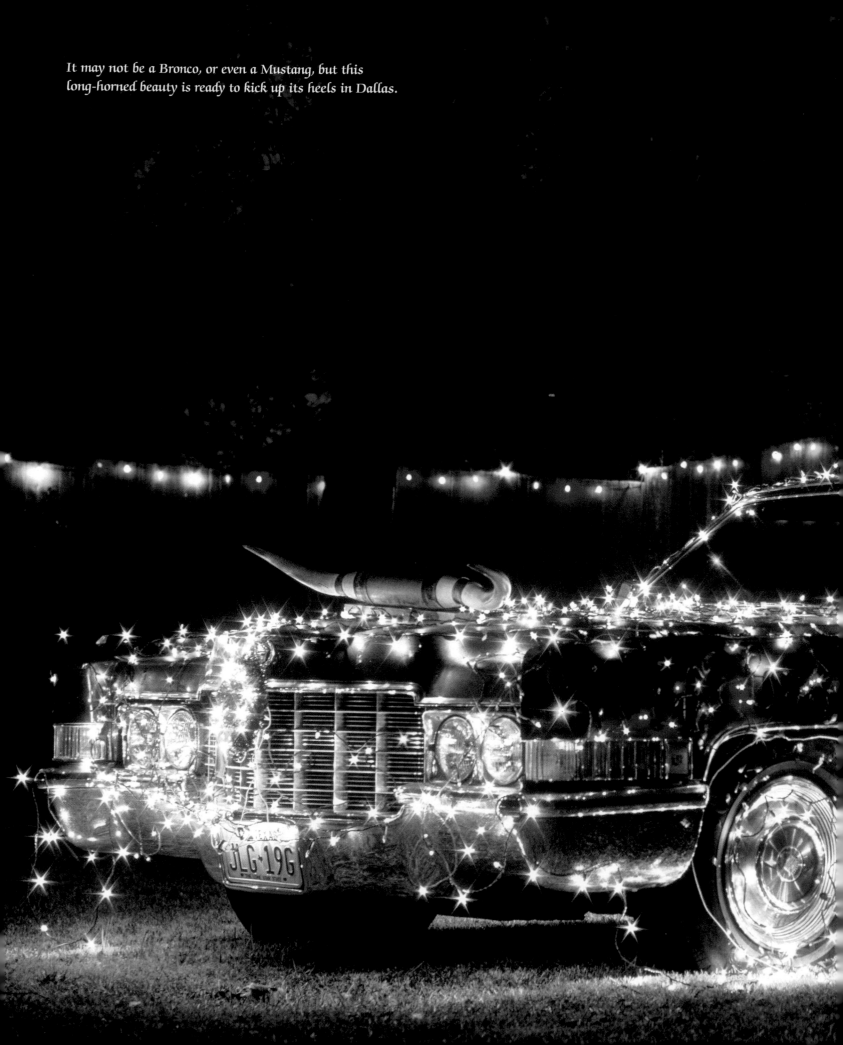

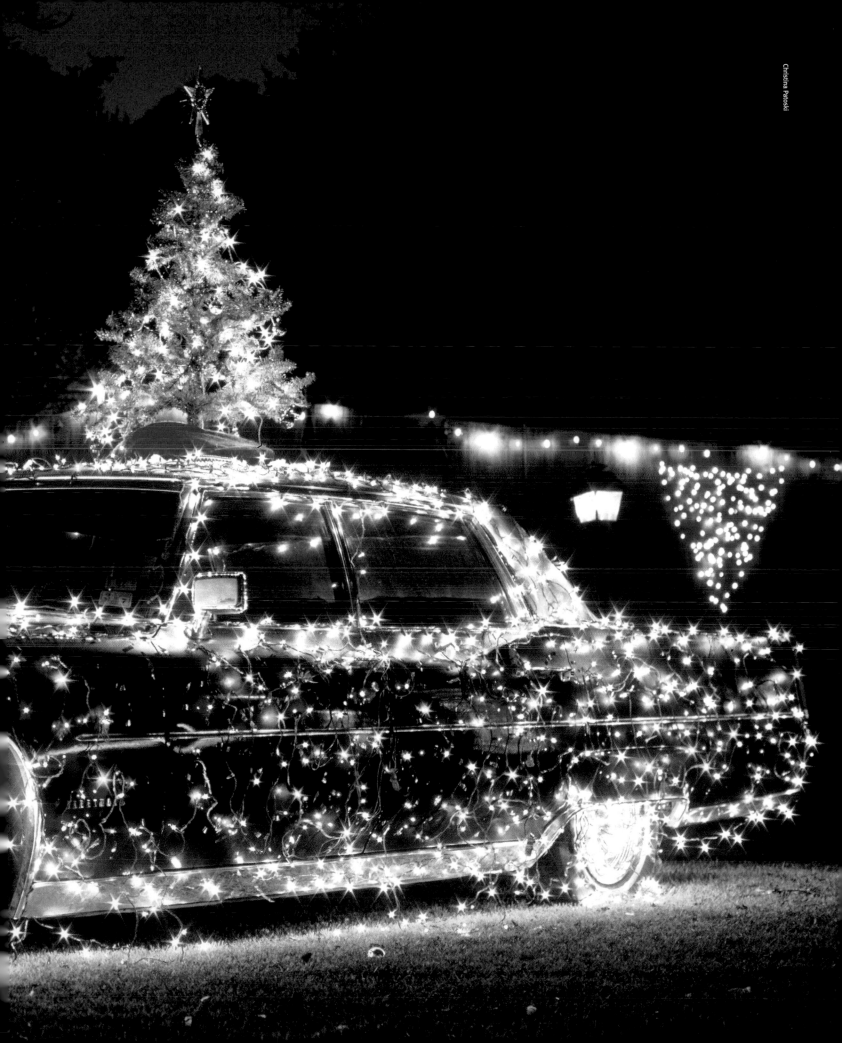

The Pageantry

*T*he statement can comfortably be made that Christmas is the world's most beloved holiday, if only because Christianity has more adherents than any other religion. In the United States, Gallup polls have shown that more than 90 percent of Americans consider it their favorite holiday. Of course, this really doesn't come as any surprise. After all, what else could measure up to the many pleasures Christmas has to offer? With the season traditionally beginning after Thanksgiving, that leaves weeks for the music and shopping, for uniting with family and friends one may see only at this time of year. This is a joyous time, one of reaffirmation, of celebration. Here are some ways folks show their cheer.

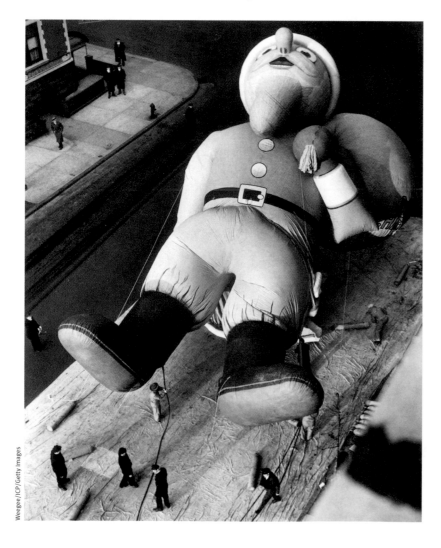

Weegee/ICP/Getty Images

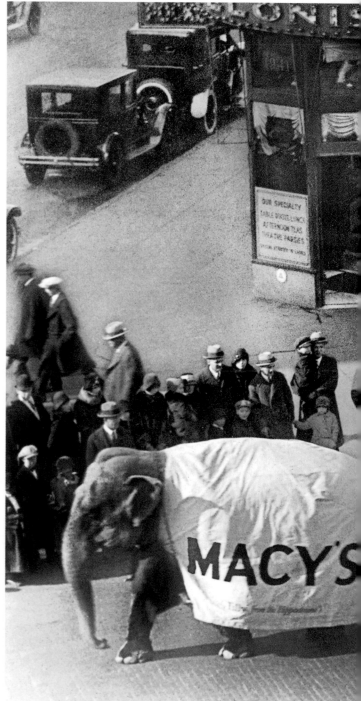

The Macy's Thanksgiving Day Parade was first held in New York City in 1924 to herald the coming of Christmas. These elephants were borrowed from the zoo. Opposite: Santa prepares for the procession in 1940.

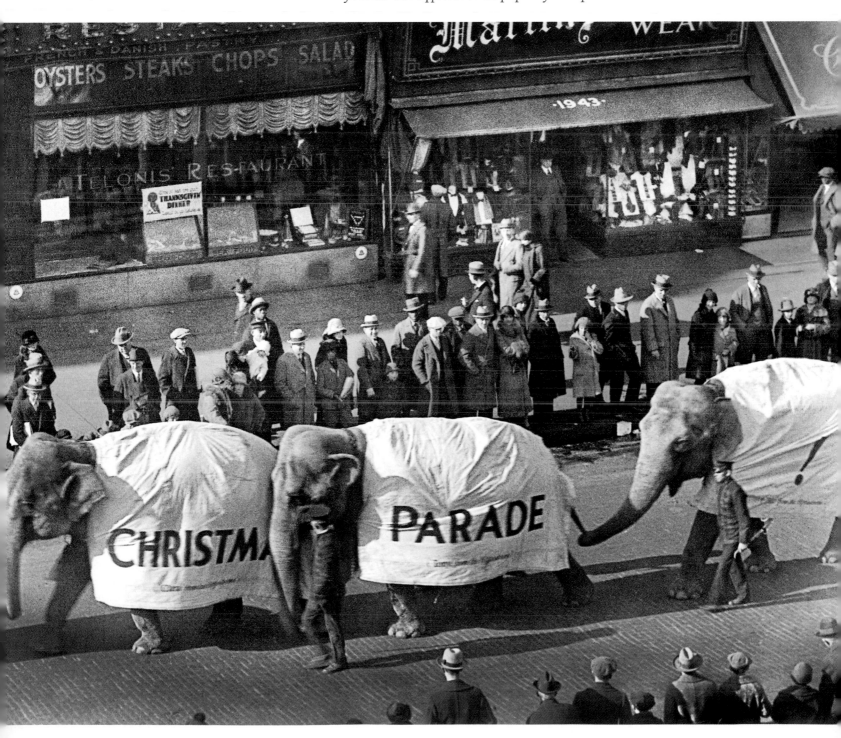

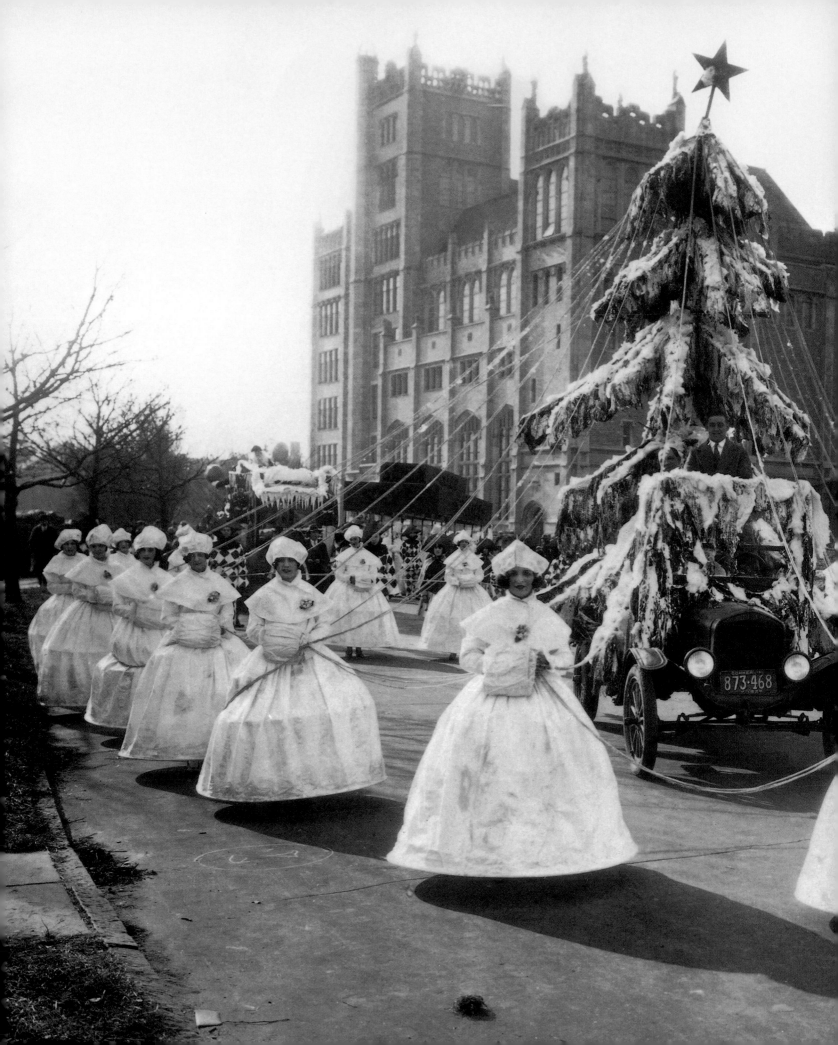

In the mid-1920s, not far removed from the staging ground of the parade, the Christmas tree is sent off with a most enchanting escort.

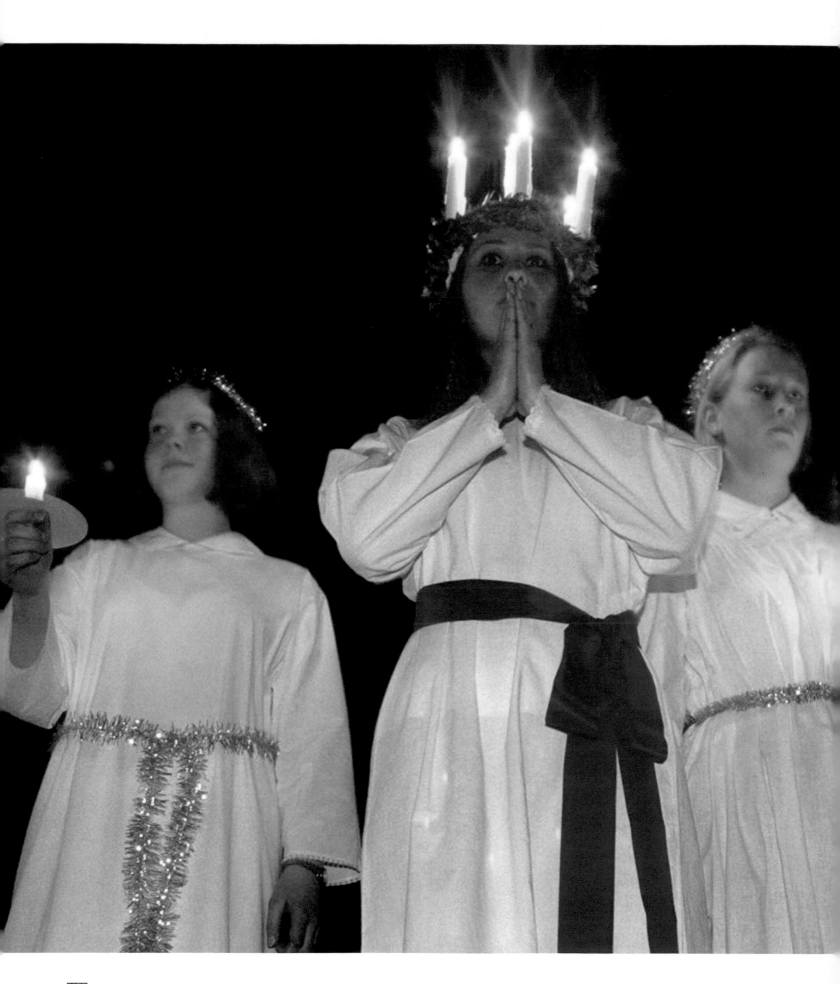

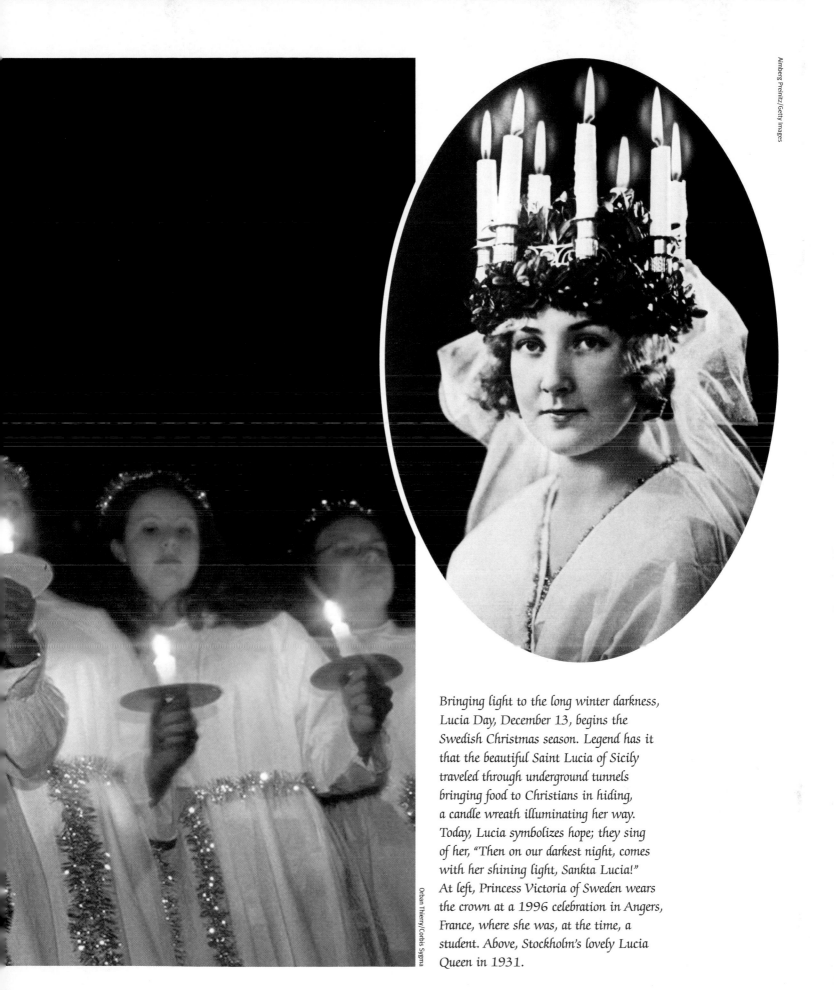

Almberg Preinitz/Getty Images

Orban Thierry/Corbis Sygma

Bringing light to the long winter darkness, Lucia Day, December 13, begins the Swedish Christmas season. Legend has it that the beautiful Saint Lucia of Sicily traveled through underground tunnels bringing food to Christians in hiding, a candle wreath illuminating her way. Today, Lucia symbolizes hope; they sing of her, "Then on our darkest night, comes with her shining light, Sankta Lucia!" At left, Princess Victoria of Sweden wears the crown at a 1996 celebration in Angers, France, where she was, at the time, a student. Above, Stockholm's lovely Lucia Queen in 1931.

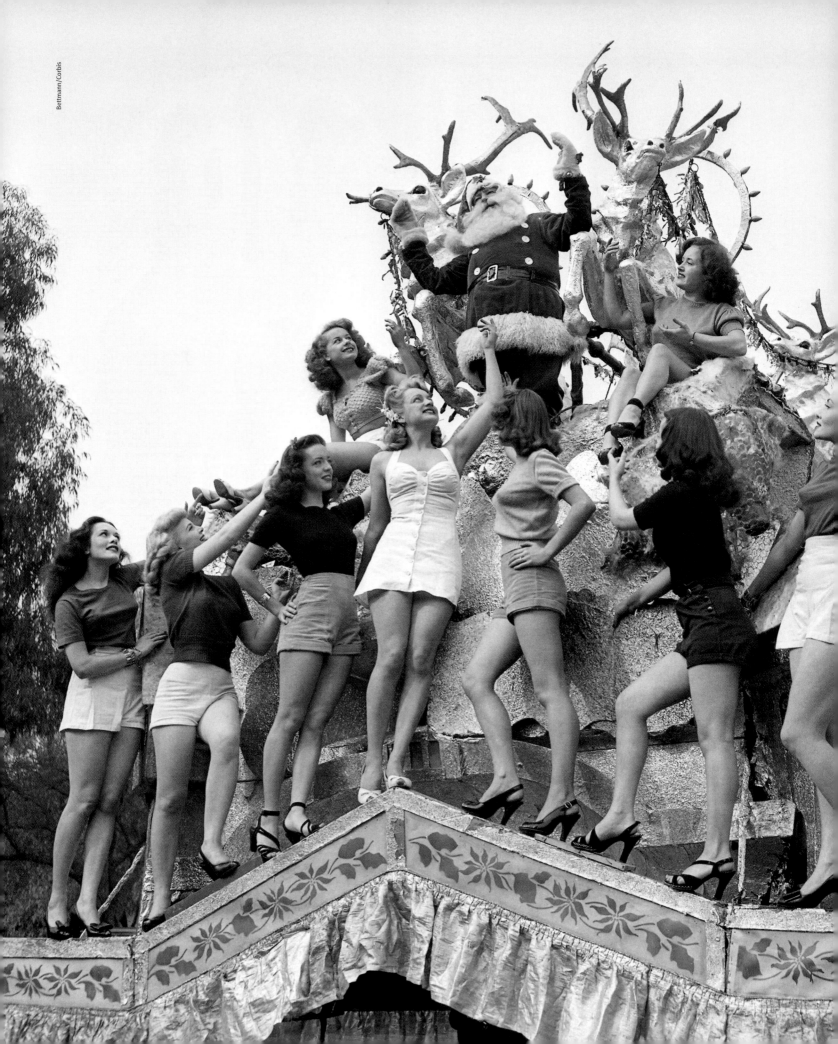

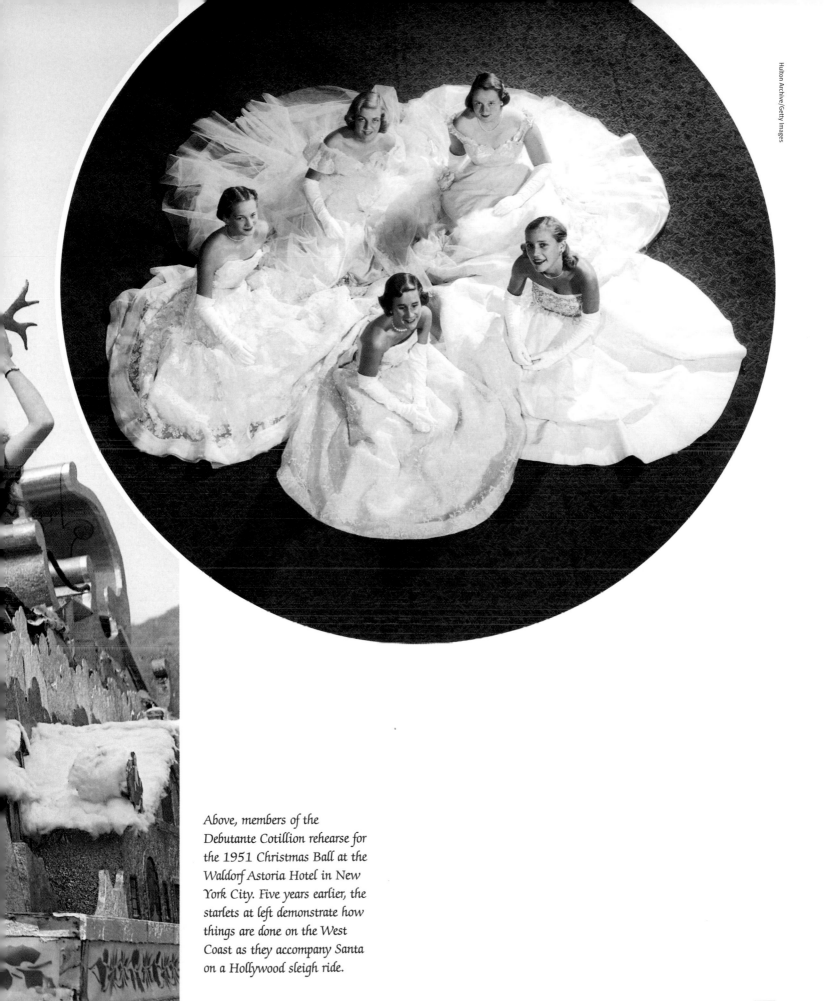

Hulton Archive/Getty Images

Above, members of the
Debutante Cotillion rehearse for
the 1951 Christmas Ball at the
Waldorf Astoria Hotel in New
York City. Five years earlier, the
starlets at left demonstrate how
things are done on the West
Coast as they accompany Santa
on a Hollywood sleigh ride.

Looking at the "snow" in the 68th annual Hollywood Christmas Parade on Hollywood Boulevard in the year 2000, it's easy to see why that town is the capital city of illusion. The seasonal festivity also helps explain its nickname: Tinseltown!

Paul Morse/Los Angeles Times

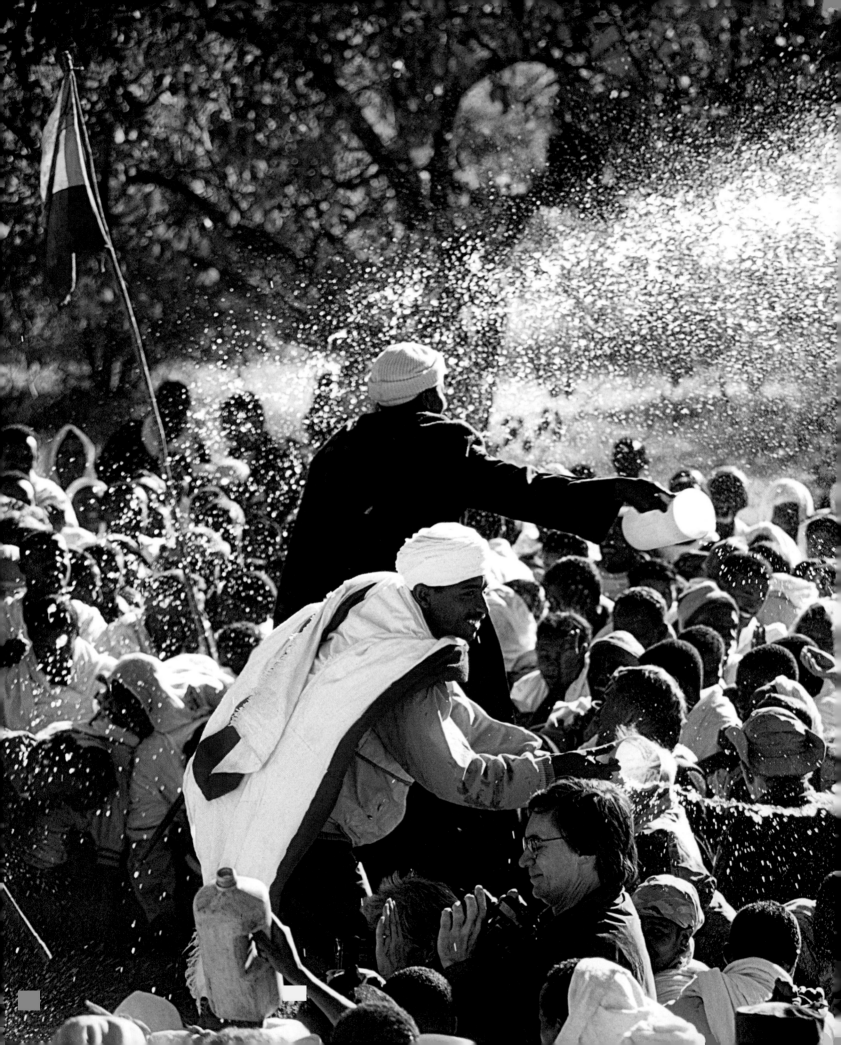

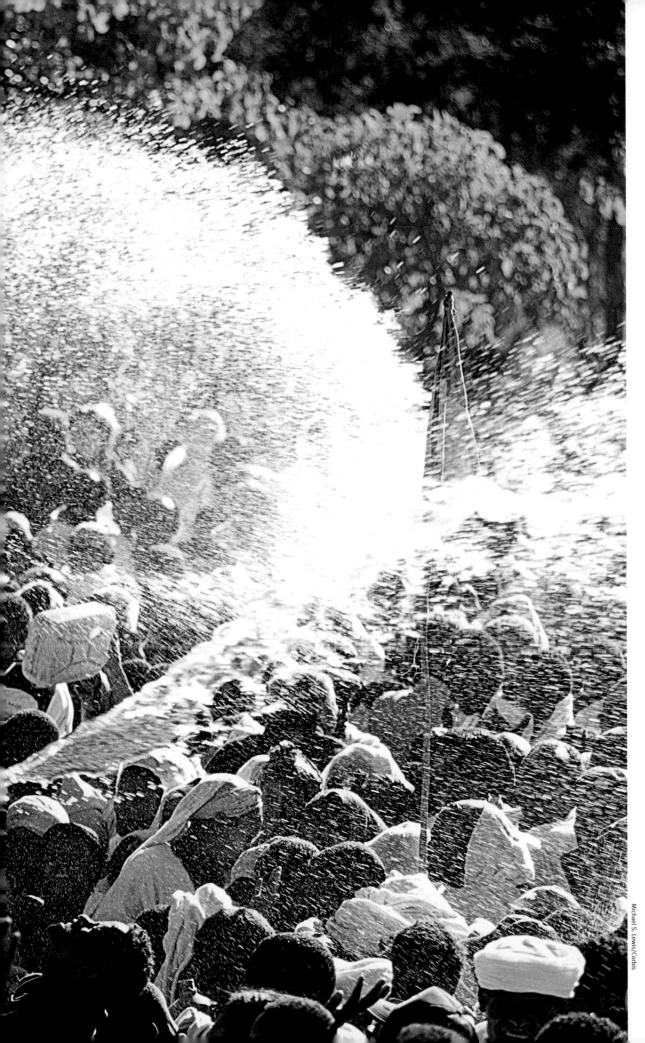

One of the earliest Christian nations, Ethiopia celebrates its Christmas Day, which is called Ganna, on January 7. At the ceremony, everyone is given a candle, then they walk around the church three times before standing for the duration of the three-hour service. Here, in 2001, priests bless the crowd with holy water.

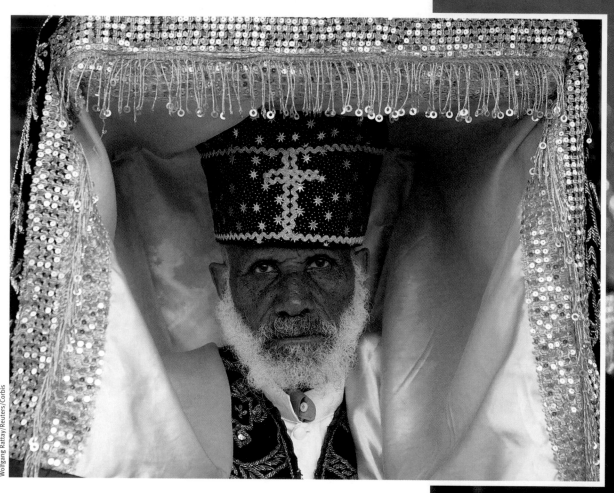

Above, an Orthodox priest in
Ethiopia carries the "tabot"
on his head. Made of stone or
wood, the tabot contains the
Ten Commandments. At right,
clergy carry ornate umbrellas
during Timket, a three-day
festival commemorating
Christ's baptism.

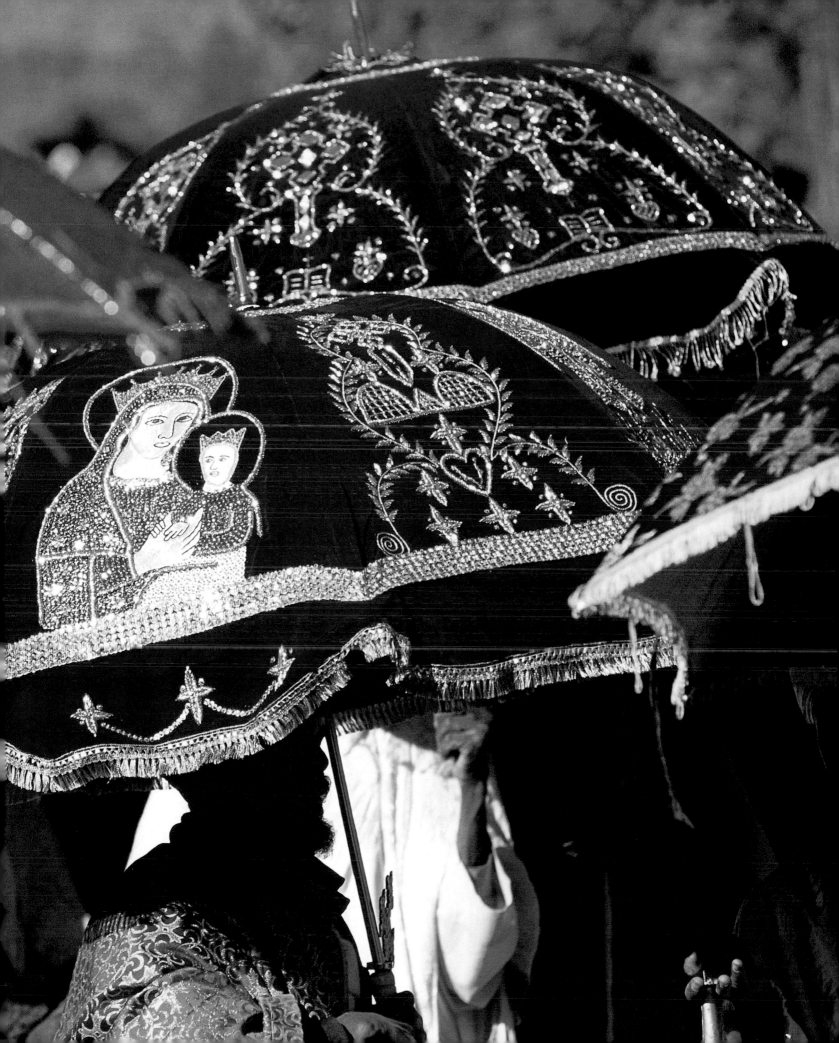

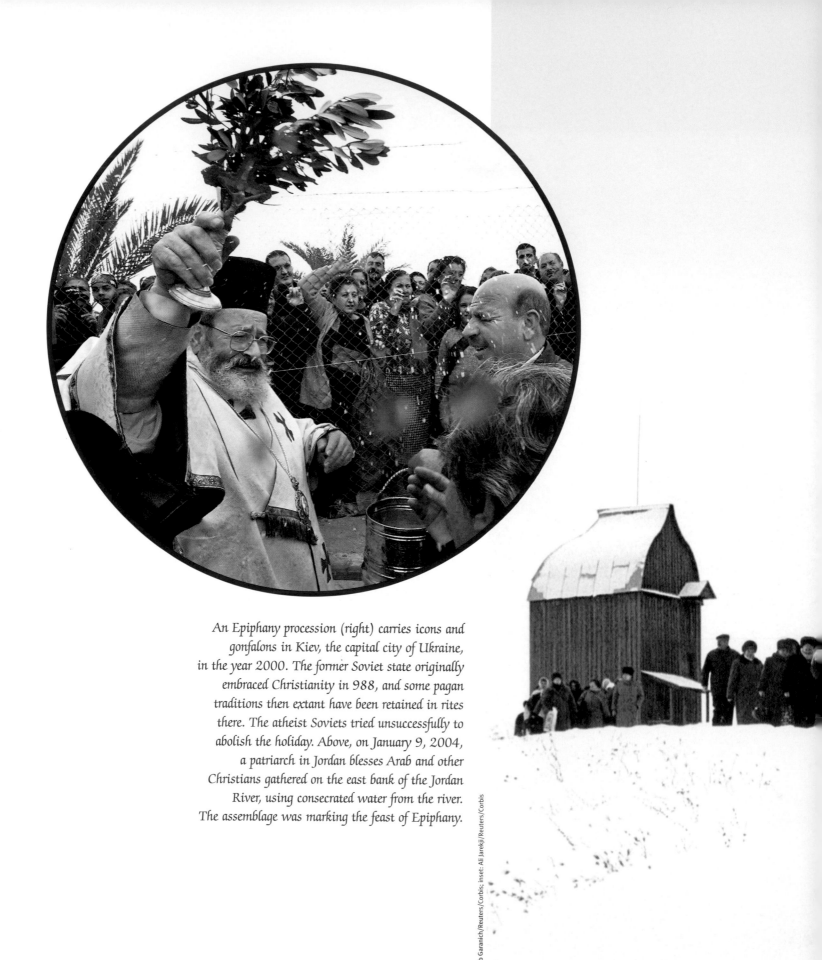

An Epiphany procession (right) carries icons and gonfalons in Kiev, the capital city of Ukraine, in the year 2000. The former Soviet state originally embraced Christianity in 988, and some pagan traditions then extant have been retained in rites there. The atheist Soviets tried unsuccessfully to abolish the holiday. Above, on January 9, 2004, a patriarch in Jordan blesses Arab and other Christians gathered on the east bank of the Jordan River, using consecrated water from the river. The assemblage was marking the feast of Epiphany.

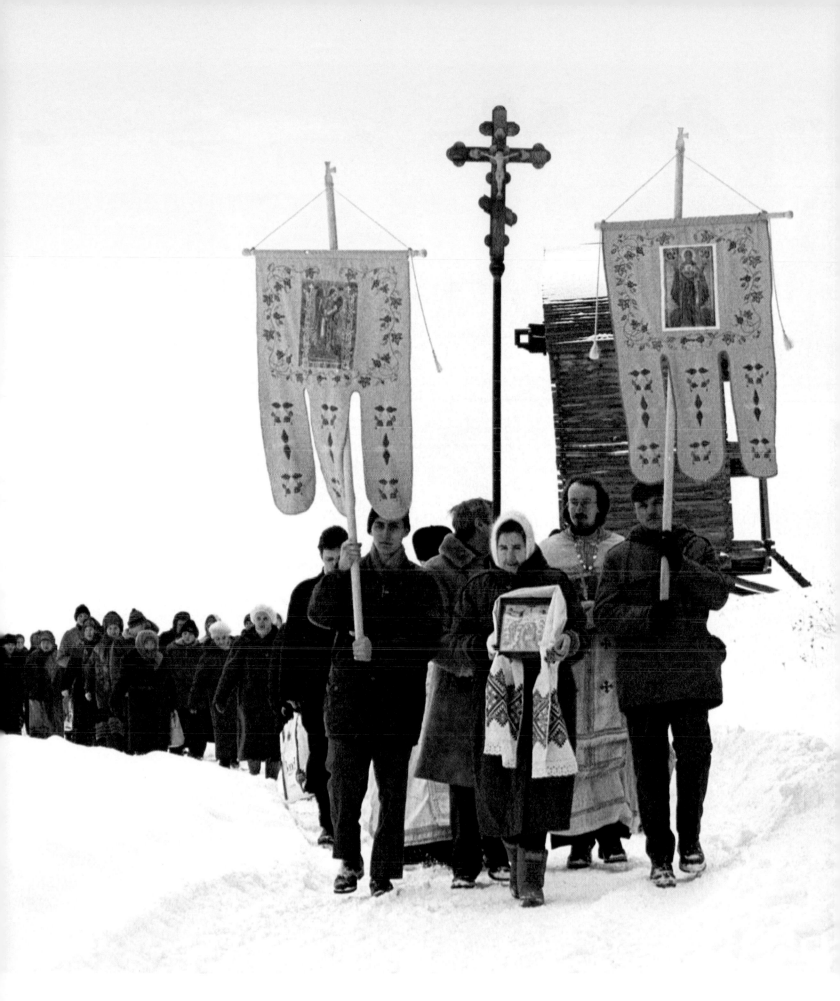

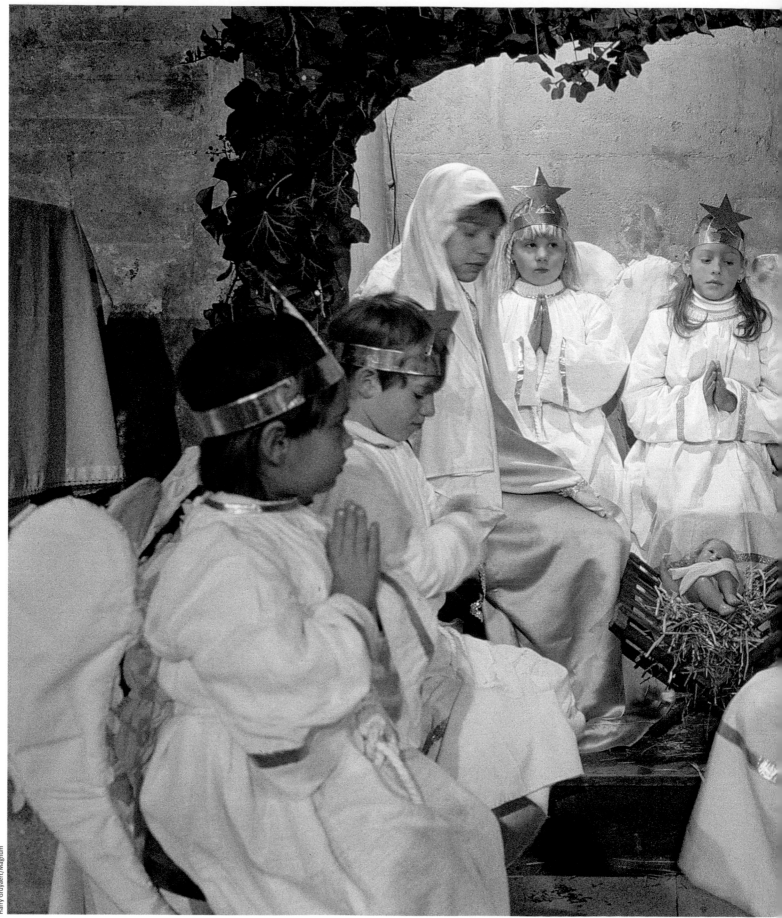

The Hawaiian schoolboys above wish you
"Mele Kalikimaka"; the French kids at left say,
"Joyeux Noël." Hawaiian Santa comes in an
outrigger canoe; the French Père Noël arrives
by donkey. Both of their countries share in
the traditions of the Nativity. In France,
clay figurines called "santons," or "little saints,"
populate the crèche. At left, life-size santons
in the village of Les Baux de Provence perform
in a Christmas Eve midnight ceremony at Saint
Vincent Church. Tradition calls for "Pastrage,"
in which local shepherds offer a newborn lamb
to the baby Jesus. Above, the Hawaiian boys as
shepherds in their own Nativity play.

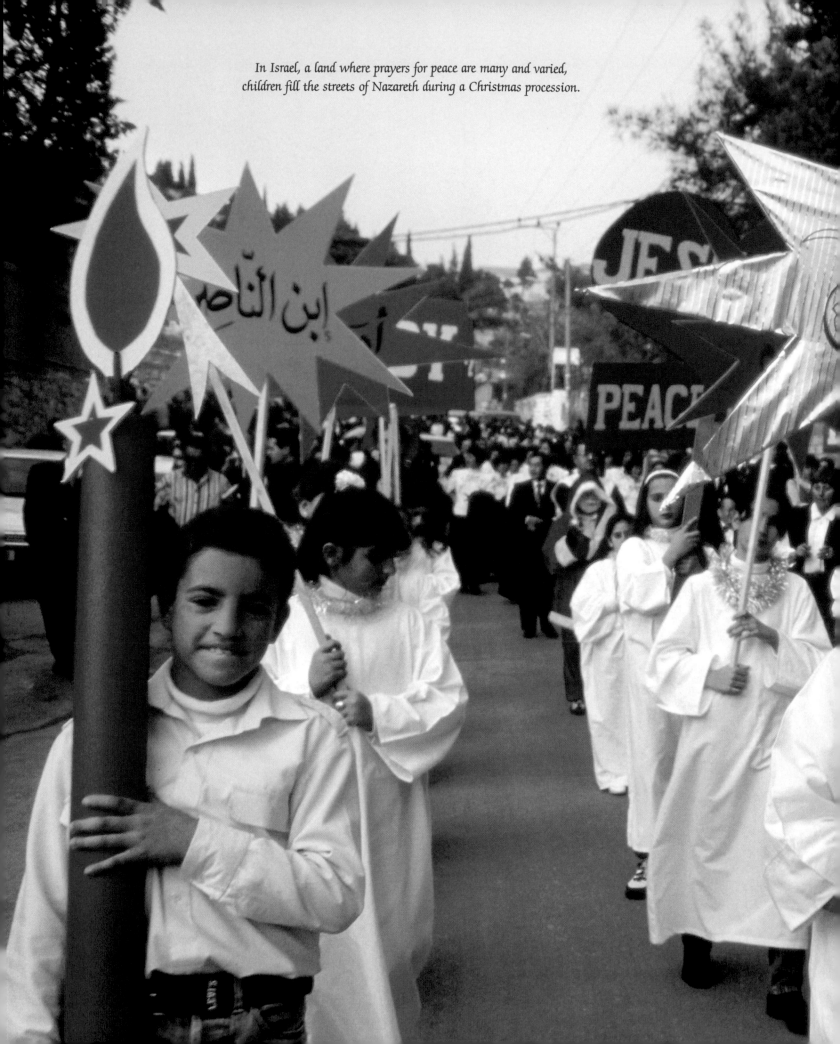

In Israel, a land where prayers for peace are many and varied, children fill the streets of Nazareth during a Christmas procession.

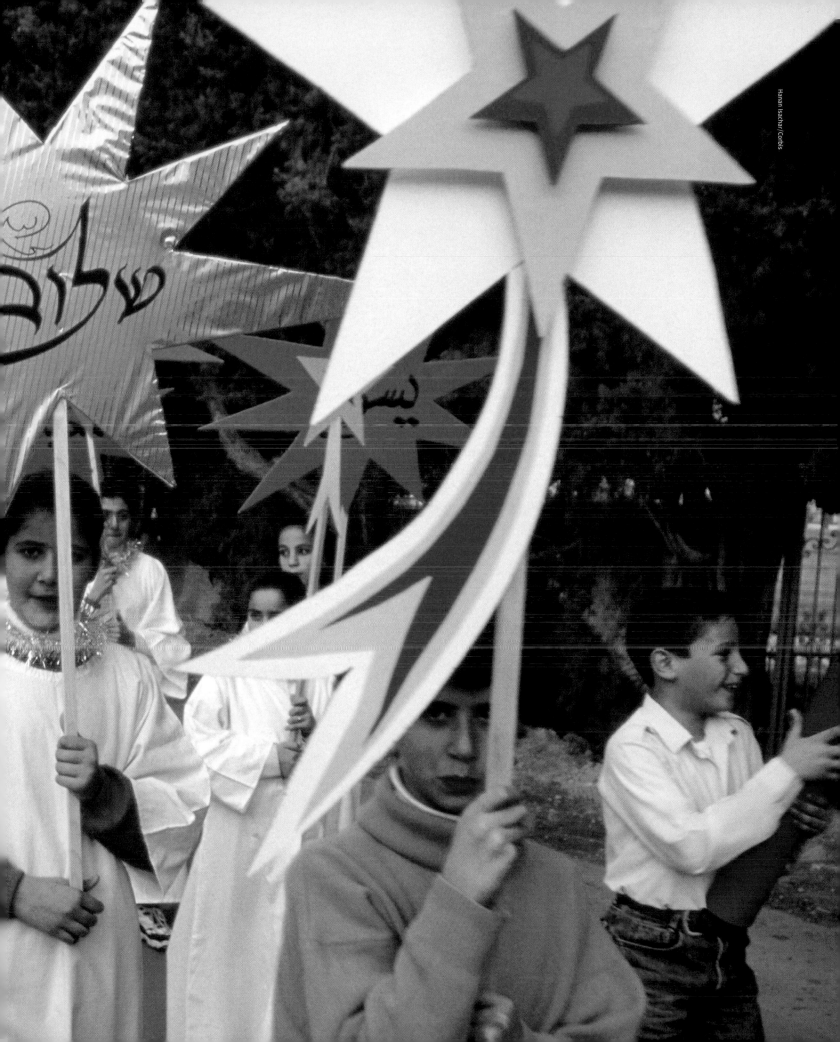

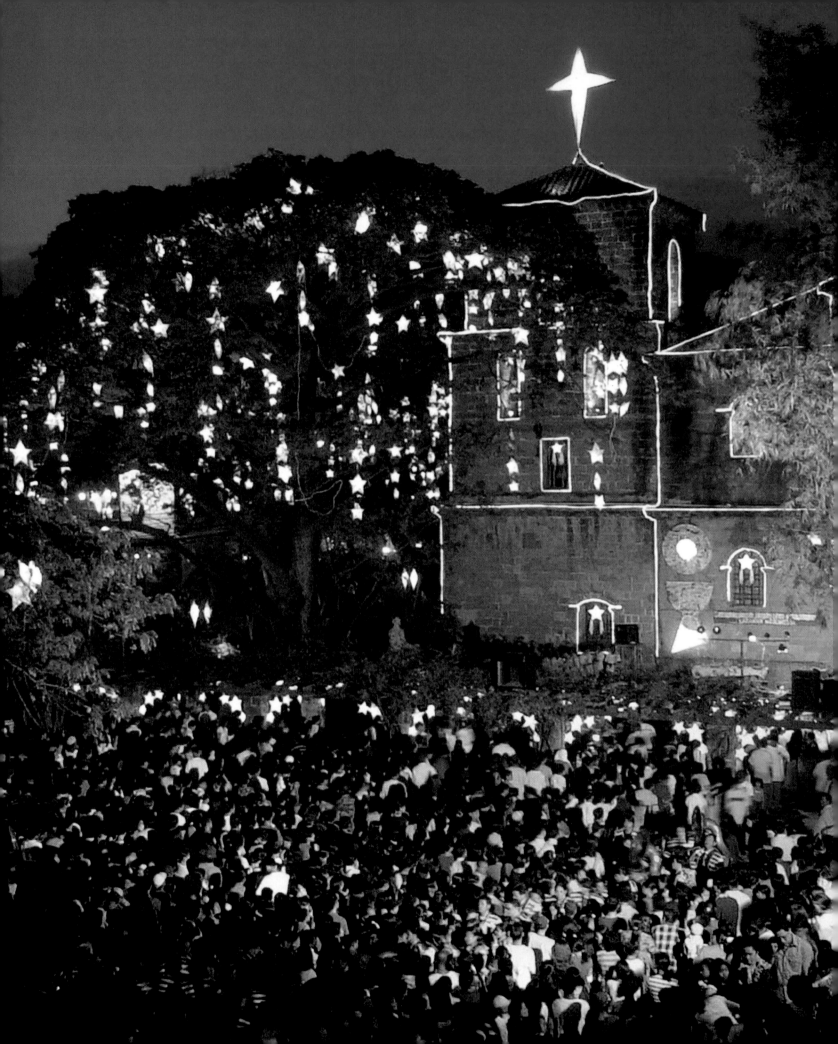

Filipinos honor the
Christmas season with
nine dawn Masses known
as "misa de gallo."
In Manila, at left and above,
hundreds venture out in the
early morning hours to
attend services at a church
in the capital. Above, rice-
cake vendors offer their
wares to the festive crowds.

In Lima, policemen dress as the Three Kings to meet some of their biggest fans, the children of Peru, in 2003. Three Kings Day is an integral part of a season filled with fiestas, fireworks—and even a Christmas Day bullfight.

Silvia Izquierdo/AP Wide World

On a cold winter's night in Germany in 1993, two girls appear in the raiment of the Christkind (Christ Child), who is said to deliver gifts to children's homes on Christmas Eve. They are meant to resemble the famous tinsel angels of Nuremberg where, every two years since 1933, one lucky, lovely girl has been crowned the city's own Christkind.

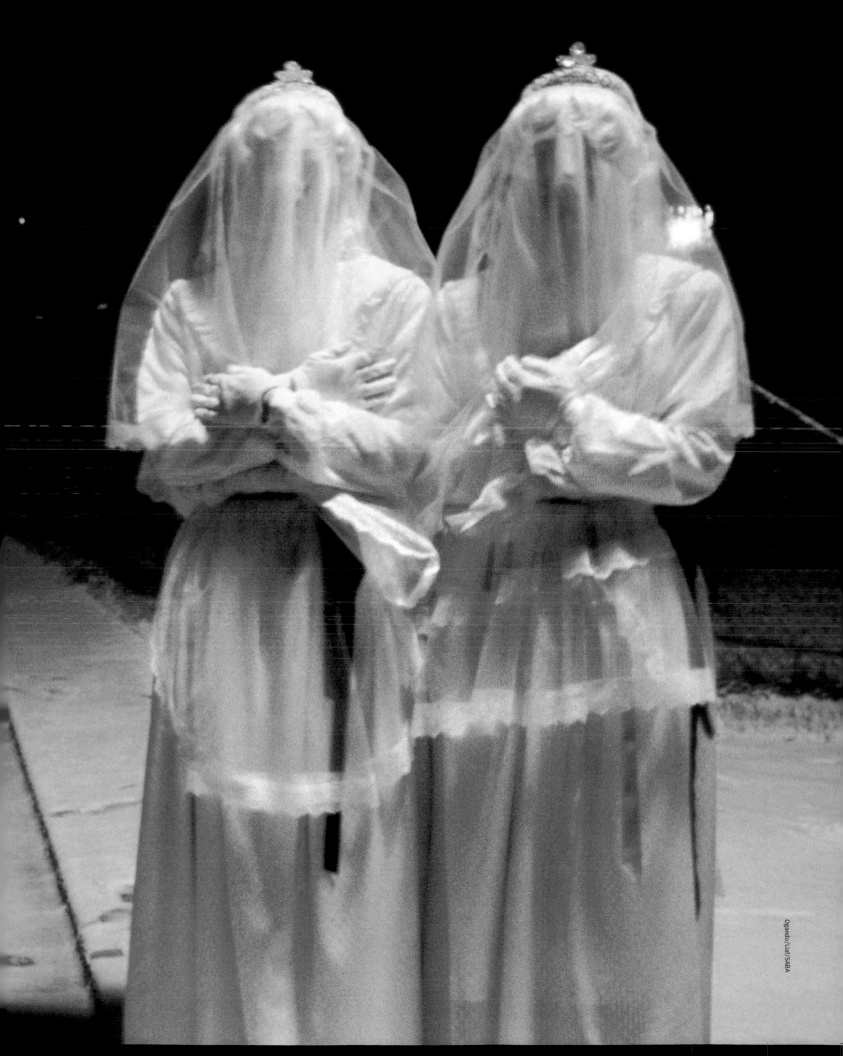

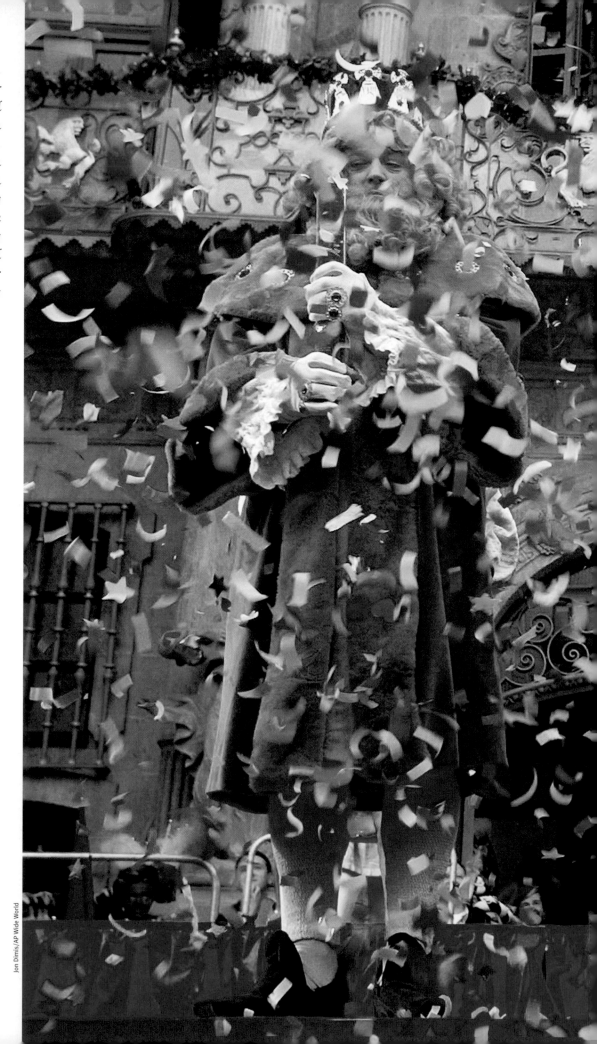

Much beloved and long awaited, the Three Kings arrive at their parade in Pamplona in 2004 and shoot confetti into the crowd. On their way to Bethlehem, Melchior, Gaspar and Balthazar stop off in Spain every year. And although Three Kings Day is the last big bash of the season, it's not the only chance for gaiety. Bustling holiday markets offer treats and music, and on Christmas Eve, after Mass has ended, the feasting continues until dawn.

Jon Dimis/AP Wide World

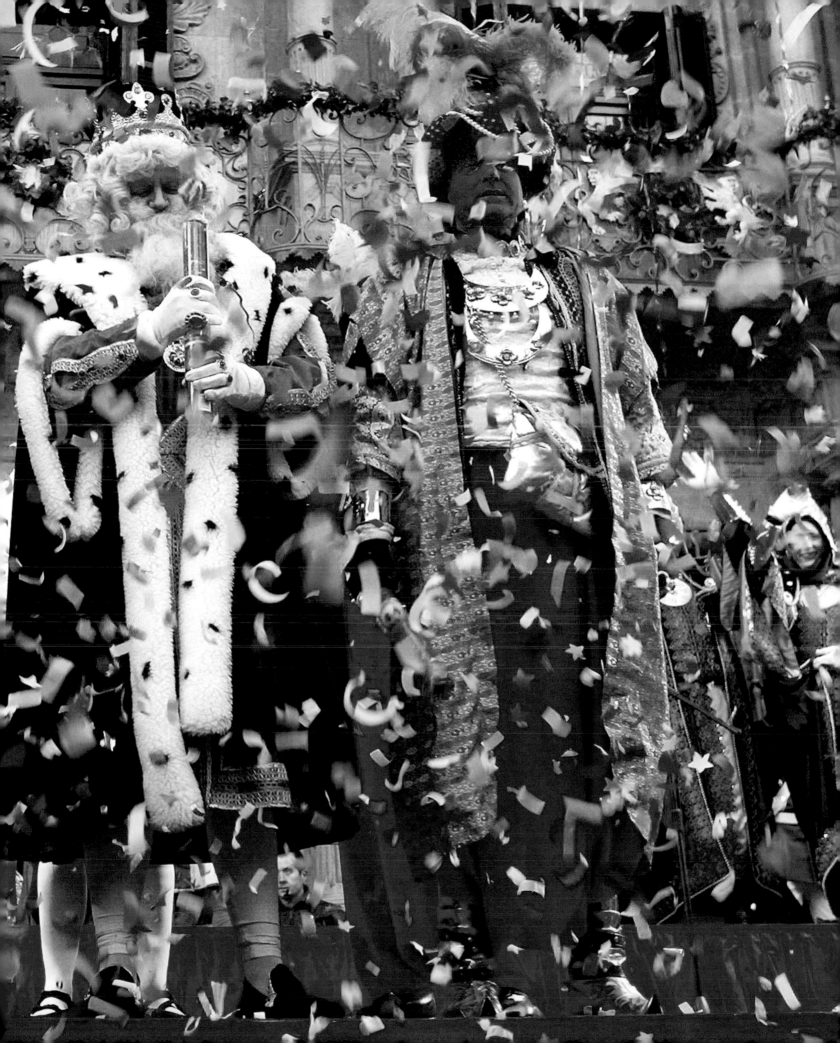

Christmas is a time of many colors, and no one surpasses the mummers in that regard. Popular in Europe as long as five centuries ago, mummery may date back to ancient Rome and the Saturnalia that was an early influence on Christmas. Through the years mummery has embraced flamboyant disguise and drama, intermingled with gift-giving. The spirit is still alive and well in Philadelphia, as seen in these photos from 2003. At right, the Broomall String Band plays, while below, a member of the Golden Sunrise Fancy Brigade performs. About 15,000 mummers appear in the city's annual parade.

William Thomas Cain/Getty Images (2)

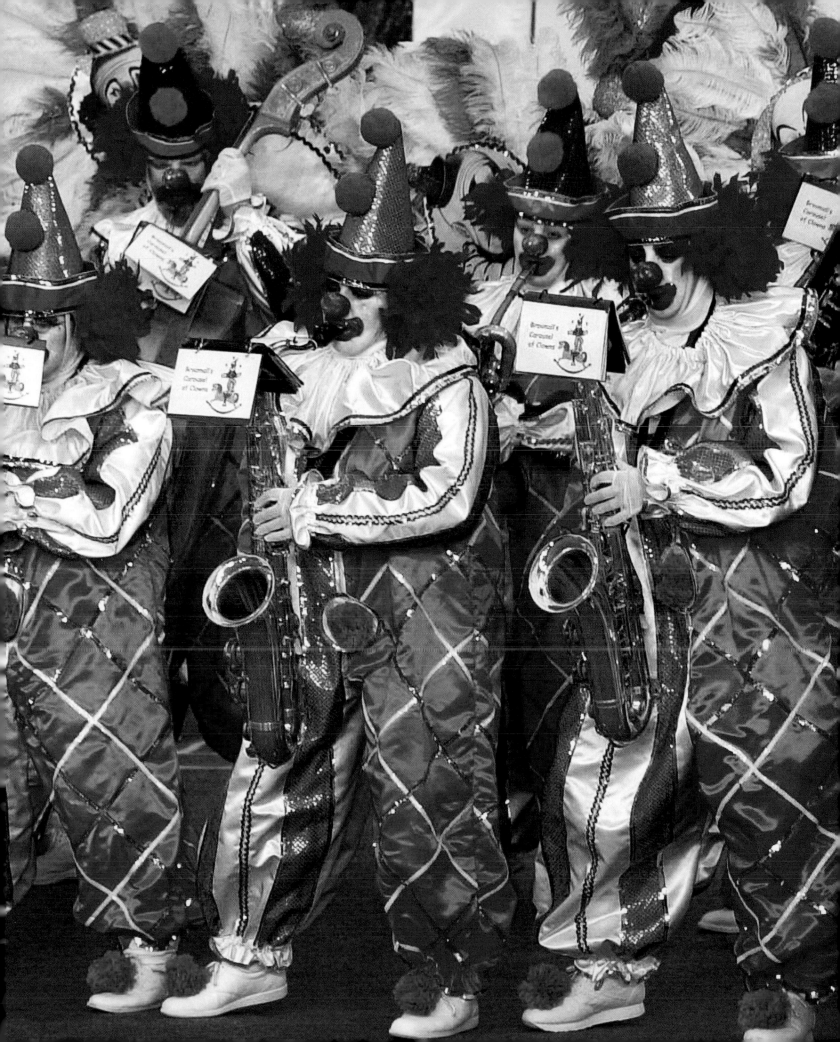

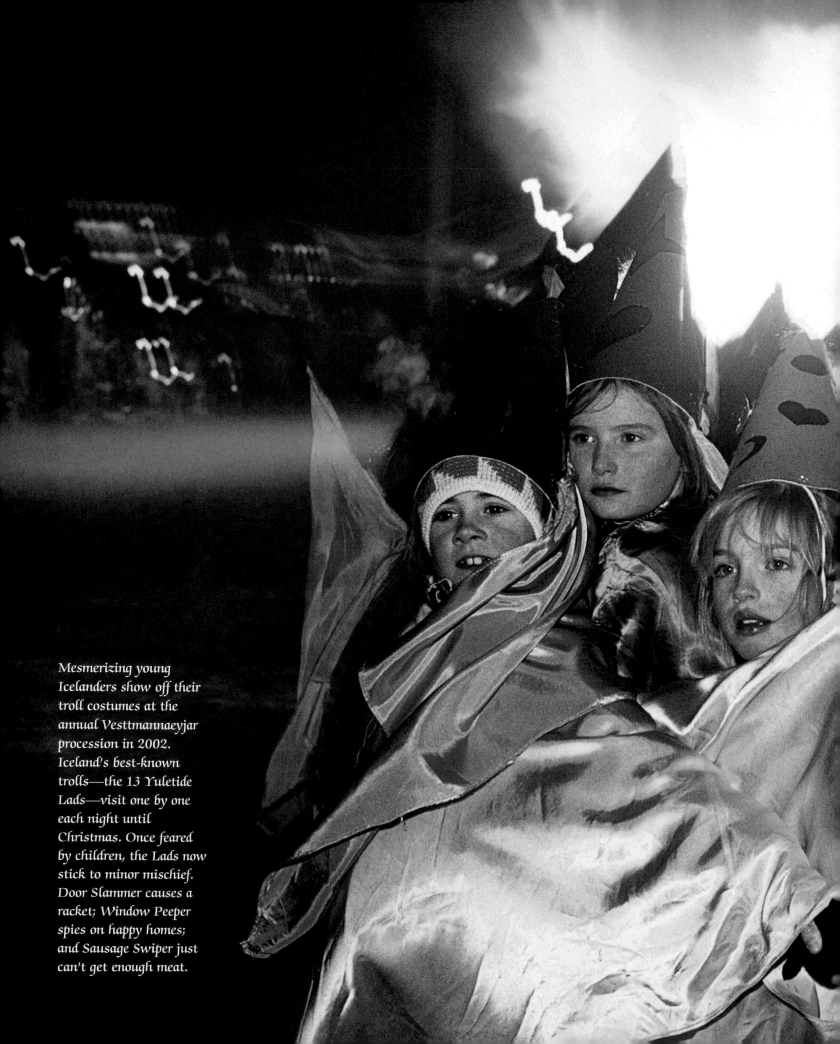

Mesmerizing young Icelanders show off their troll costumes at the annual Vesttmannaeyjar procession in 2002. Iceland's best-known trolls—the 13 Yuletide Lads—visit one by one each night until Christmas. Once feared by children, the Lads now stick to minor mischief. Door Slammer causes a racket; Window Peeper spies on happy homes; and Sausage Swiper just can't get enough meat.

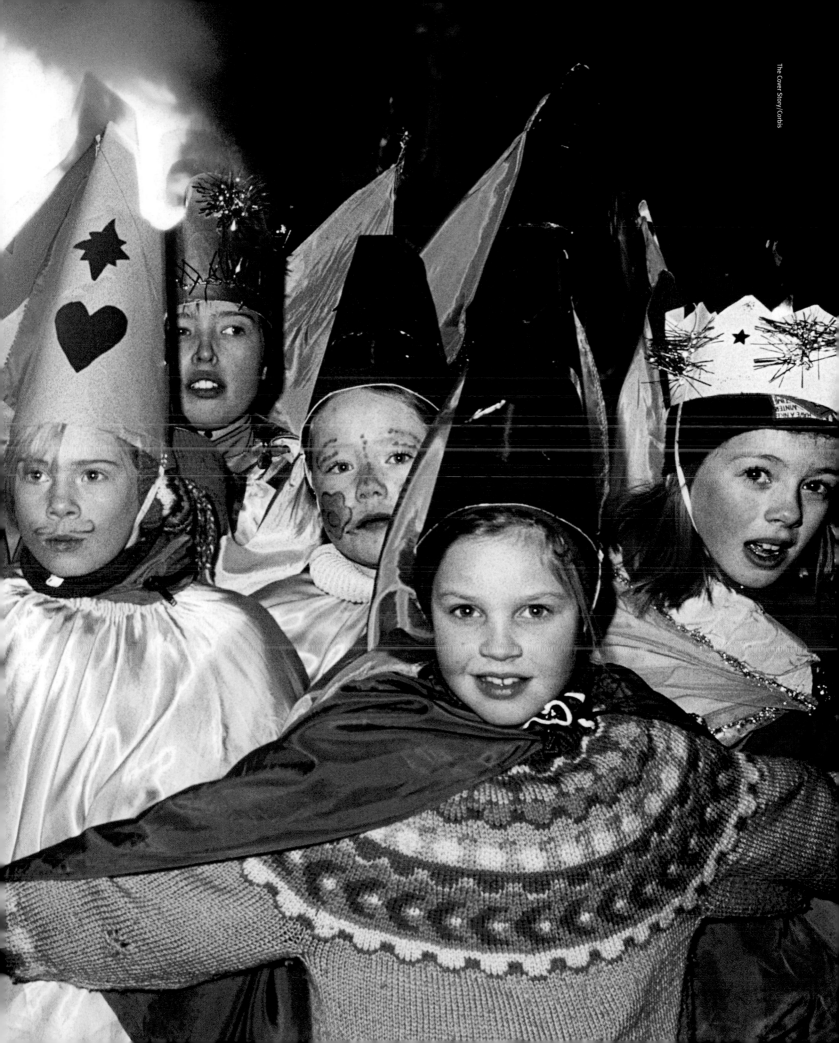

Tinseltown

As reliable as the leaves falling and a nip returning to the air is the autumn appearance of movie posters heralding that season's Christmas offerings. In the multimedia 20th century, film directors such as Frank Capra and tunesmiths like Irving Berlin joined the ranks of Dickens, Nast, Moore and other earlier auteurs in helping define the way we felt about Christmas. Entrusting the holiday to an industry based in sunny Southern California might have seemed ironic, but by and large, Hollywood has been most comfortable with Christmas, and has left us with a heavenly host of memorable images and emotions.

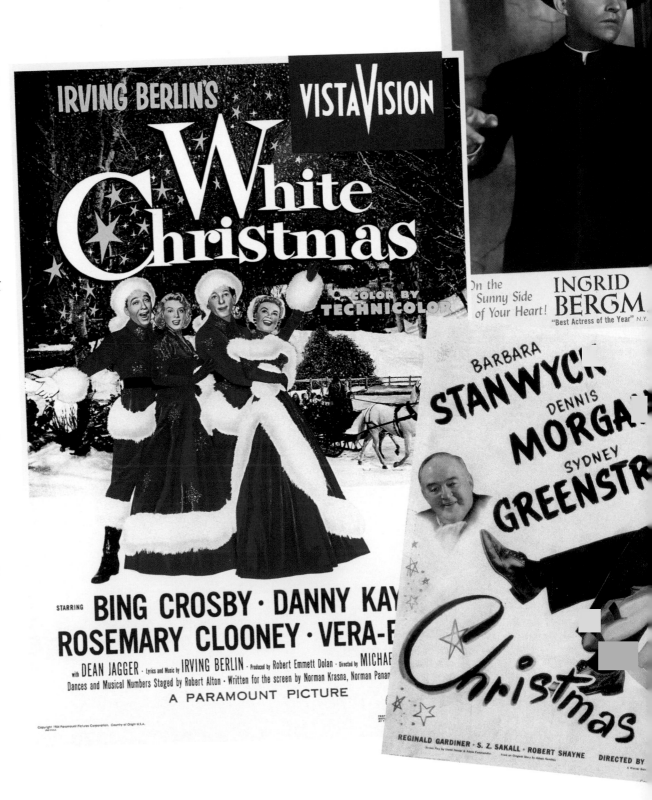

IRVING BERLIN'S · VISTAVISION

White Christmas

COLOR BY TECHNICOLOR

On the Sunny Side of Your Heart!

INGRID BERGM

"Best Actress of the Year" N.Y.

STARRING **BING CROSBY · DANNY KAY ROSEMARY CLOONEY · VERA-E**
with DEAN JAGGER · Lyrics and Music by IRVING BERLIN · Produced by Robert Emmett Dolan · Directed by MICHAI
Dances and Musical Numbers Staged by Robert Alton · Written for the screen by Norman Krasna, Norman Panan

A PARAMOUNT PICTURE

Copyright 1954 Paramount Pictures Corporation. Country of Origin U.S.A.

BARBARA **STANWYCK**
DENNIS **MORGA**
SYDNEY **GREENSTR**

Christmas

REGINALD GARDINER · S. Z. SAKALL · ROBERT SHAYNE · DIRECTED BY

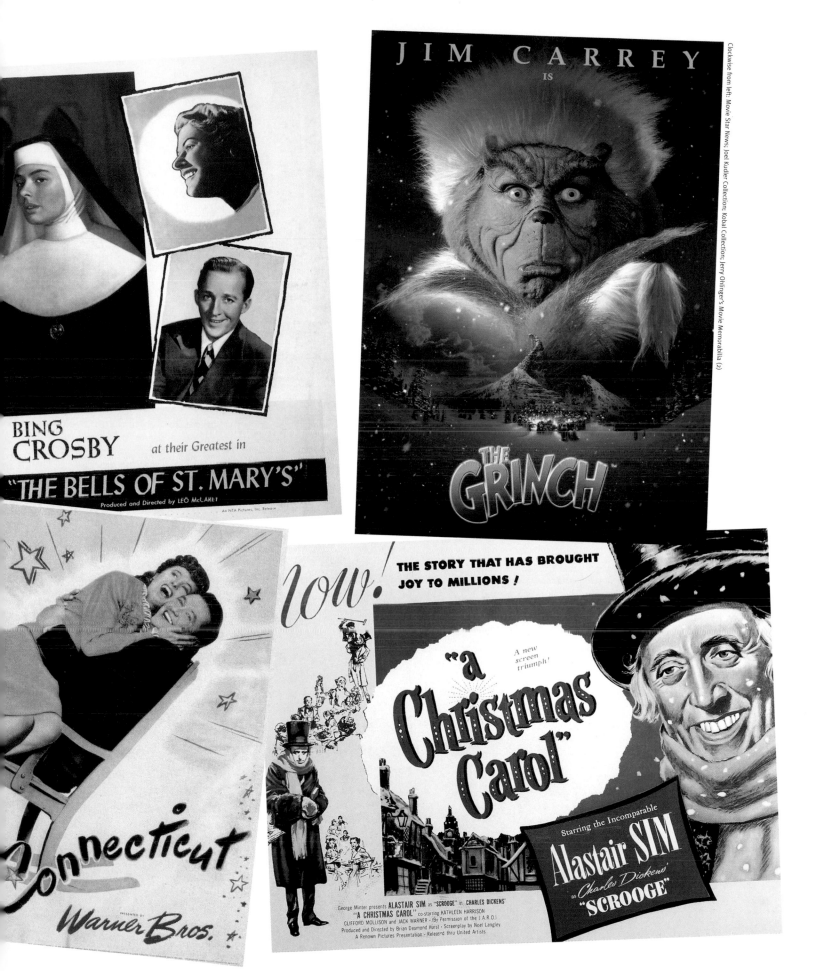

BING CROSBY at their Greatest in
"THE BELLS OF ST. MARY'S"
Produced and Directed by LEO McCAREY
An NTA Pictures, Inc. Release

JIM CARREY is
THE GRINCH

Connecticut
PRESENTED BY
Warner Bros.

Now!

THE STORY THAT HAS BROUGHT JOY TO MILLIONS!

A new screen triumph!

"a Christmas Carol"

Starring the Incomparable
Alastair SIM
as Charles Dickens'
"SCROOGE"

George Minter presents ALASTAIR SIM as "SCROOGE" in CHARLES DICKENS'
"A CHRISTMAS CAROL" co-starring KATHLEEN HARRISON
CLIFFORD MOLLISON and JACK WARNER · (By Permission of the J.A.R.O.)
Produced and Directed by Brian Desmond Hurst · Screenplay by Noel Langley
A Renown Pictures Presentation · Released thru United Artists

Christmas is a unique holiday, one
suffused with drama, celebration, laughter
and magic. In consequence, it has long
been an ideal subject for the silver screen
and has been an important genre since the
earliest days of what we call motion
pictures. Indeed, there was a series of
Christmas "movies" made in 1897, with
simple titles like "Christmas Morning" and
"Night Before Christmas." This image is
from 1908's "The Christmas Burglars."

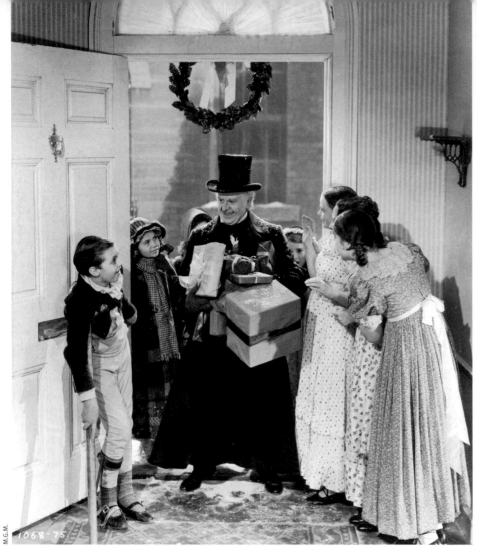

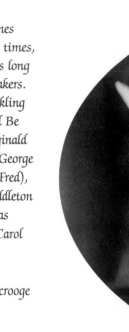

Alternately traveling as "A Christmas Carol," "Scrooge" or another pseudonym, and sometimes updated to contemporary times, Dickens's classic tale has long been a favorite of filmmakers. Clockwise from left: Tackling the role of He Who Will Be Redeemed have been Reginald Owen, Seymour Hicks, George C. Scott (Roger Rees is Fred), Fredric March (Ray Middleton is the Ghost of Christmas Present), Bill Murray (Carol Kane is the Ghost of Christmas Present) and Alastair Sim, the best Scrooge of them all.

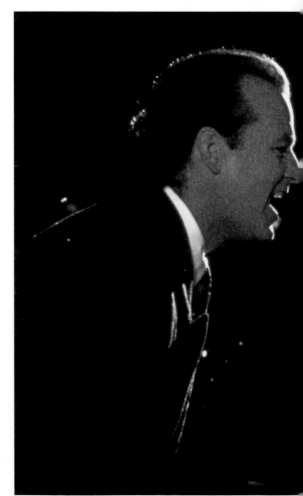

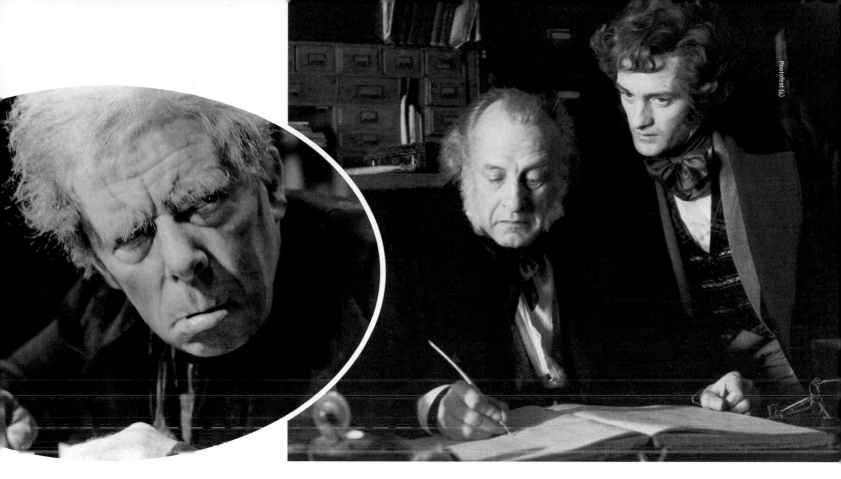

In December 1946, the greatest Christmas film of all time was dropped into the well of American pop culture— and it made hardly a ripple. Frank Capra's "It's a Wonderful Life," starring James Stewart and Donna Reed, did little at the box office, and though nominated for some Oscars, it won none. The story of George Bailey, a small-town man on the brink who gets a glimpse of how things would have gone without him, might have been forgotten altogether— but in 1973, someone failed to renew the film's copyright. TV stations began to air it repeatedly each Christmas season, and after years in the public domain, "It's a Wonderful Life" had retired the title as America's Christmas Movie.

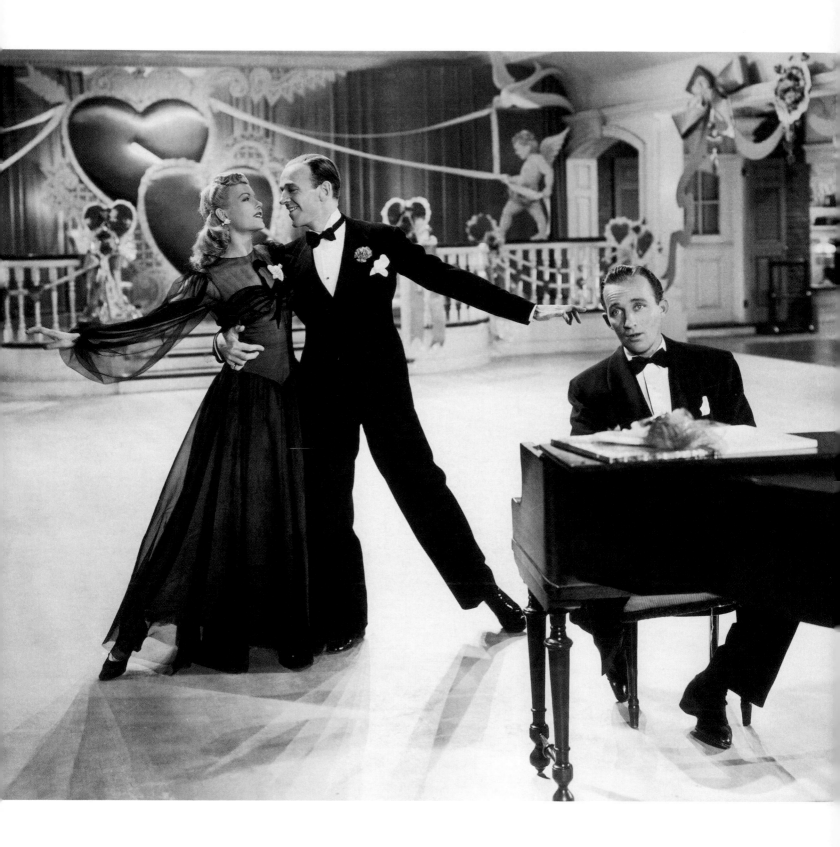

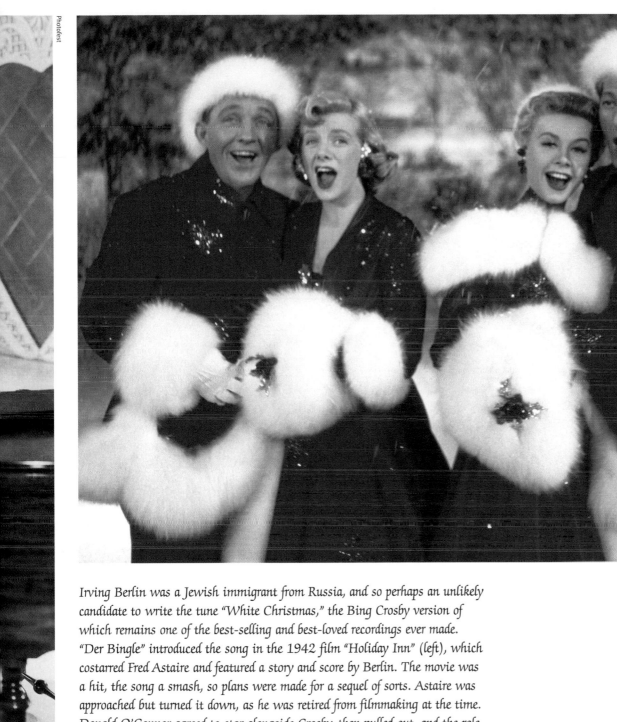

Irving Berlin was a Jewish immigrant from Russia, and so perhaps an unlikely candidate to write the tune "White Christmas," the Bing Crosby version of which remains one of the best-selling and best-loved recordings ever made. "Der Bingle" introduced the song in the 1942 film "Holiday Inn" (left), which costarred Fred Astaire and featured a story and score by Berlin. The movie was a hit, the song a smash, so plans were made for a sequel of sorts. Astaire was approached but turned it down, as he was retired from filmmaking at the time. Donald O'Connor agreed to star alongside Crosby, then pulled out, and the role went to Danny Kaye. The love interests in 1954's "White Christmas" were Rosemary Clooney (above, left) and Vera-Ellen.

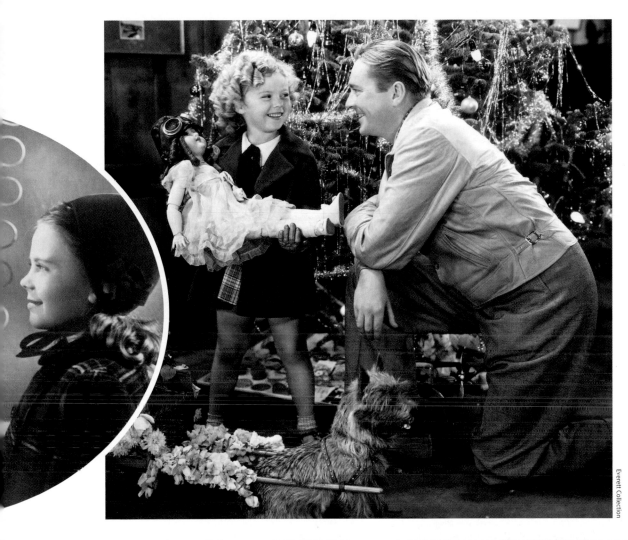

It seems like everyone got into the act—some you'd expect, some you wouldn't. Clockwise from far left: Jeanne Crain and Farley Granger in "O. Henry's Full House," which featured an adaptation of the writer's classic story, "The Gift of the Magi"; Edmund Gwenn and Natalie Wood in "Miracle on 34th Street"; Shirley Temple in "Bright Eyes"; Janet Leigh and Robert Mitchum in "Holiday Affair"; Gig Young, Katharine Hepburn and Spencer Tracy in "Desk Set"; Barbara Stanwyck and Fred MacMurray in "Remember the Night."

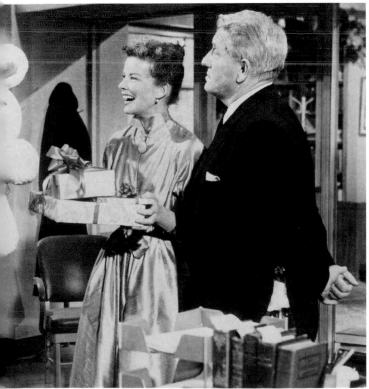

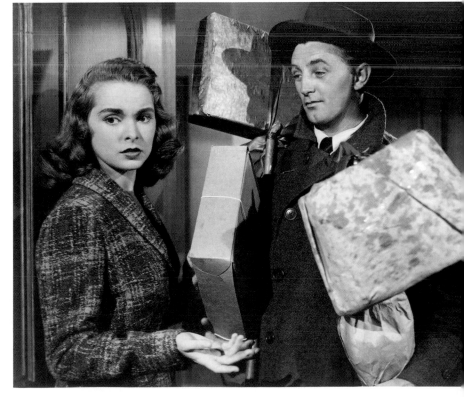

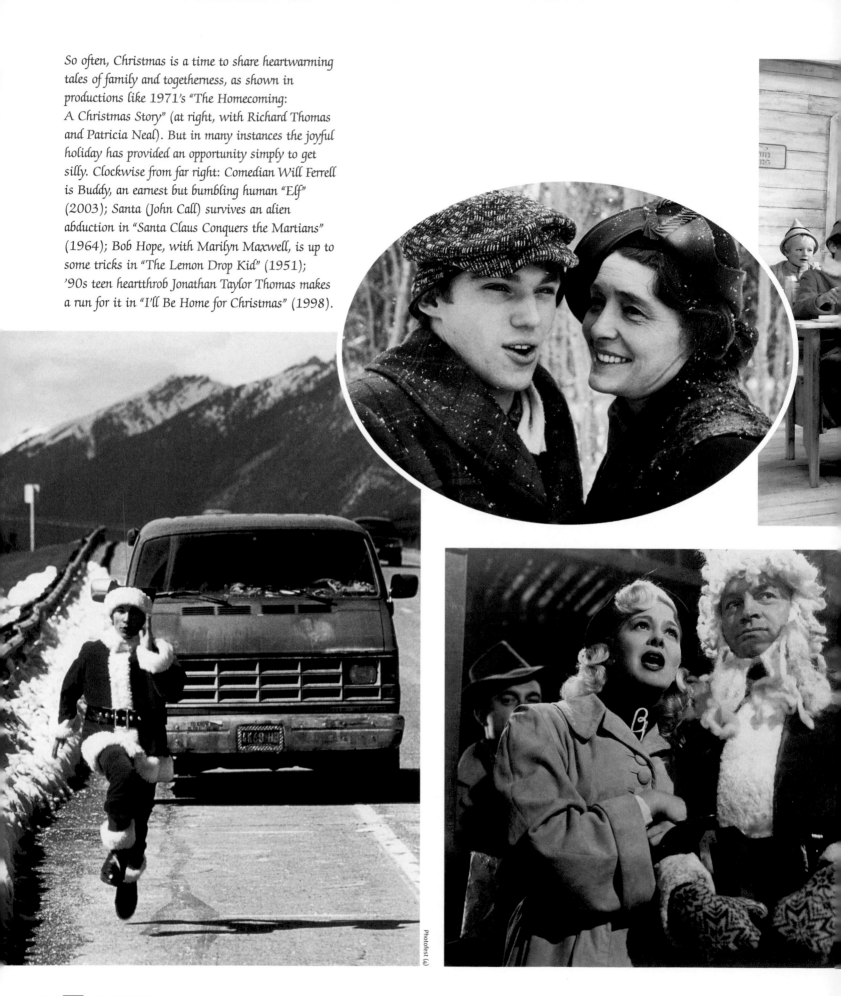

So often, Christmas is a time to share heartwarming tales of family and togetherness, as shown in productions like 1971's "The Homecoming: A Christmas Story" (at right, with Richard Thomas and Patricia Neal). But in many instances the joyful holiday has provided an opportunity simply to get silly. Clockwise from far right: Comedian Will Ferrell is Buddy, an earnest but bumbling human "Elf" (2003); Santa (John Call) survives an alien abduction in "Santa Claus Conquers the Martians" (1964); Bob Hope, with Marilyn Maxwell, is up to some tricks in "The Lemon Drop Kid" (1951); '90s teen heartthrob Jonathan Taylor Thomas makes a run for it in "I'll Be Home for Christmas" (1998).

Photofest (4)

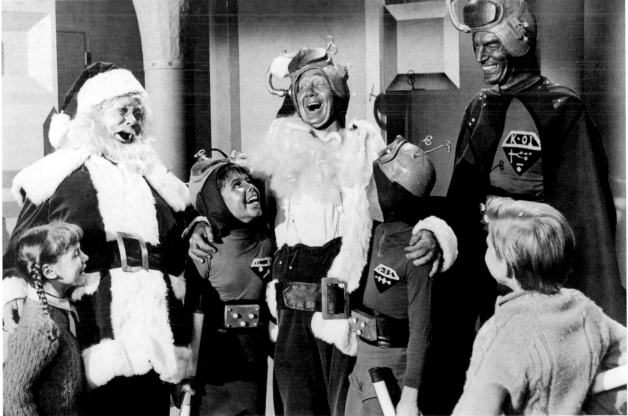

Many Christmas stories have been particularly well rendered in animation. The "Peanuts" gang's TV special not only became a yearly staple in the 1960s but gave us wonderful new holiday music in its jazzy Vince Guaraldi score. So, too, did "Rudolph the Red-Nosed Reindeer" propel Burl Ives' version of "A Holly Jolly Christmas" into heavy seasonal rotation. Director Tim Burton's "The Nightmare Before Christmas" (bottom, right) was a visual tour de force. Burton admits being influenced by Dr. Seuss's "How the Grinch Stole Christmas!"— a marvelous book that was turned into a superior television special by Seuss (Ted Geisel) and animator Chuck Jones. Another classic storybook, Chris Van Allsburg's "The Polar Express," became a feature film.

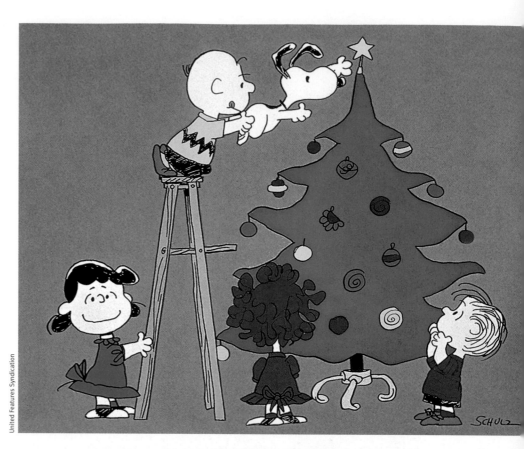

United Features Syndication

Classic Media/CBS Photo Archive/Getty Images

The Nutcracker

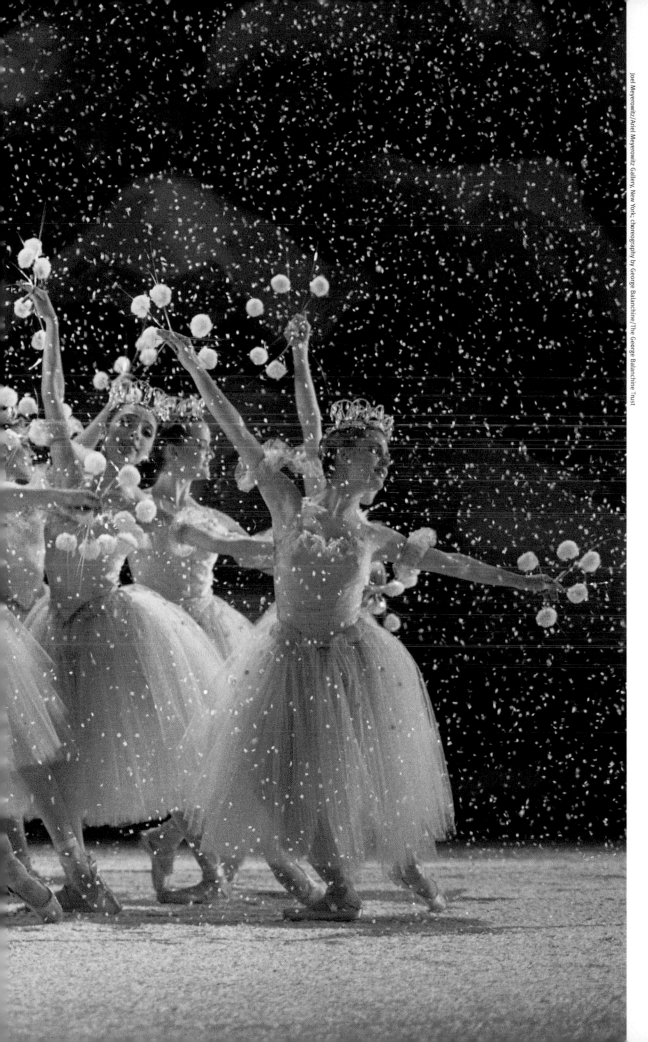

The Russian composer Tchaikovsky gave it an unforgettable score, George Balanchine brought it new life in New York City with his choreography, but it was the German writer E.T.A. Hoffmann who first imagined the little girl's Christmas Eve dream. In the world's most famous and oft-performed ballet, a nutcracker, with the aid of toy soldiers, must combat his fearsome foe, the Mouse King. Emerging victorious, the nutcracker is transformed into a prince, and he and the girl embark on a journey to marvelous lands. Today, "The Nutcracker" is a perennial Christmas gift to millions.

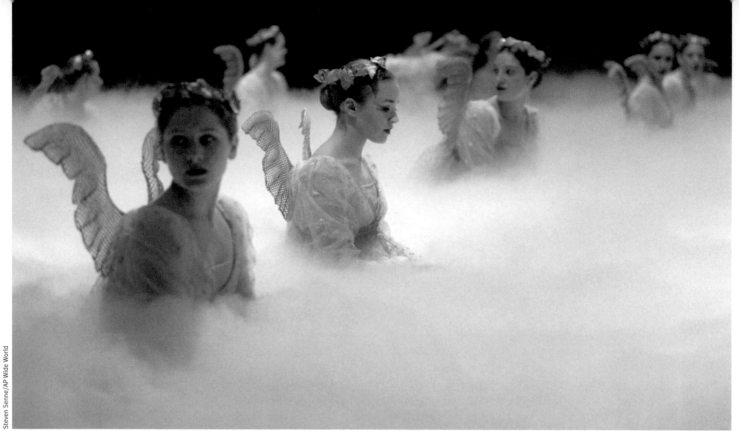

"The Nutcracker" made an inauspicious 1892 debut in St. Petersburg, but today's productions are frothy seasonal delights. At the San Francisco Ballet, for example—the site of the 1944 American premiere—there are now 170 costumes, 148 child dancers, 100 pounds of paper snow and a 28-foot Christmas tree. Below: After fighting the Mouse King, this bunny soldier waits to don an angel costume for Act II. Opposite: behind the curtain in a sea of fog; a young angel bedecked in gold; toy soldiers in preparation for battle.

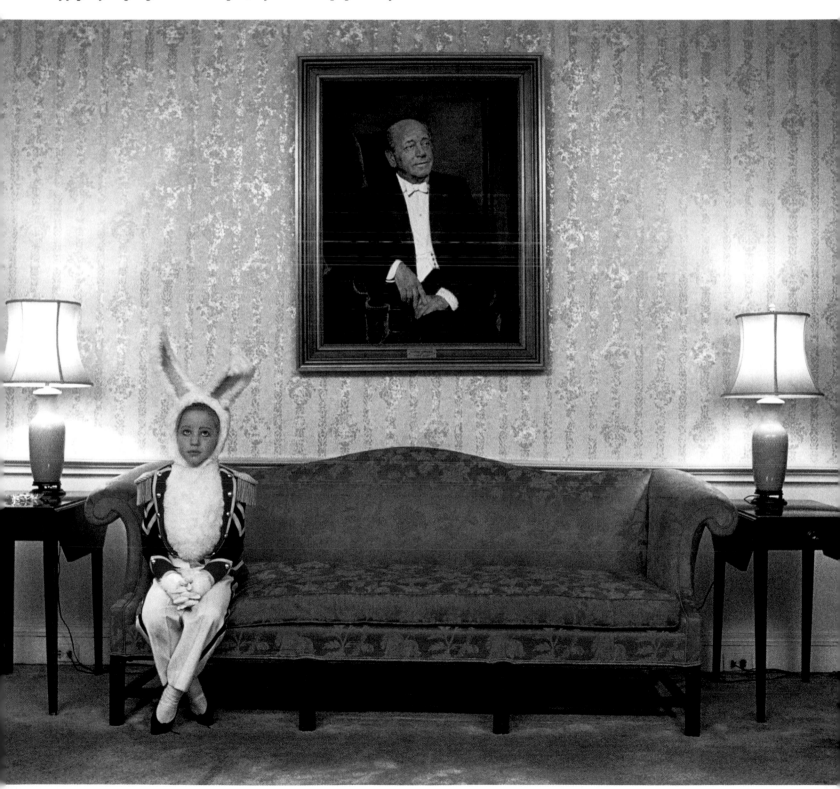

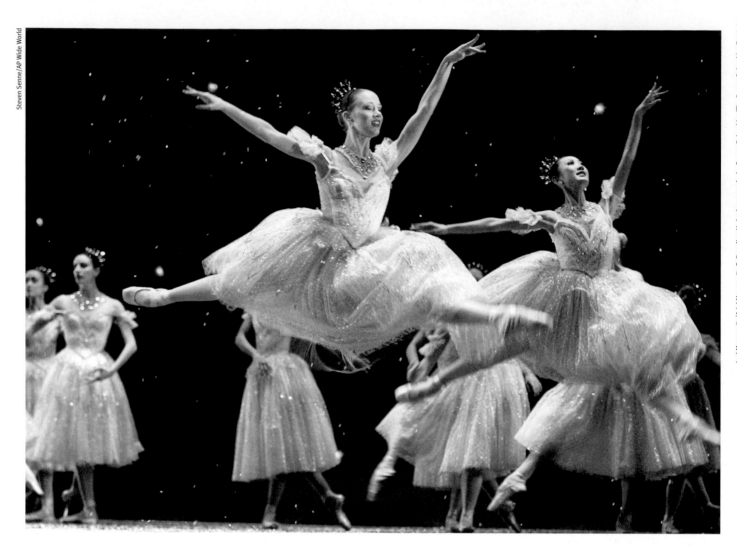

When "The Nutcracker" debuted in America, according to the costume designer of the San Francisco Ballet, "The strains of the overture filtered backstage, and what followed seems like a dream." Above, shimmering snowflakes leap through the air. After defeating the Mouse King, the Nutcracker Prince brings Clara to the enchanted Land of Snow, and then it is on to visit the Sugar Plum Fairy in the Land of Sweets, where they watch joyous dances from around the world. In the end, of course, Clara must awake, and "The Nutcracker" must draw to its charming conclusion.

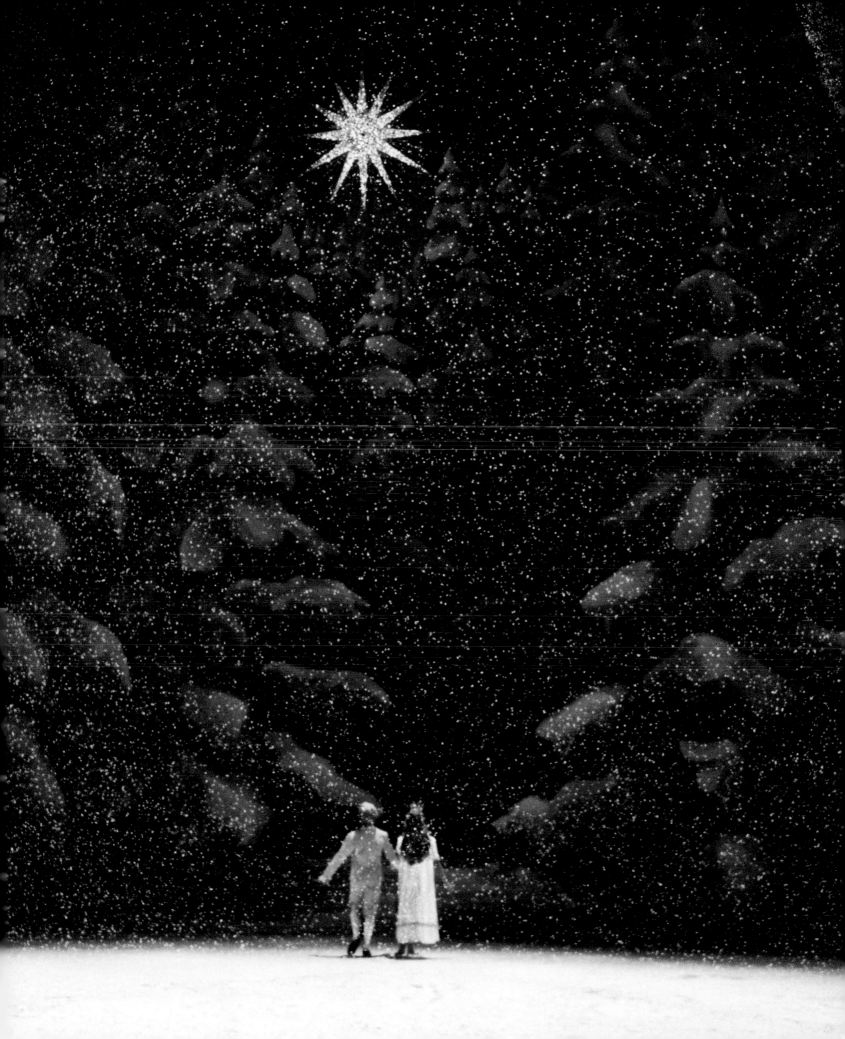

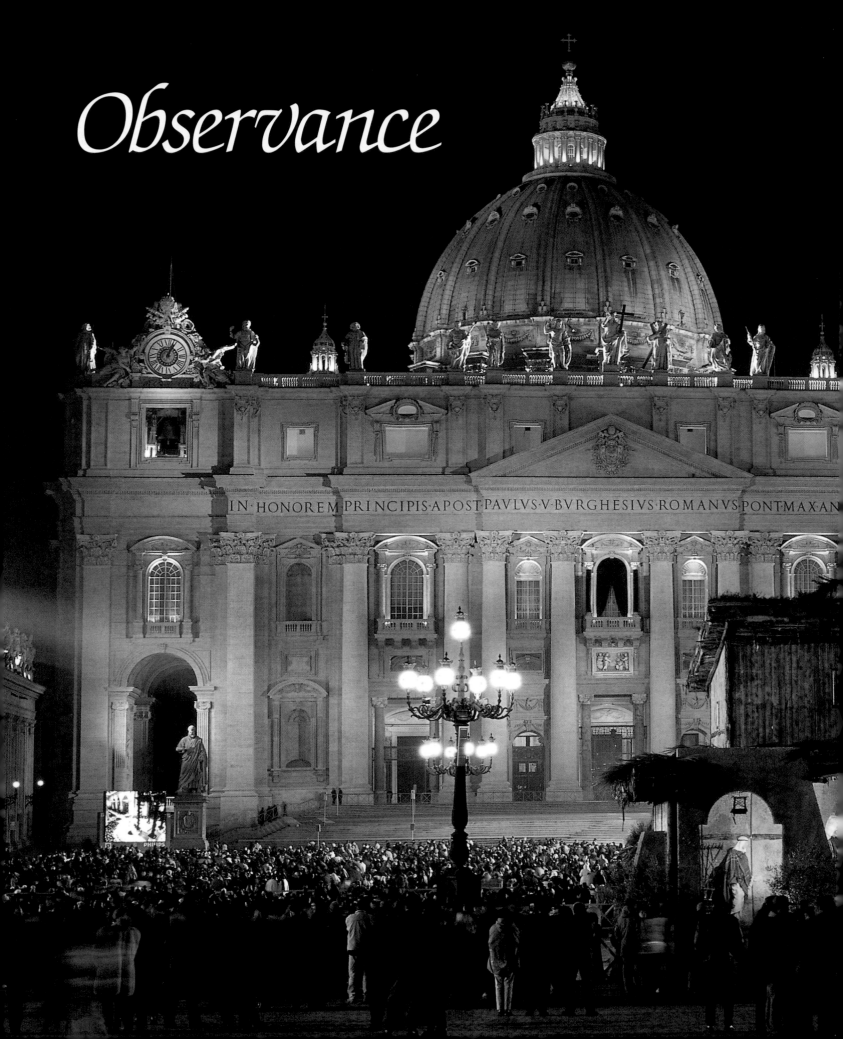

Observance

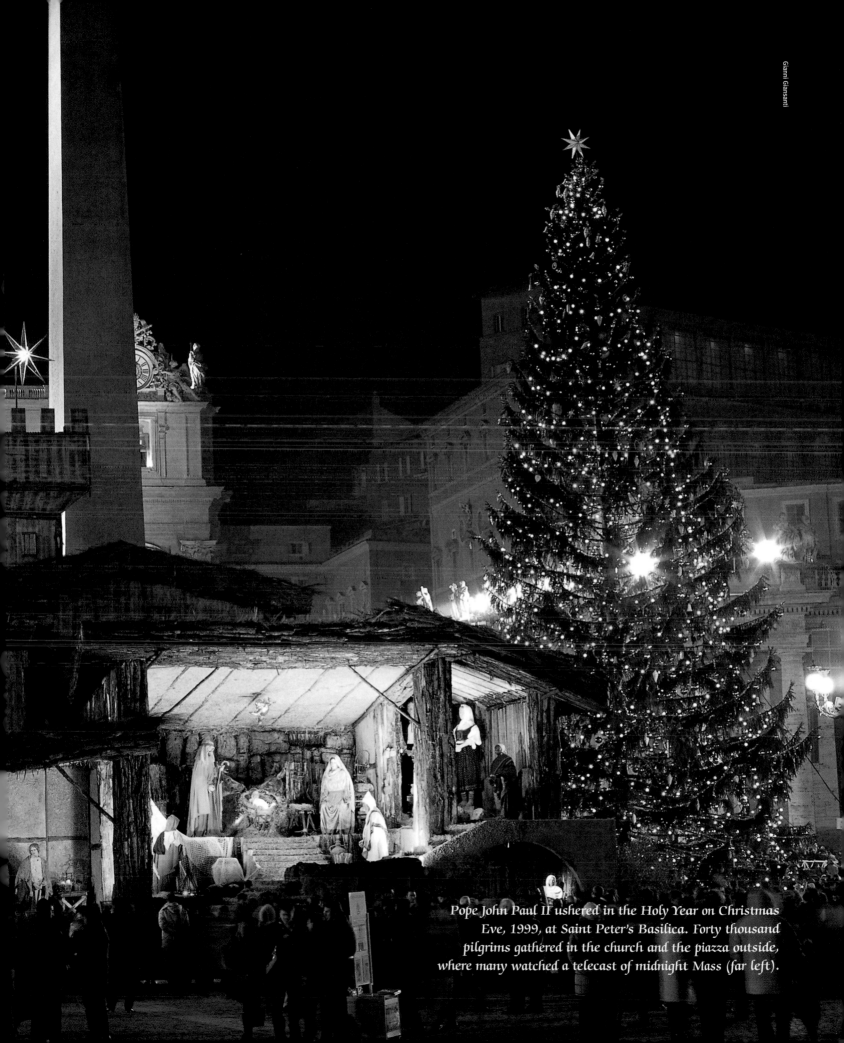

Pope John Paul II ushered in the Holy Year on Christmas Eve, 1999, at Saint Peter's Basilica. Forty thousand pilgrims gathered in the church and the piazza outside, where many watched a telecast of midnight Mass (far left).

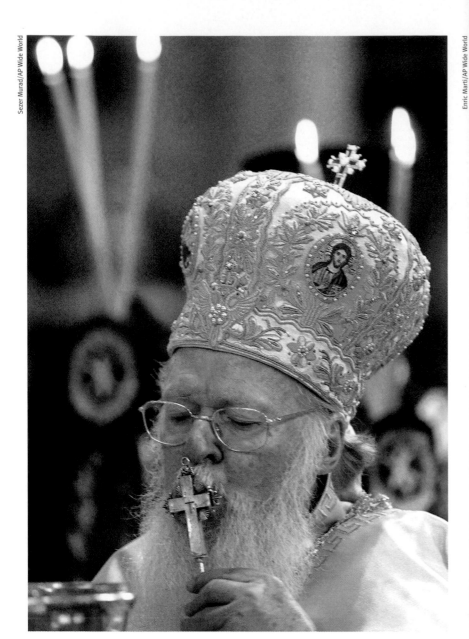

Though it has been embraced by secular cultures, Christmas remains an important time for the devout. Above, Ecumenical Patriarch Bartholomew I, the spiritual leader of the world's 300 million Orthodox Christians, kisses a cross during a service at the Patriarchal Cathedral of St. George in Istanbul in 2004. At right, in 1998, Cyril, a bishop of Crete, attends a solemn Greek Orthodox Mass in Egypt's Saint Catherine Monastery, which is located in the Sinai Peninsula.

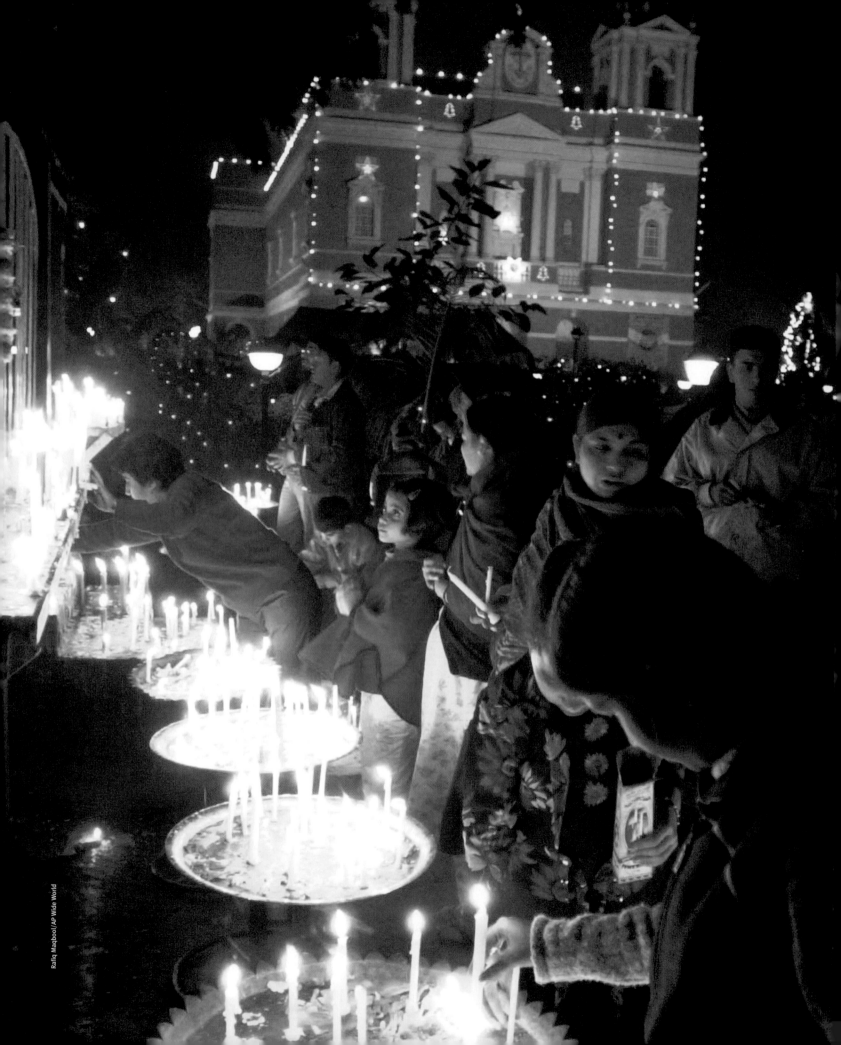

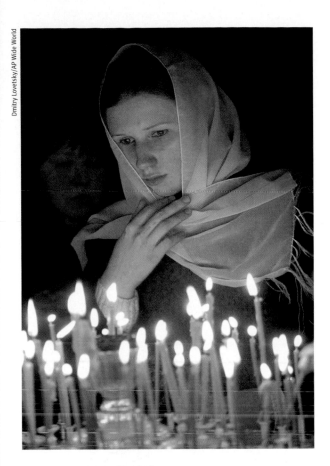

For those who wish to find a little peace, nothing offers more comfort than candlelight. Far left, celebrating Christmas Eve at the Sacred Heart Cathedral in New Delhi; near left, a Russian woman in a moment of contemplation at the Orthodox Christmas service in St. Petersburg's Kazansky Cathedral; below, a young Palestinian Christian boy in the Church of the Nativity in Bethlehem.

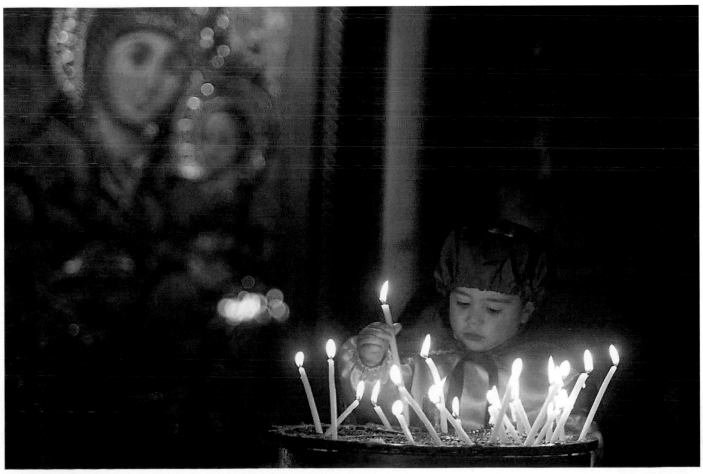

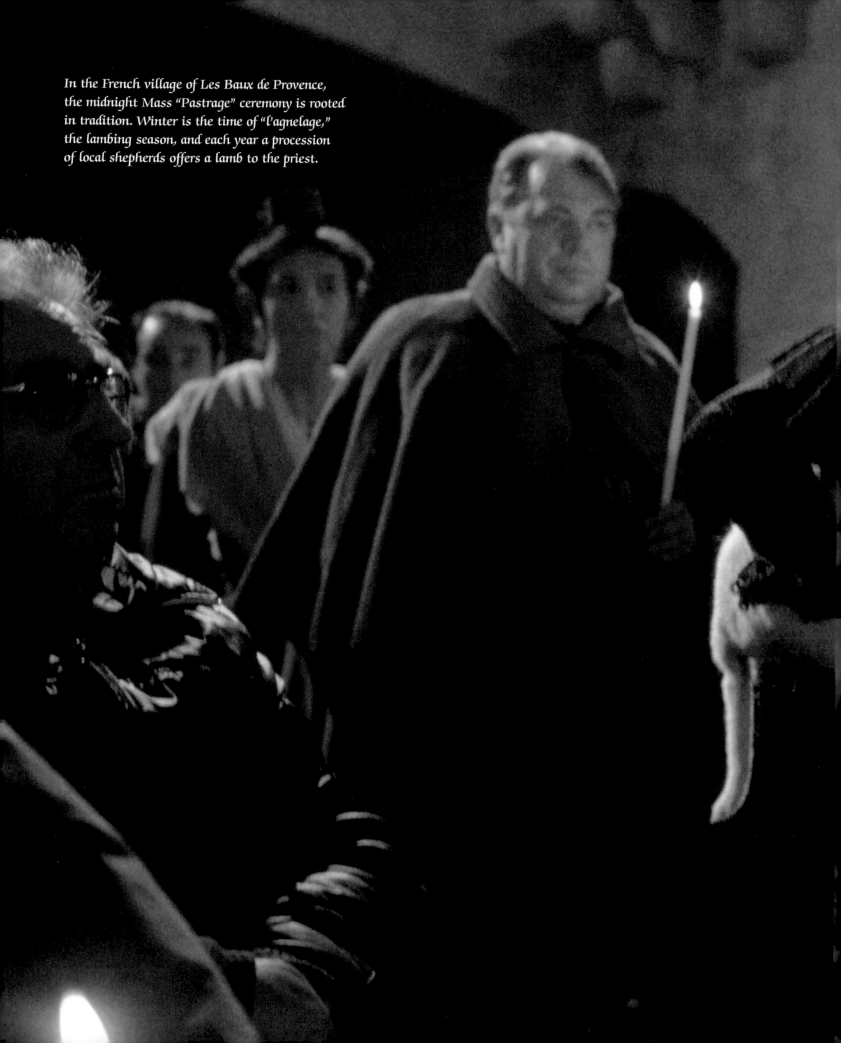

In the French village of Les Baux de Provence, the midnight Mass "Pastrage" ceremony is rooted in tradition. Winter is the time of "l'agnelage," the lambing season, and each year a procession of local shepherds offers a lamb to the priest.

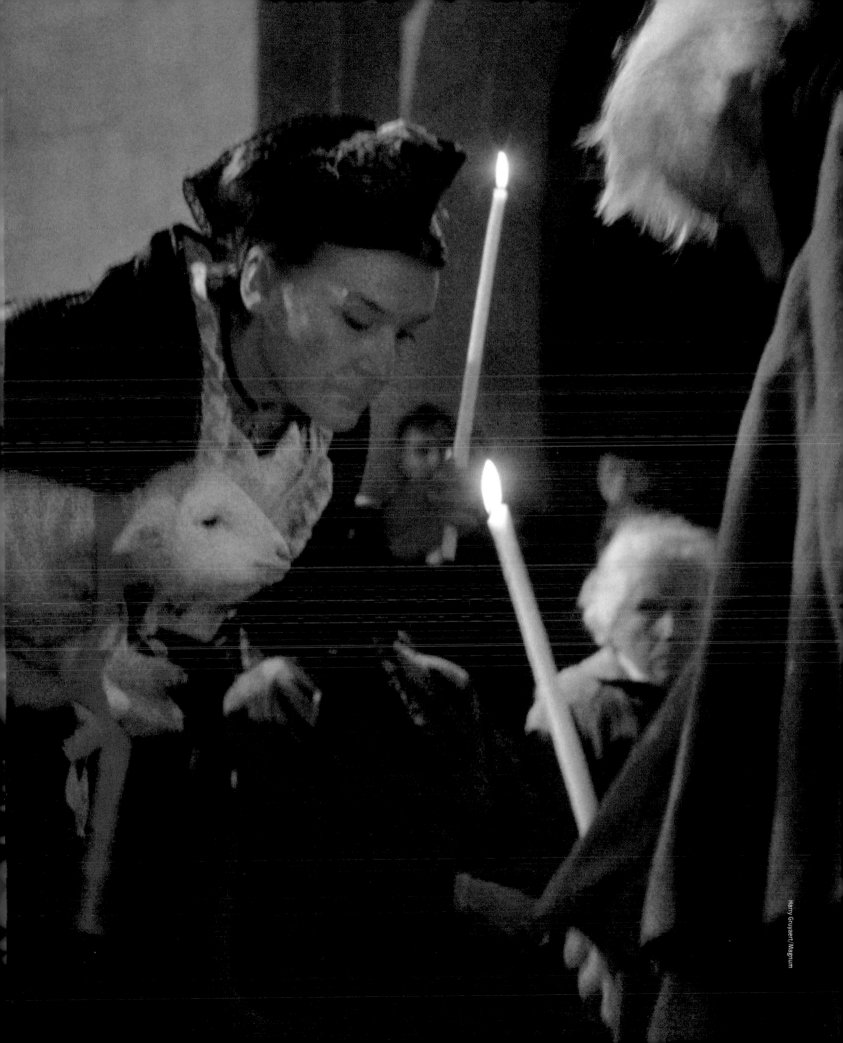

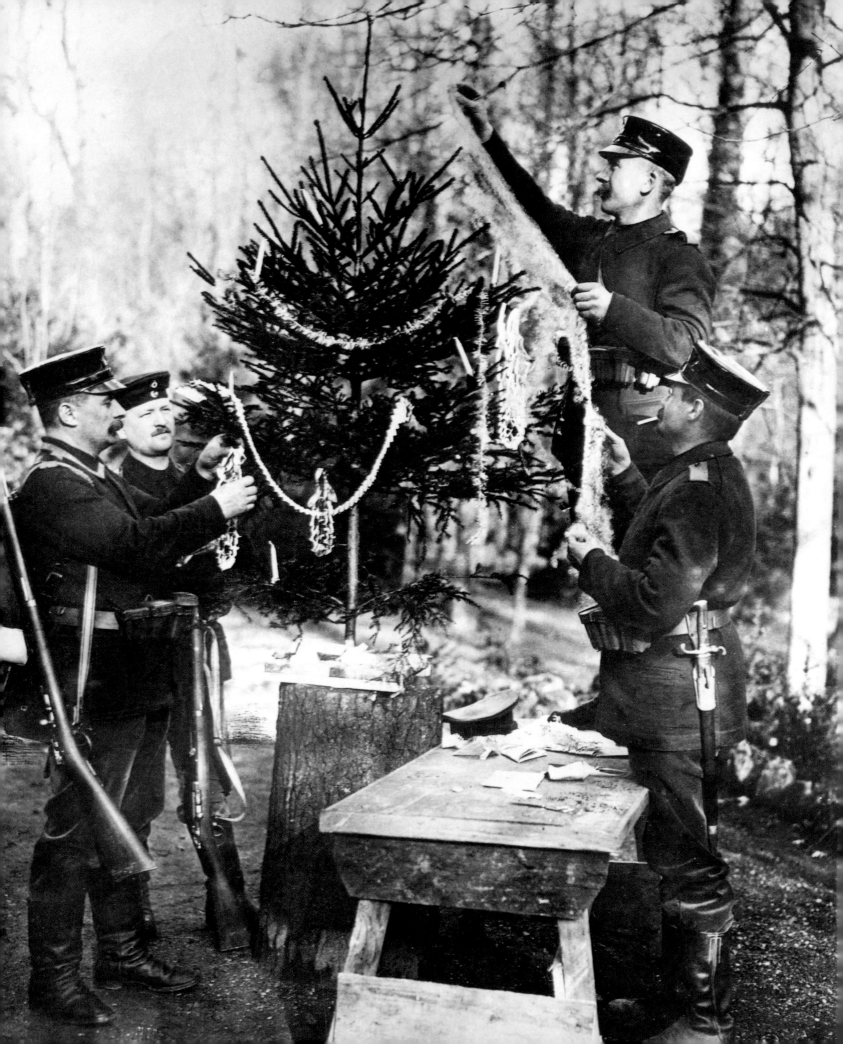

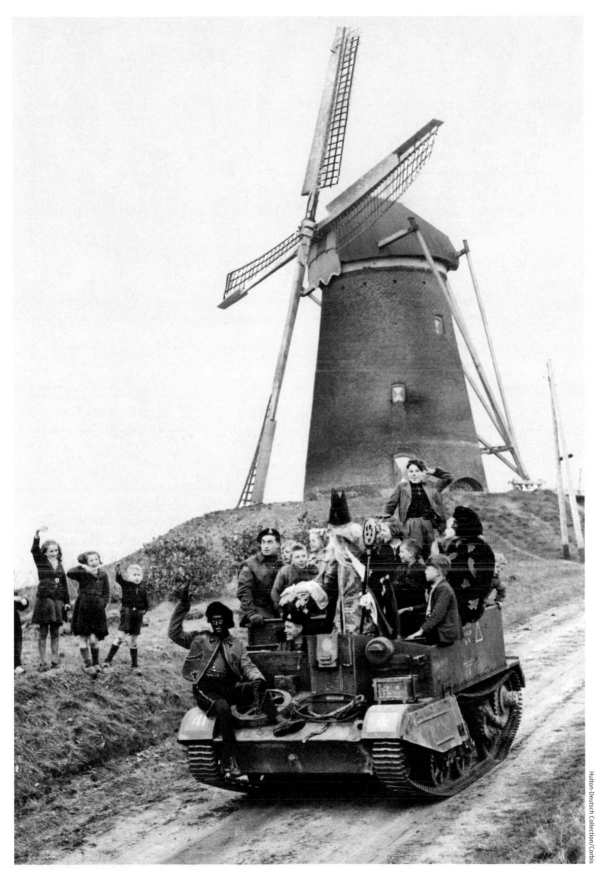

Even in the chaos of war, Yuletide goodwill can survive. Opposite: In 1914, the first year of WWI, German (seen here) and British troops emerge from the trenches to celebrate a Christmas Day armistice. Historian Malcolm Brown wrote of the truce, "It is perhaps the best and most heartening Christmas story of modern times." Left: During WWII, Canadian soldiers and Dutch kids get together for a Sinterklaas party, circa 1944.

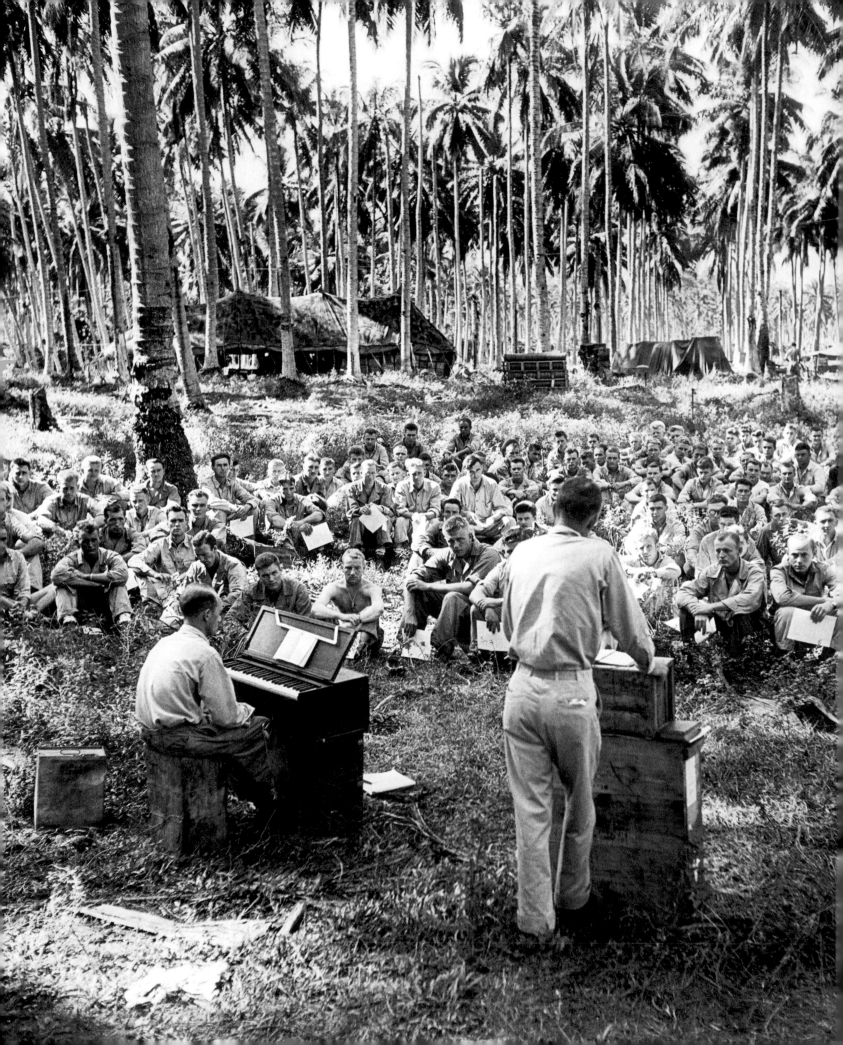

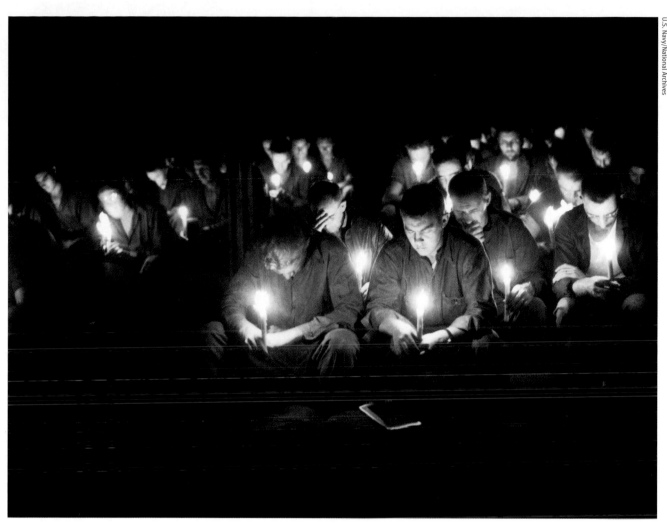

For the brave yet battle-weary servicemen of World War II, the holidays often became a time for prayer. These two pictures were taken at the sites of some of the fiercest fighting waged in the Pacific Theater. At left, in the middle of a prolonged struggle, Americans attend a Christmas service on Guadalcanal in 1942. Above, on Christmas Eve, 1944, Navy Seabees of the 50th Battalion, seated on sandbags, pray during a Holy Communion service on the island of Tinian.

Below: British troops in the 1956 Suez Crisis trim a tree in their dugout. Opposite: Before Christmas dinner in 2003 in Samarra, Iraq, U.S. Army 4th Infantry Division Sgt. Robert Scott of Colorado Springs and Lt. James Micheletti of Billings, Mont., fashion a makeshift tree. Perhaps the spirit of Christmas is most keenly felt in these places of strife—where the ideals of joy and peace may seem farthest off, but where that other Christmas essential, hope, shines on through the darkness.

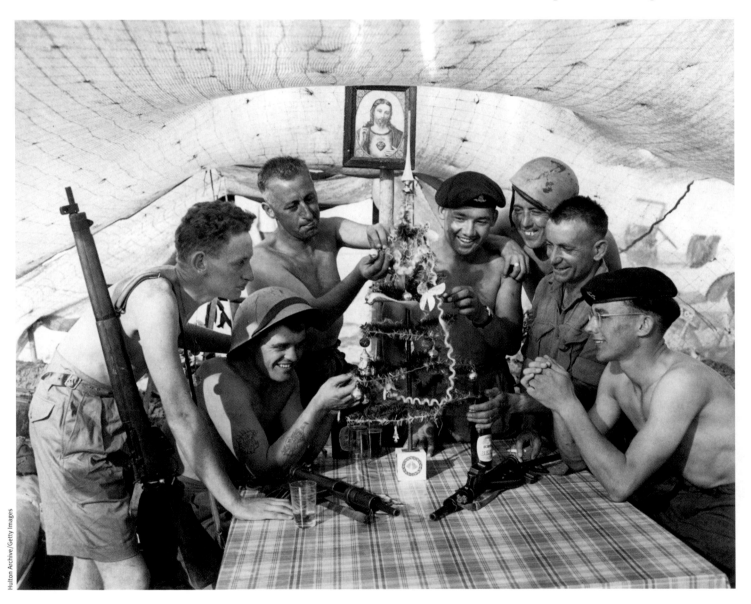

Hulton Archive/Getty Images

Mario Tama/Getty Images

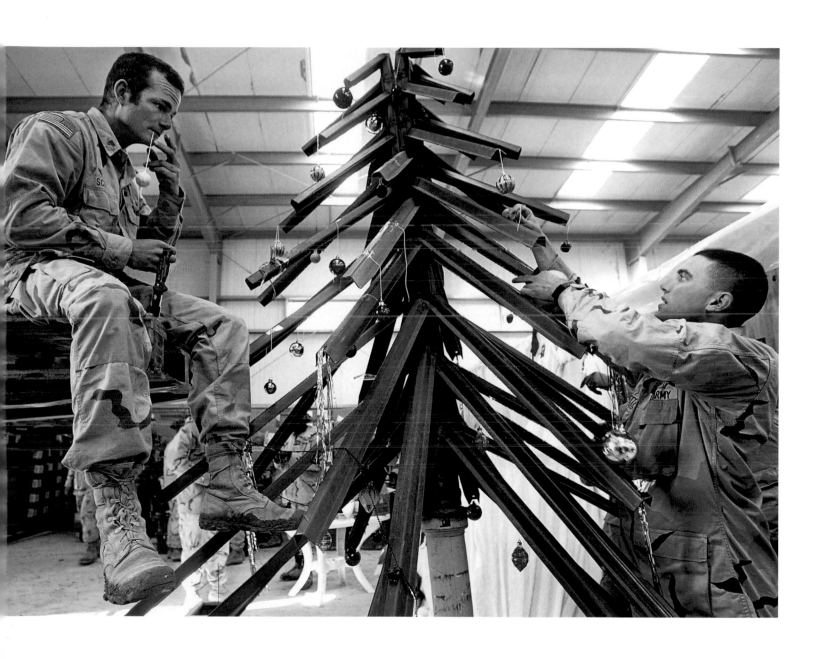

And to all a good night!

Hanover, N.H., December 24, 1991
An unidentified . . . something . . . is clocked at 650 miles per second.